HOW WE LIVE

MARCIA PRENTICE

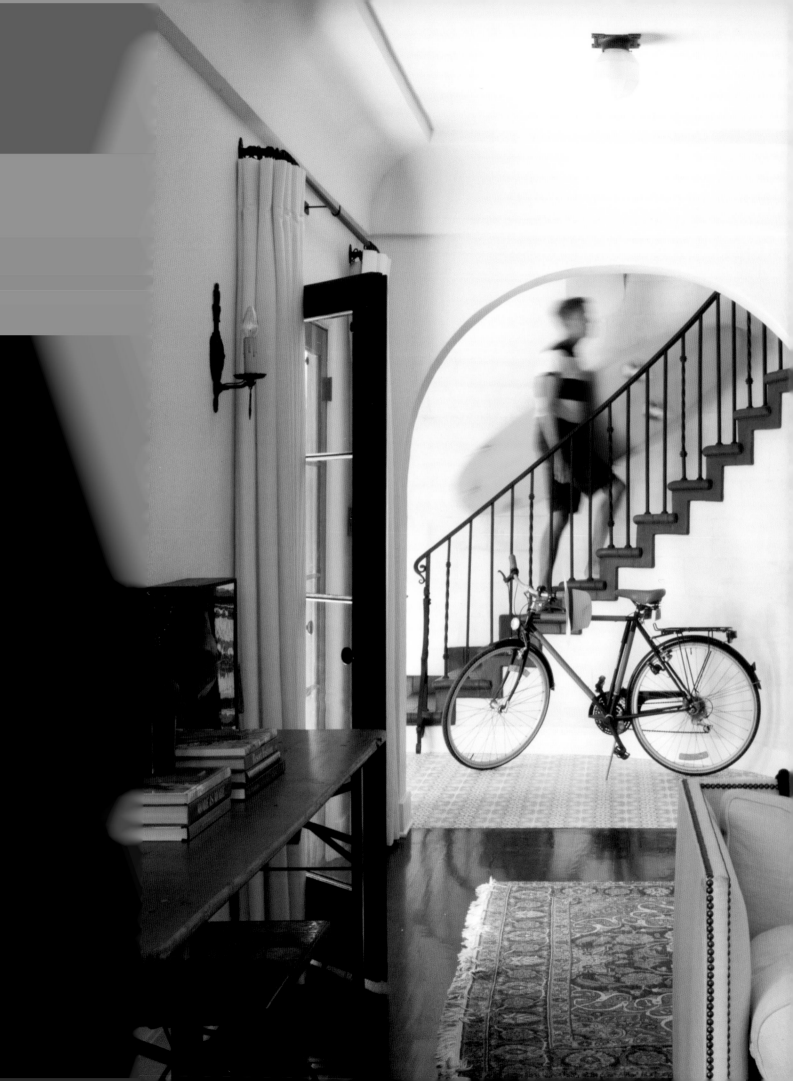

HOW WE LIVE

MARCIA PRENTICE

teNeues

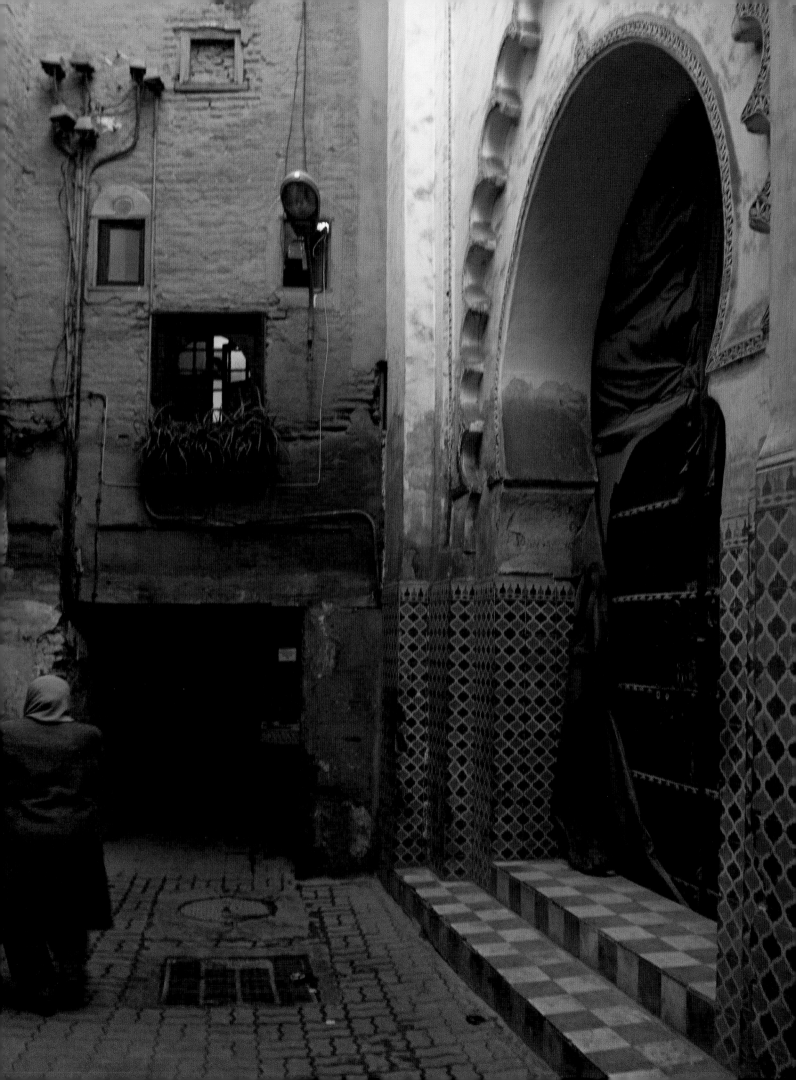

CONTENTS

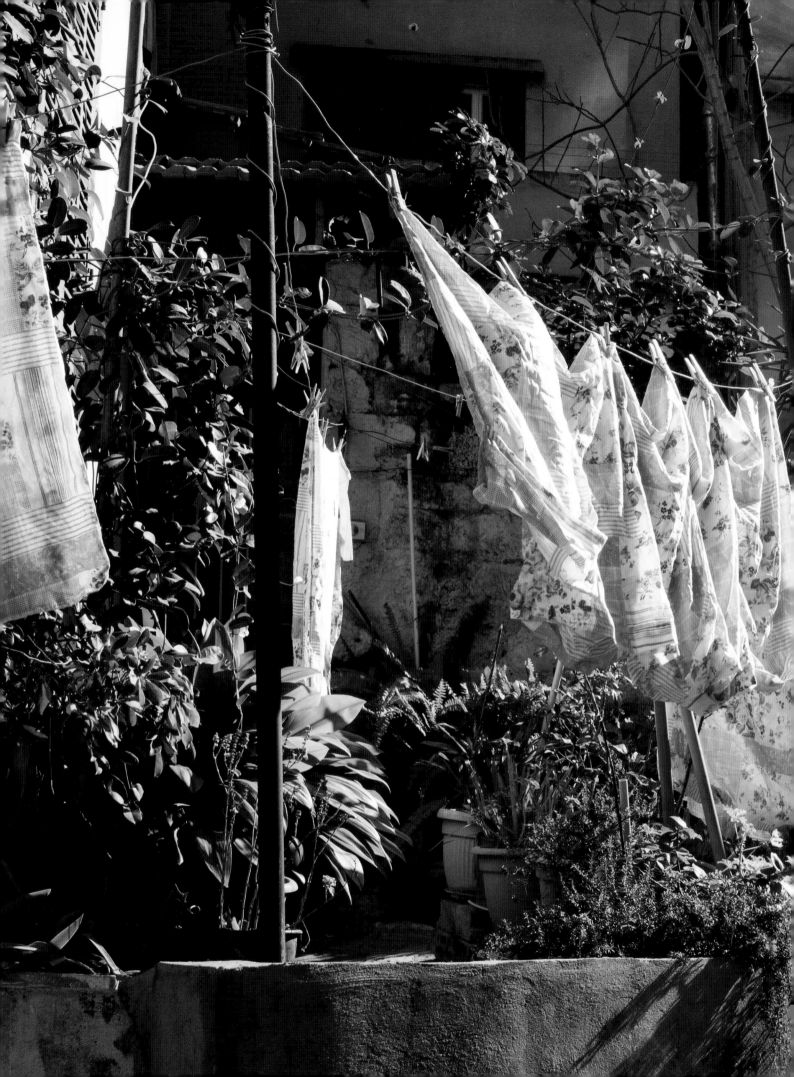

INTRODUCTION
MARCIA PRENTICE

This project began shortly after I turned 30 years old. As for many at this age, it was a reflective moment when I was presented with a crossroads. I had just taken a trip to Rome. It was my first time leaving the United States and I returned home with even stronger feelings of wanderlust and the thought that there is something more important in the world that I needed to explore. As this idea was becoming certain, I was brainstorming about how to create a meaningful project that would allow me to experience the real realities of living and working creatively in cities around the world. The book project for *How We Live* was born in a vivid moment when I had figured out a way to satisfy my curiosity to explore the world through a design perspective and share my experience through photographs.

Up until the beginning of my book project, I had met and photographed more than 75 homes of designers and artists in Los Angeles. I could see how the interior decor of the homes of American creatives were very eclectic as they were inspired by other cultures and influenced by design aesthetics that originated in Denmark or Italy, for example. The homes in Los Angeles really reflect the very basis for how America began—immigrants from around the world settling in this new place and bringing their cultures, familiar materials, textures, colors, and particular way of setting up their homes. This collective trend made me start thinking about the origin of design aesthetics, not just from the usual design cities such as Milan and Copenhagen, but I also wanted to explore unexpected cities such as Mumbai, Guadalajara, and Reykjavik.

The difference between the cities is not only in design aesthetic and culture, but also the political, economic, and overall daily environment that affects how designers live and work in their city. I wanted to delve deeper with the design 'conversation'—an overarching, global 'dialogue,' as it were—and bring an awareness of the value of personalized design and designers beyond the major, more-established, design cities, primarily in Western Europe and the United States. There are interesting stories waiting to be told, cities waiting to open their doors to curious minds, and places in the world that are wanting to prove their charm and overturn negative misconceptions.

The entire project took two years to complete. I started with the concept of photographing designer and artist homes around the world. I traveled to each city alone with no agenda, trying to squash any preconceived notions—allowing the cities and designers to reveal themselves to me. Along the way I never had much money, but as long as I had my camera, laptop, and passport, and energy to keep going, I knew I would be able to capture and chronicle my journey of discovery. I was welcomed into artists' homes because there seemed to be a mutual trust and curiosity about the other. The premise was to talk about design, but having an objective conversation about design concepts became a more nuanced study of the homeowner's private, interior world; a home is an intimate space, a place of complete self-expression, where one feels safe from the world, and where the deepest conversations and secrets are revealed. All of the homes in the book have a specific design quality, but also soul, emotion, expression and a way of living that isn't always striving for perfection. The goal is for you to feel that you are right there in the room with me really experiencing the energy of the space and meeting and getting to know the designer for the first time.

After all of my travels around the world and with the completion of the book, where does this all lead? I hope to encourage others to be more adventurous and give in to unusual experiences when they travel. And for the design community, this means that certain cities deserve to be seen with fresh eyes and to be presented in a new light. By opening our minds and hearts, we are enriched by other cultures by finding vital inspiration in the most unexpected places, which can only deepen our design conversations. For me, exploring the Middle East, Mexico, and India is just the beginning, but an exciting start to even more wondrous and enlightening design experiences.

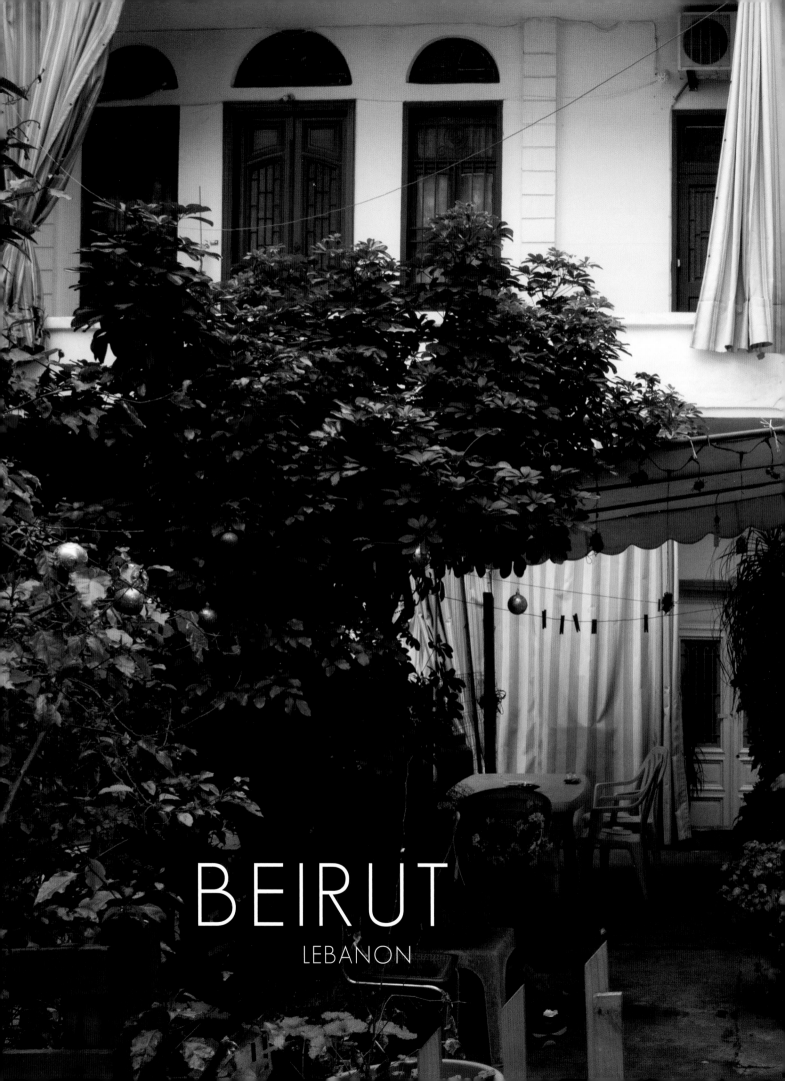

BEIRUT

LEBANON

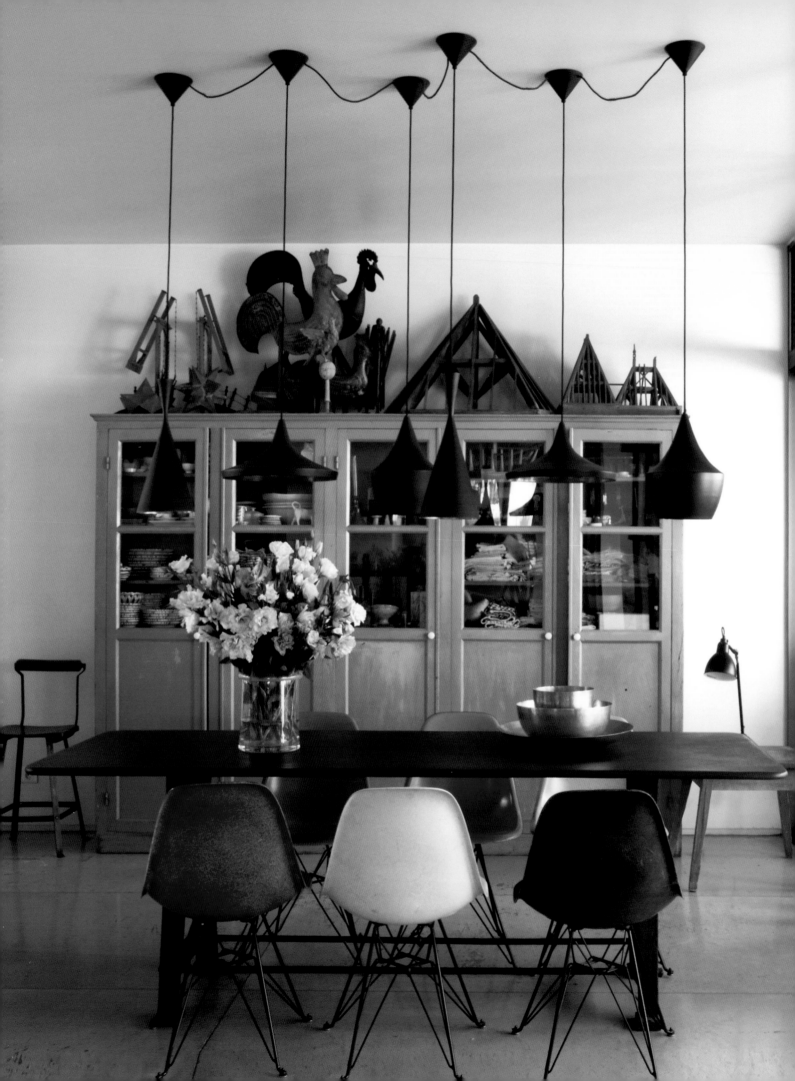

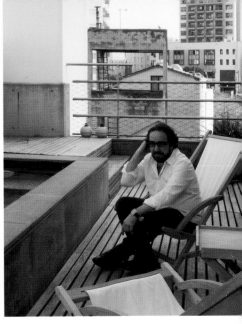

RAËD ABILLAMA
ARTISAN ARCHITECT

Having been born in Beirut and currently living in Lebanon, there has not been a dull moment in Raëd Abillama's life thus far. Raëd was born in 1969, the same year that Neil Armstrong landed on the moon. Raëd's name means "pioneer" in Arabic and perhaps the name was derived from what was happening in the world at the time. At the age of nine, he moved to Paris because of the Lebanese civil war—a conflict which ended up lasting 15 and a half years.

Raëd's father had an architectural education and a way of looking at the world that influenced Raëd from a young age. During his youth, he was always building something or taking something apart and somehow he always knew he would end up becoming an architect. Raëd's early influences led him to study architecture at Rhode Island School of Design, which was followed by a Master's degree in architecture at Columbia University in New York City.

After working at an architectural practice in New York for a few years he grew frustrated by the lack of connection he had to the construction process. He wanted to be involved at every level of the design and to learn from it. At the same time, Beirut needed to be rebuilt after the 15-year civil war had destroyed much of the city. Raëd viewed the situation in Beirut as an architectural opportunity, calling it "the biggest urban workshop at the time." The city was starting from the beginning again and the whole architectural landscape had to be rethought from the urban planning to its architecture programs.

Raëd, along with a few of other architects who studied abroad, decided to move back to Beirut and really dive into the exciting architectural challenge in front of them to start rebuilding the city.

Raëd says that living and working in a city that is often in conflict is something that you never really adapt to; it requires a lot of patience, faith, and flexibility. In 2006, during the Israel-Hezbollah War, Raëd had a busy office with many projects in progress, and had to continue working the best he could while waiting for the war to end. Living with this type of constant uncertainty, Lebanese people have developed a resilient persona with the ability to quickly bounce back and move on.

Working in Beirut is a "jungle" with unclear regulations, filled with developers and opportunists who are shaping the look of Beirut. Within the lack of structure and rules, architects have a unique creative freedom to test and invent new ideas and possible solutions. Compared to the much stricter architectural guidelines of countries like the United States or even Europe, Beirut lacks red tape, which makes it is possible for architects to realize their dreams much faster.

Even with its challenges, it is a motivating and exhilarating time in Beirut. Raëd has designed a cutting-edge café/concept shop named Ginette; he has been involved with rehabilitating the Beirut pine forest; designed a number of apartments around the city; and he has an industrial design practice that explores new materials and concepts.

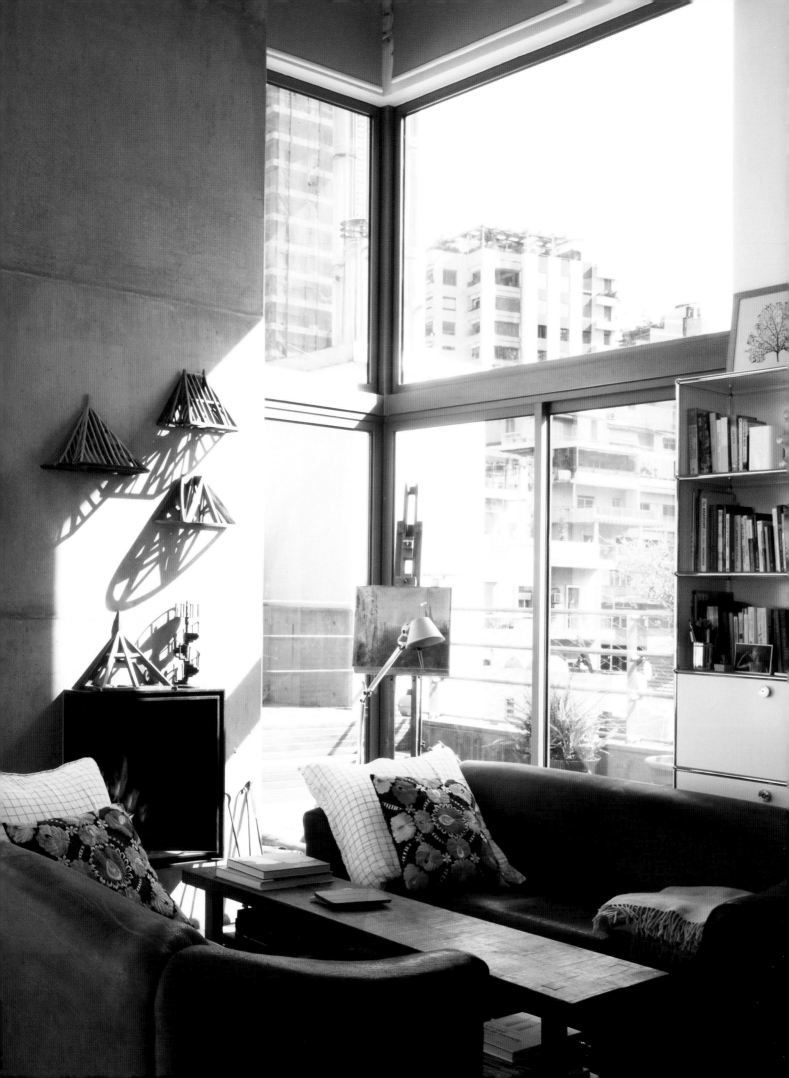

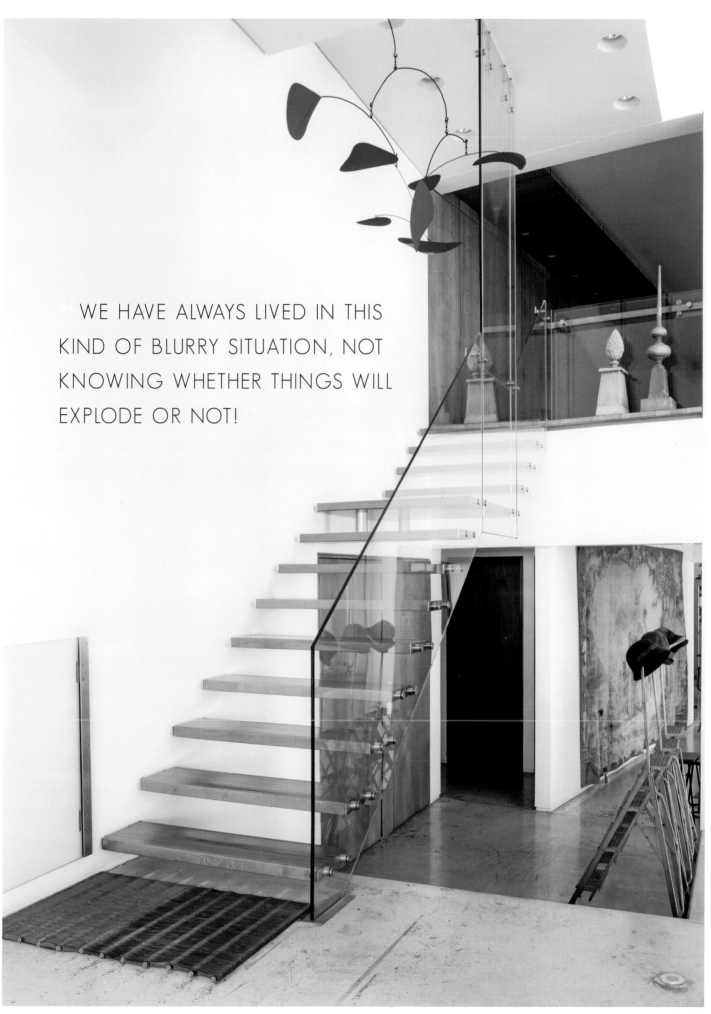

WE HAVE ALWAYS LIVED IN THIS
KIND OF BLURRY SITUATION, NOT
KNOWING WHETHER THINGS WILL
EXPLODE OR NOT!

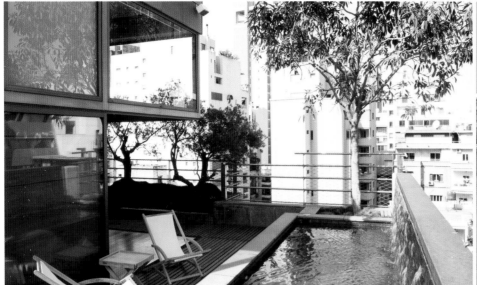

BEIRUT WAS DESTROYED AND REBUILT SEVEN TIMES.

ONE OF THE MOST RELIGIOUSLY DIVERSE CITIES IN THE MIDDLE EAST, BEIRUT IS ALSO NICKNAMED "PARIS OF THE MIDDLE EAST" BECAUSE OF ITS EUROPEAN-STYLE ARCHITECTURE, CAFE, AND CULTURE SCENE.

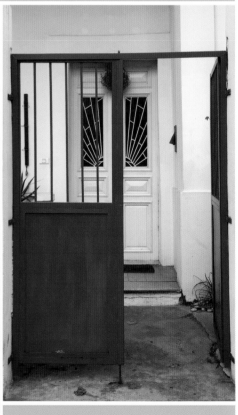

BEIRUT DESIGN WEEK IS THE LARGEST DESIGN FESTIVAL IN THE MIDDLE EAST AND NORTH AFRICA.

ARABIC IS THE OFFICIAL LANGUAGE, BUT FRENCH AND ENGLISH ARE COMMONLY SPOKEN.

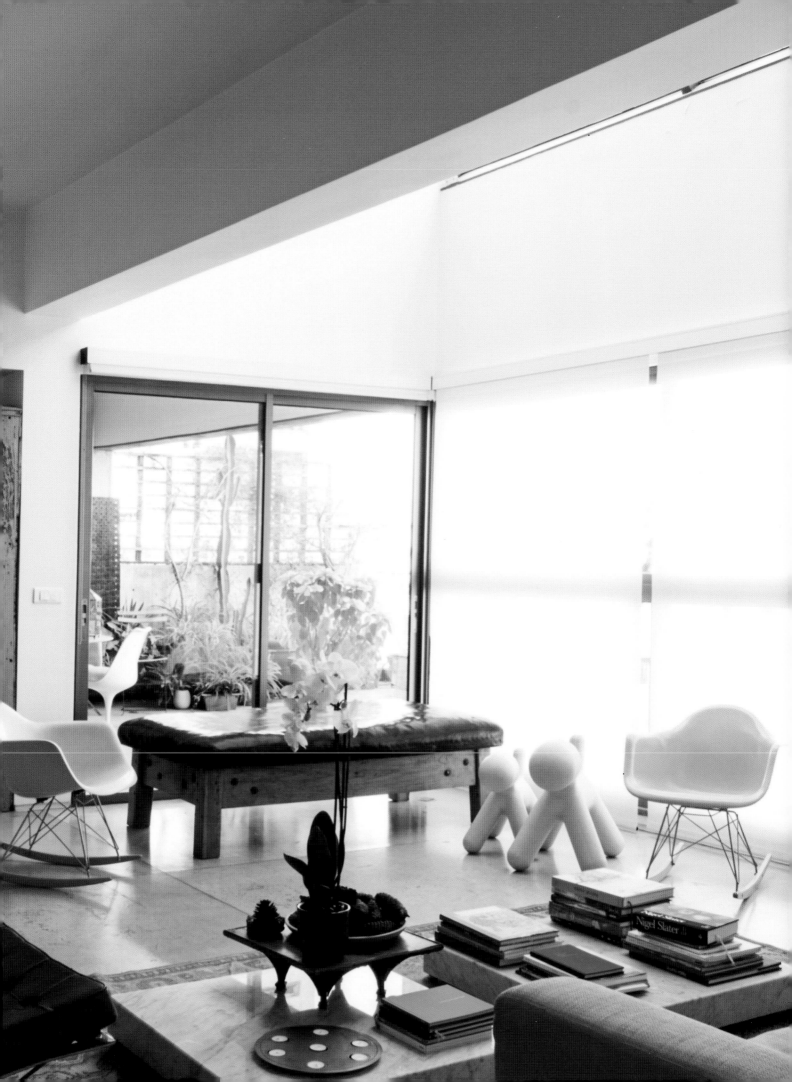

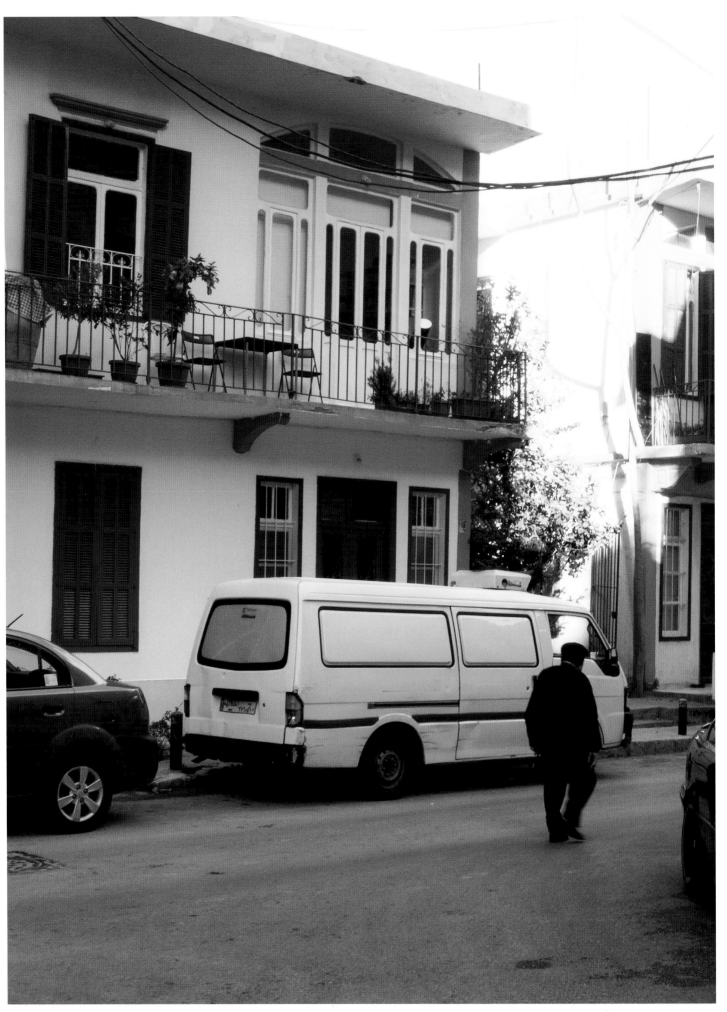

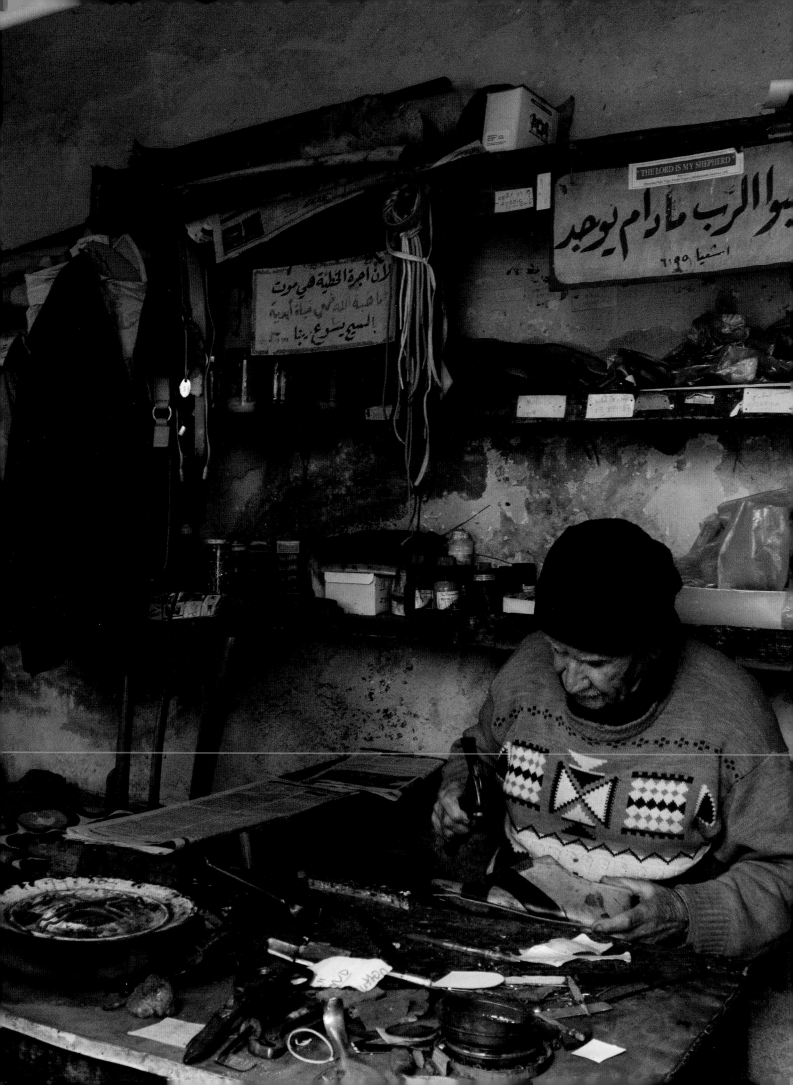

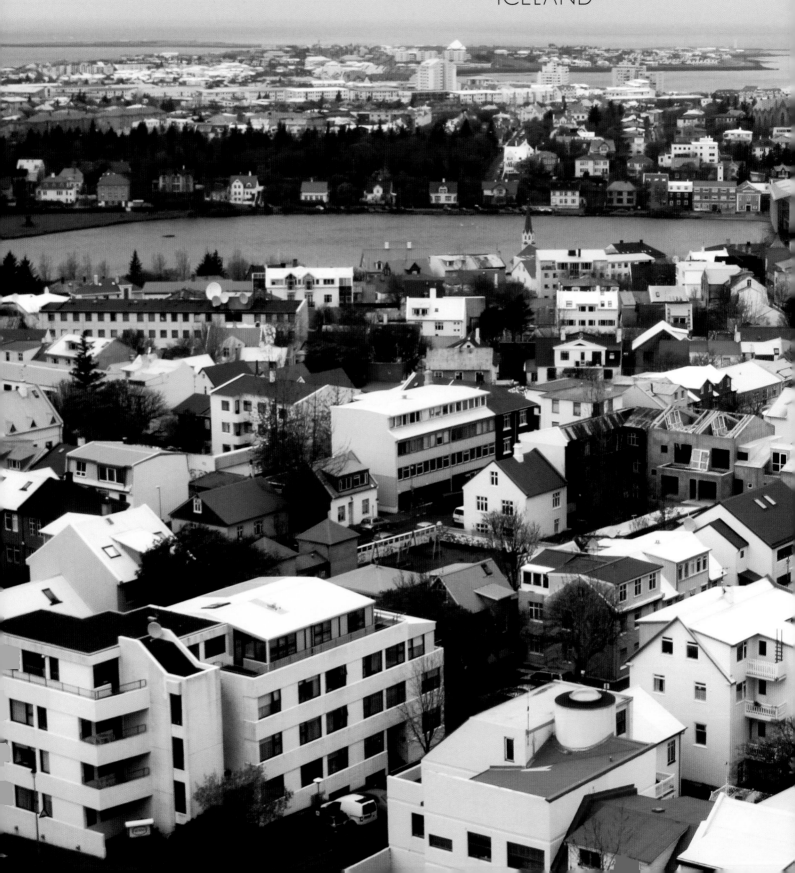

REYKJAVIK

ICELAND

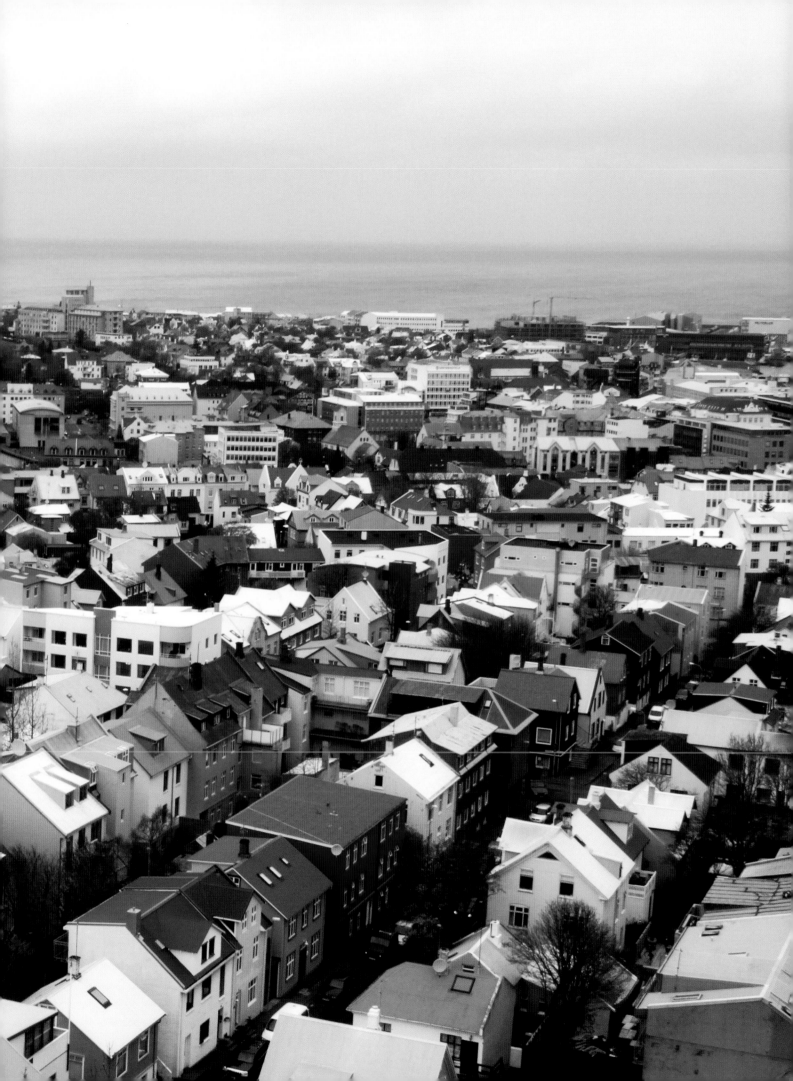

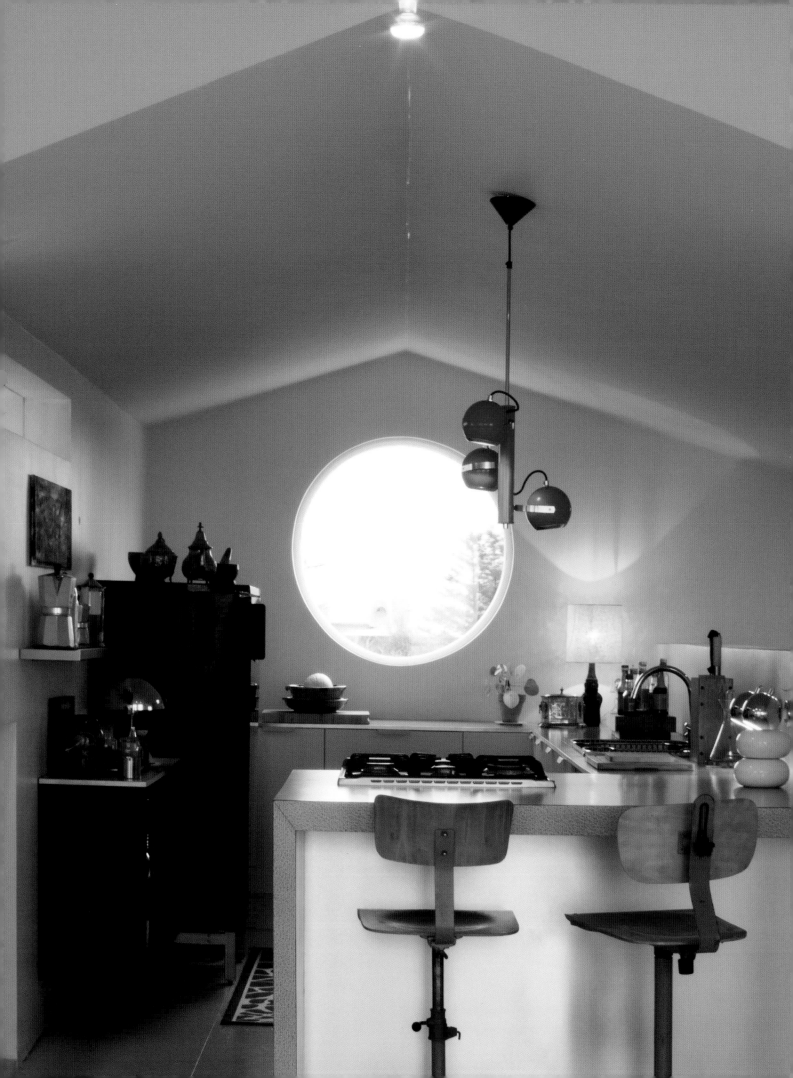

AUÐUR GNÁ INGVARSDÓTTIR
INTERIOR DESIGNER

Auður was born and raised in Reykjavik. She grew up in an area of the city where a lot of young families lived; it was a new and very safe neighborhood, so she was able to stay outside all day and simply enjoy the vast open fields. Outside of living in Reykjavik, she spent a few summers in foreign countries.

Auður studied interior design in Barcelona at one of the first established design schools in Spain, ELISAVA (Barcelona School of Design and Engineering). After living in Barcelona for 10 years, she returned to Iceland to work on projects in the field of branding and marketing. A few years ago, Auður shifted her focus back to design to start her own home accessory line, Further North. She is currently building the product line and concentrating on interior design as well.

In 2006, she bought her apartment, but it was in very bad condition and not livable. Because of the extensive and complicated renovation plans, it took over a year to obtain all the building permits. When her remodeling was complete, Auður had doubled the size of the apartment, rebuilt the roof, and constructed a long balcony. Overall, she wanted to keep an open layout to bring in as much natural light as possible.

For a designer in Iceland, there is a unique freedom in living and working there because of the communal spirit and attitude of the Icelandic people. They are always looking for solutions to challenges and there is little difficulty in finding workers who can make small batches of products, which is very helpful for testing out new products. Overall, there is a strong support system for designers wanting to create something on their own and it seems that everyone finds a way to somehow make it happen.

Founded in the late 1700s, Reykjavik is still a relatively young city and so it has been able to preserve some of its original spirit as a fishing village and coastal town. The landscape of Reykjavik is unlike anything you will find in the world. Reykjavik's close proximity to the Arctic Circle causes arrestingly deep blue skies and sea waters. Its topography of mountains and sea coves and straits in close range to the urban center draws many designers and people, in general, who want to experience this unusually beautiful setting. Even the light in Reykjavik is very different than many other cities around the world as certain months have lots of daily sunlight, while the rest of the year have shorter days or are overcast in haze or low light.

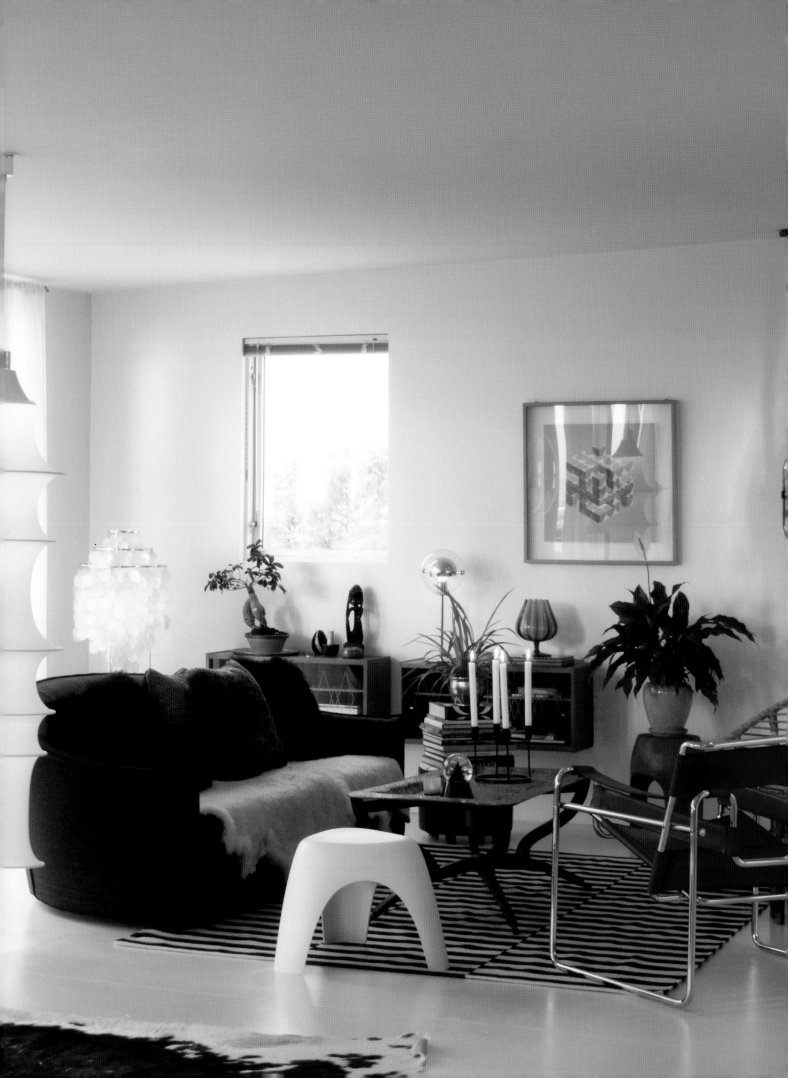

"AROUND ICELAND YOU WILL ONLY FIND VILLAGES...WE DO NOT HAVE ANOTHER URBAN UNIT OR CITY APART FROM REYKJAVIK, WHICH IS JUST A TINY CITY."

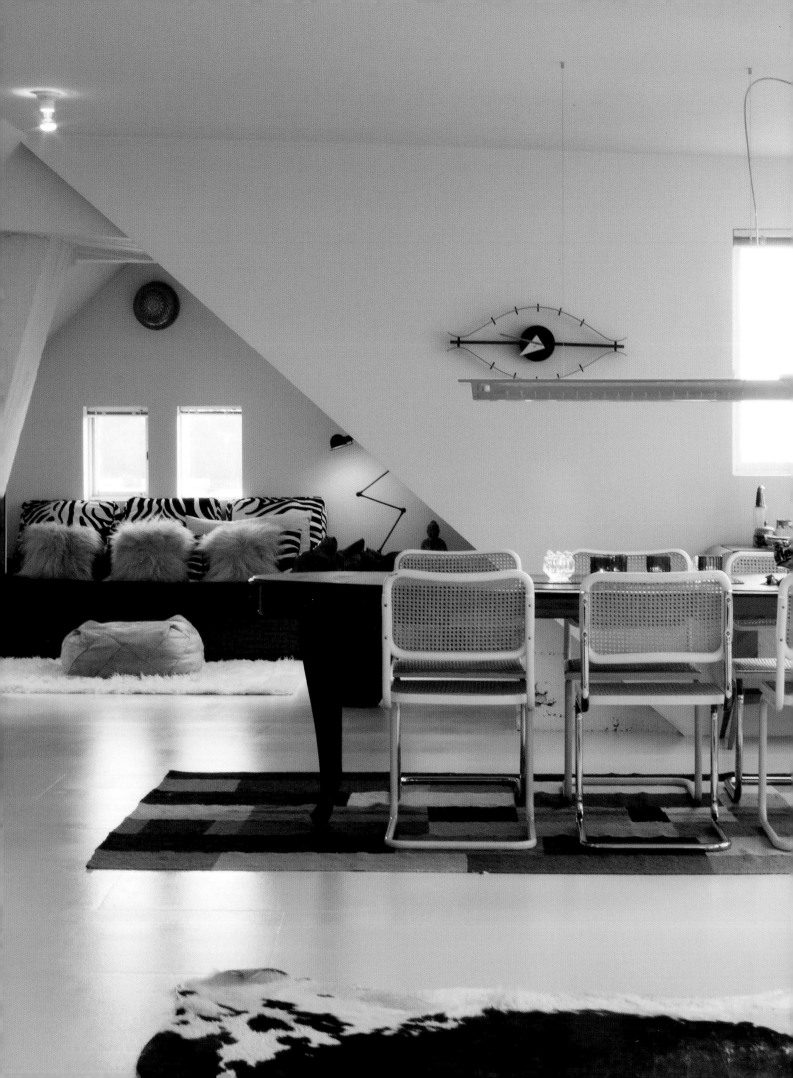

REYKJAVIK'S HIGHLY CREATIVE ART, DESIGN, AND MUSIC SCENE FINDS INSPIRATION IN ICELAND'S RUGGED AND EXPANSIVE LANDSCAPE AND ITS UNUSUALLY DEEP BLUE SKIES.

REYKJAVIK, WITH A POPULATION OF ONLY 325,000 PEOPLE, IS THE WORLD'S NORTHERNMOST CAPITAL WITH ITS CLOSE PROXIMITY TO THE ARCTIC CIRCLE.

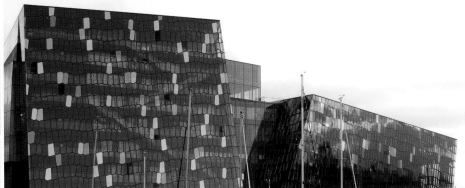

ICELAND IS KNOWN AS THE "LAND OF FIRE AND ICE" BECAUSE IT HAS SOME OF THE LARGEST GLACIERS IN EUROPE AND SOME OF THE WORLD'S MOST ACTIVE VOLCANOES.

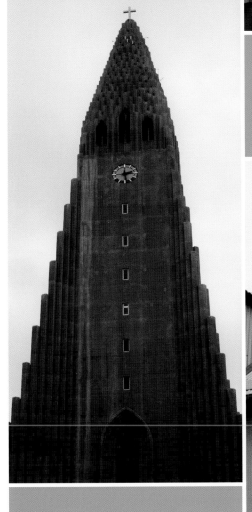

THE HALLGRÍMSKIRKJA CHURCH IN REYKJAVIK IS DESIGNED TO RESEMBLE THE BASALT LAVA FLOWS OF ICELAND AND CAN BE SEEN FROM ALMOST ANYWHERE IN THE CITY.

25

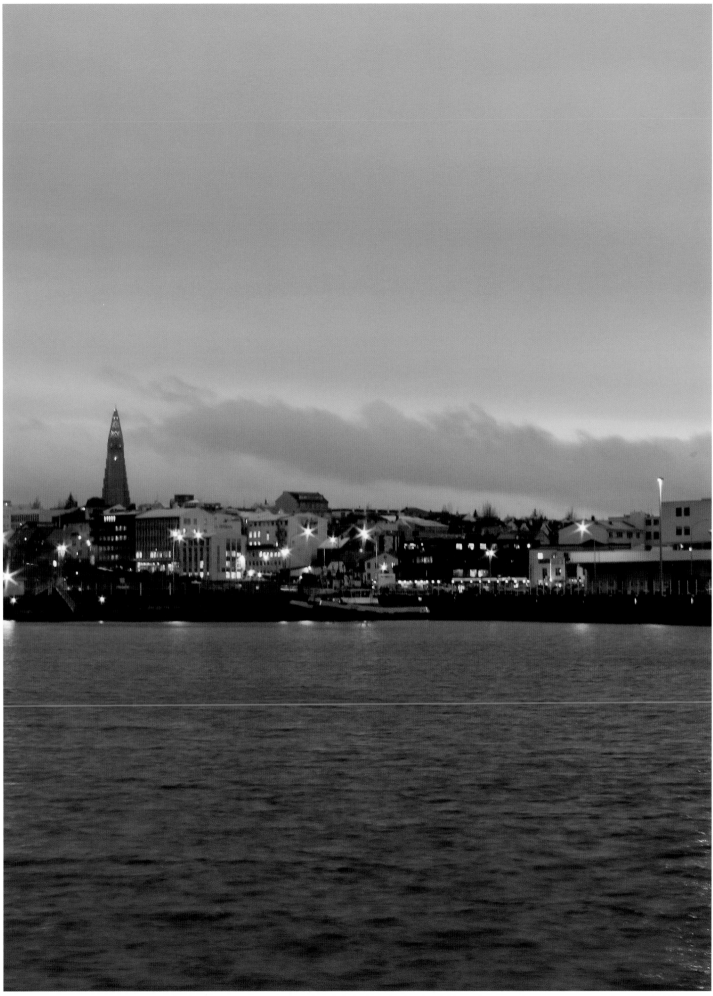

PORTO

PORTUGAL

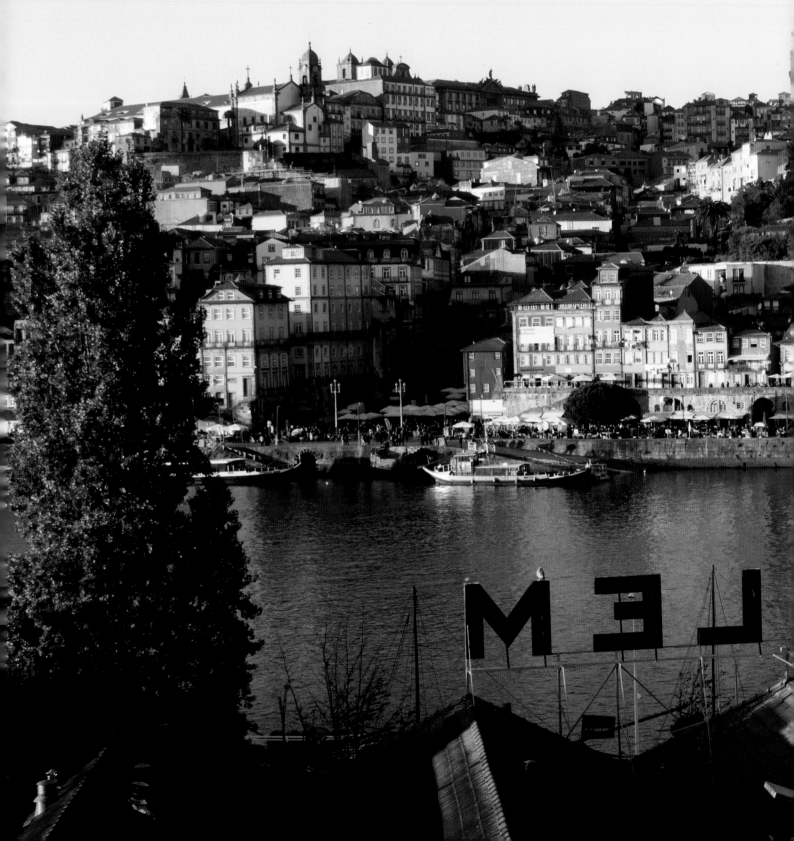

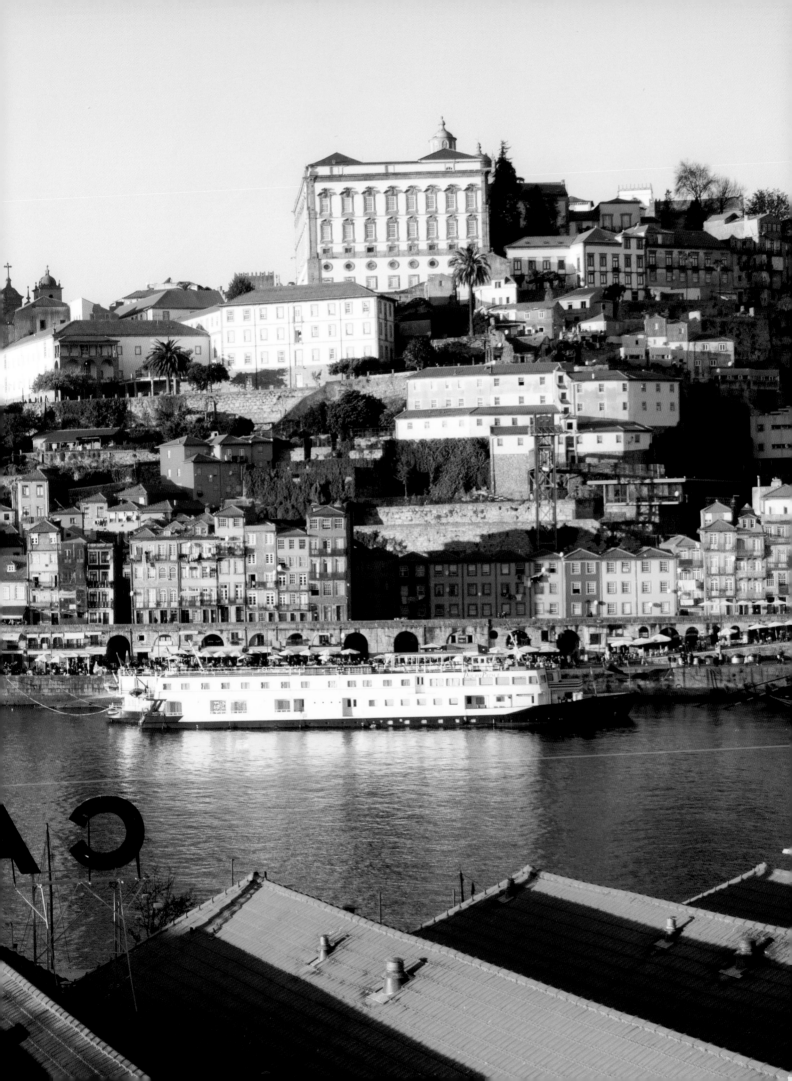

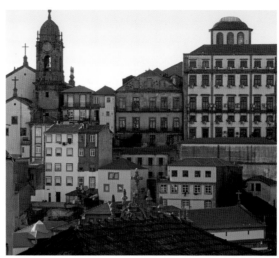

PEDRO SOUSA
EXCLUSIVE FURNITURE DESIGNER

Pedro was born in a small village in the northeast of Portugal. He spent the first eight years of his life in Lisbon, and then Porto. As a child he remembers building his toys, and drawing, painting, and observing the world around him. Thus, it was very natural for him to take an artistic career approach. Pedro studied industrial design at ESAD in Matosinhos (Porto). He also participated in the Erasmus study abroad program at the National College of Art and Design (NCAD) in Dublin.

In 2005, Pedro was one of the creators of the Boca do Lobo luxury furniture brand. He was responsible for designing all products for the Soho, Coolors, and Limited Edition collections. He was inspired to start his own design company, Pedro Sousa Design Studio, in 2009, creating experimental, unexpected, and often dichotomous furniture pieces. He often feels like he is still in the beginning stages of his career because the industry inherently entails feelings of restlessness and uneasiness. Even though he has acquired a number of achievements in his field of work, Pedro believes he is still learning professionally and enjoys the new challenges that each day brings.

Pedro's furniture designs are often sensual in shape and use disparate materials such as wood, glass, fabric, stainless steel, marble, bronze, and cork applied in a number of forms, meant to be a crossover between jewelry and architecture. He also likes to convey a material 'disharmony' and sharply graphic style that can convey an elegance and movement in its boldness and directness. For example, his Causeway side cabinet has a dazzling tri-dimensional effect from a geometric block pattern on its wood veneer surface that appears regimented, yet coolly modern. The Tornado cork table is named for its unusual mid-swivel, twisting shape and it is made from wine bottle cork waste. Pedro recalls yet re-invents Art Deco with his folding-screen design consisting of plywood panels replicating ebony and walnut with glamorous gold leaf and lacquered veneers.

Because of the scale of the city and its close proximity to the river, beach, countryside, and its national park, the city of Porto has an inviting quality of life and relaxed atmosphere. It has a long and rich history as one of the oldest European centres and it was an outpost of the Roman Empire. Old and shockingly new buildings co-exist in the city, as Porto boasts some of the most daring designs in contemporary architecture. The *azulejo* tile panels are unique and traditional decorative elements that are specific to the buildings, rail stations, churches, and fountains of Portugal. The industrial industries just outside Porto provide opportunities for designers to learn from master craftsmen and to refine and produce smaller quantities of their products. And it was because of this special access to these industrial industries that Pedro was able to set up his furniture business in Porto.

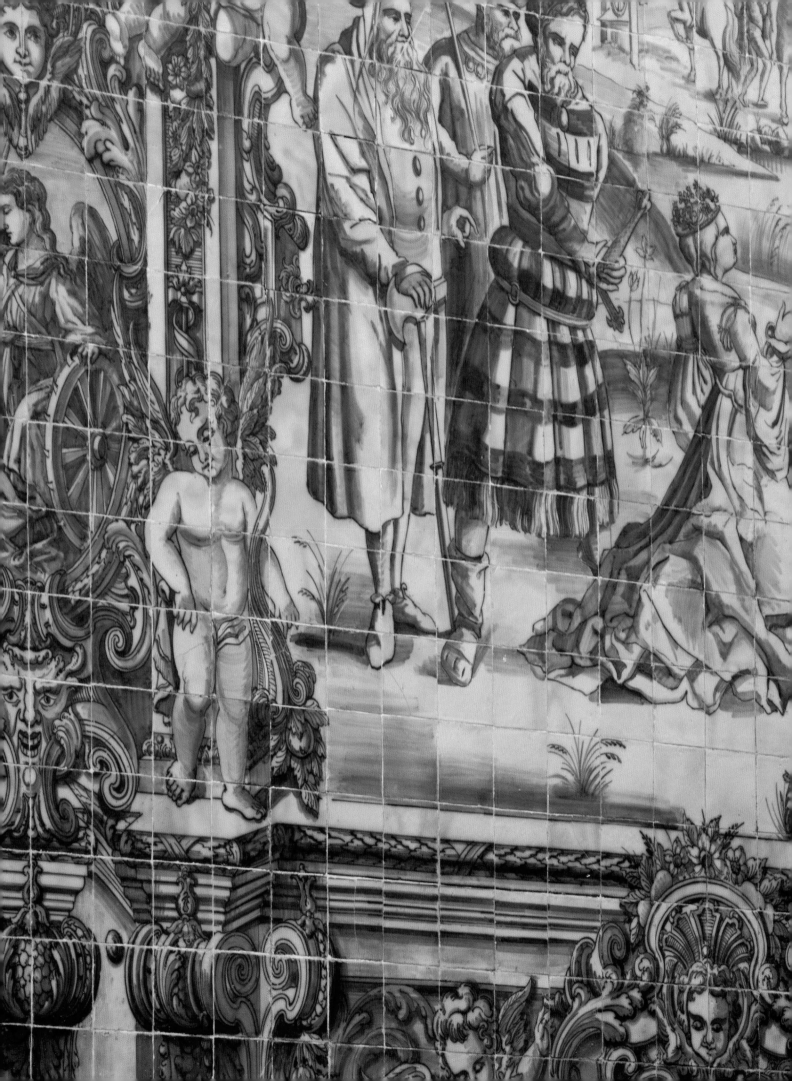

"PORTO IS TRADITIONALLY AN INDUSTRIAL CITY AND IT IS EASY TO FIND SEVERAL METAL FOUNDRIES AND INDUSTRIES OF WOOD OR TEXTILES WITH MASTER CRAFTSMEN ON THE OUTSKIRTS OF THE CITY."

THE PORTO SCHOOL OF ARCHITECTURE IS ONE OF THE MOST PRESTIGIOUS IN EUROPE, WITH ALUMNI THAT INCLUDES PRITZKER PRIZE-WINNING ARCHITECTS ÁLVARO SIZA VIEIRA AND EDUARDO SOUTO DE MOURA.

AZULEJO TILE PANELS—ELABORATELY PAINTED, GLAZED BLUE TILES OFTEN USED TO PORTRAY SCENES FROM HISTORY— ARE A UNIQUE ELEMENT OF PORTUGUESE ARCHITECTURE (AS SEEN IN THE TILE PANELS BY PAINTER JORGE COLAÇO IN THE SÃO BENTO RAILWAY STATION).

PORTO HAS A HISTORY DATING BACK TO THE 8TH CENTURY BC AND IS KNOWN AS THE CITY OF BRIDGES (IT IS THE ONLY MAJOR CITY IN EUROPE WITH SIX BRIDGES).

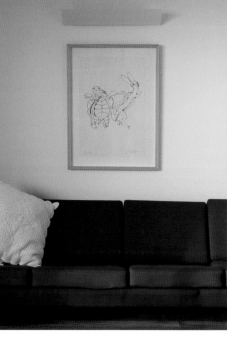

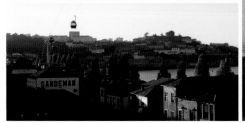

THE MARIA PIA BRIDGE IN PORTO WAS DESIGNED BY GUSTAVE EIFFEL.

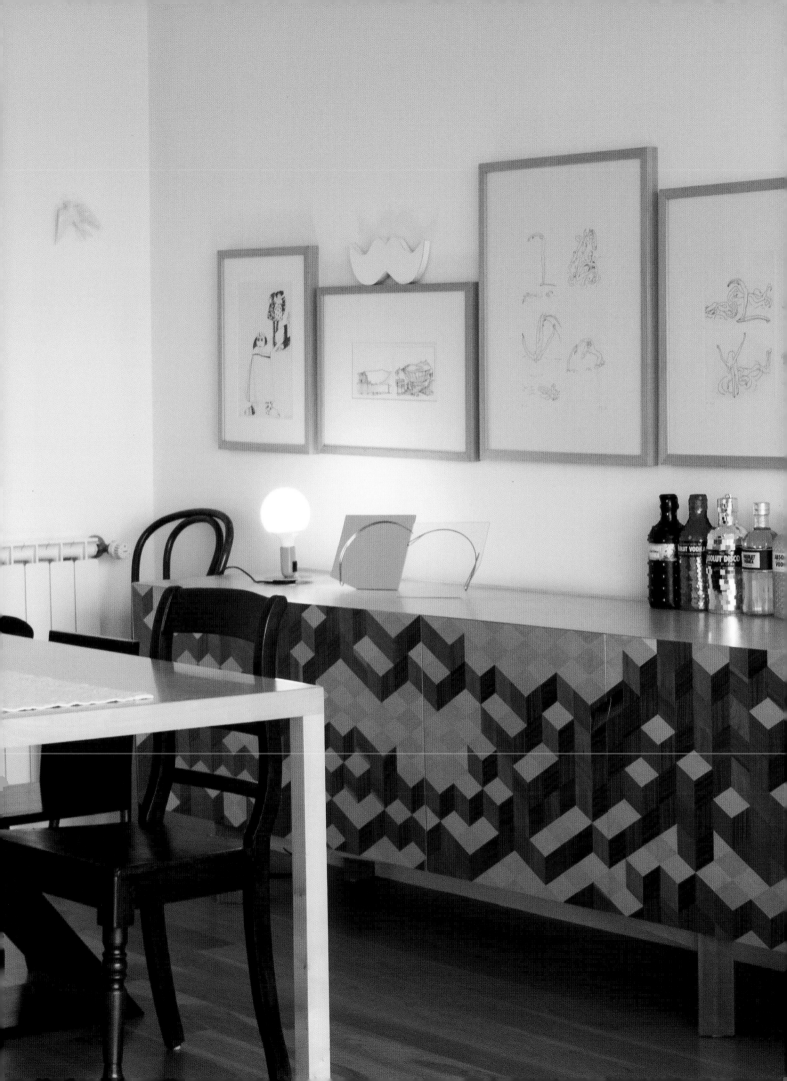

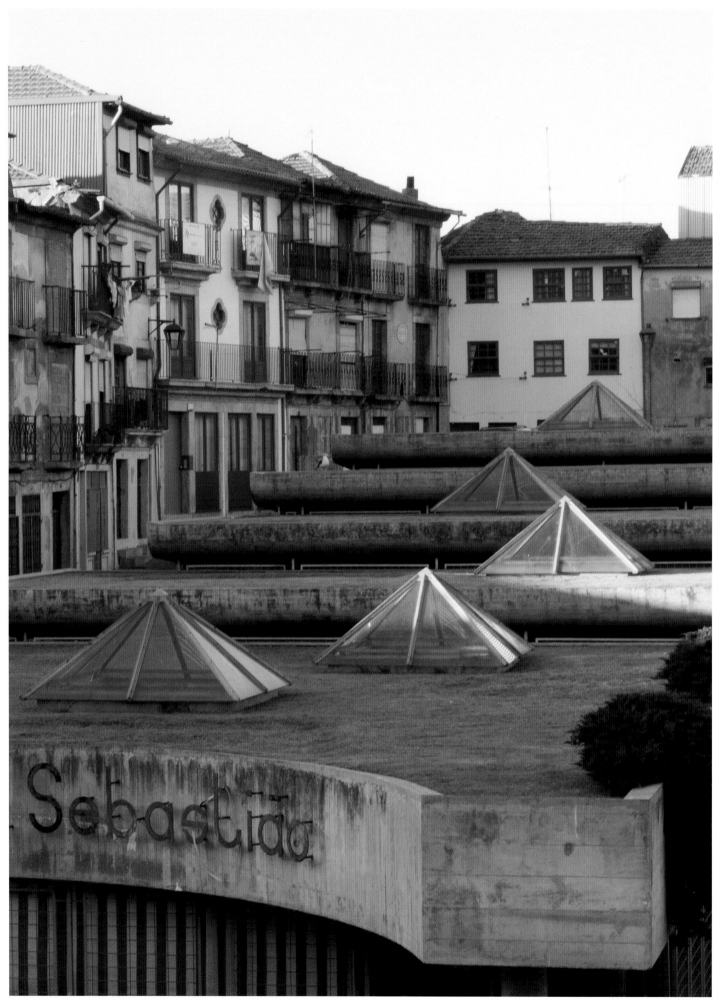

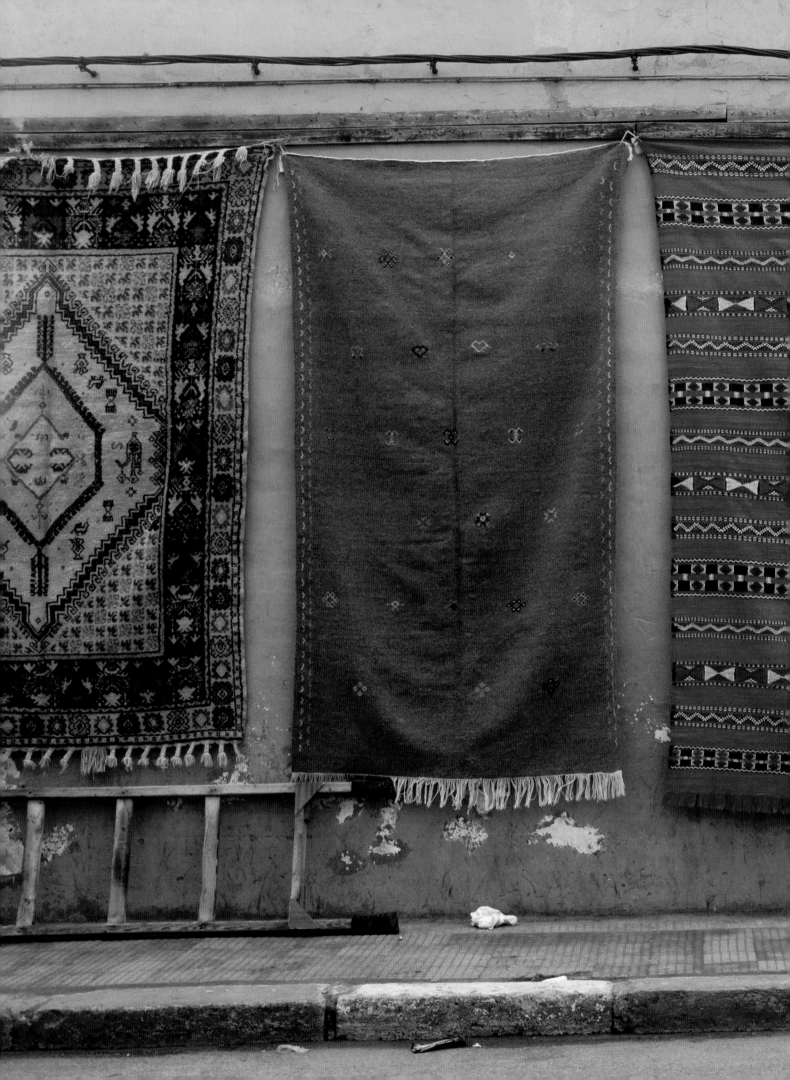

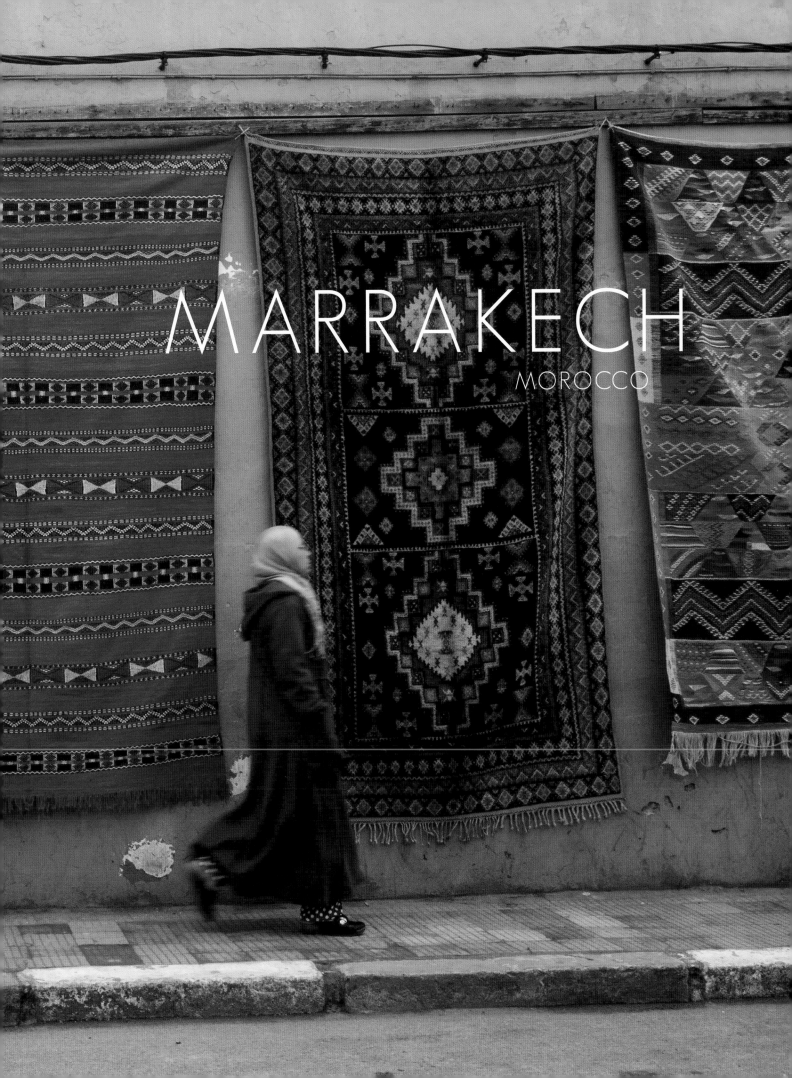

MARRAKECH
MOROCCO

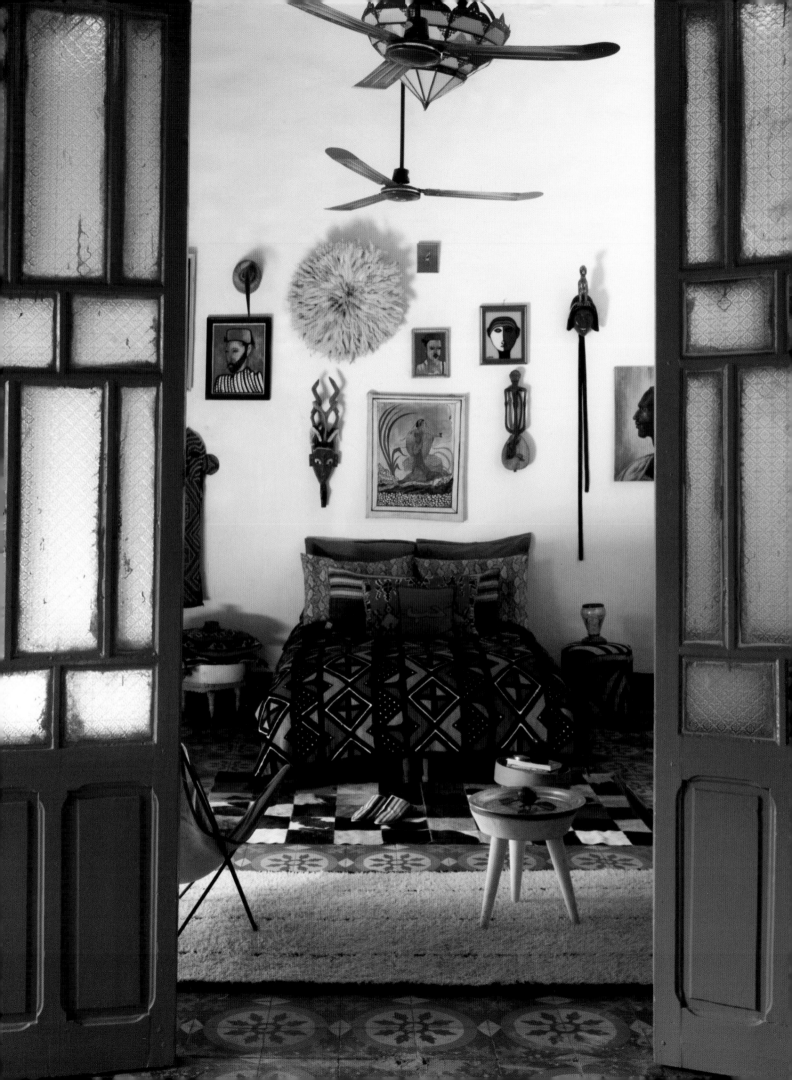

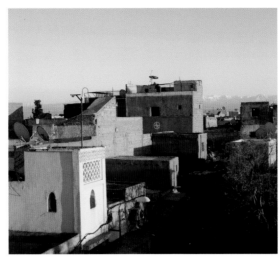
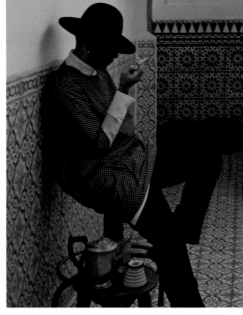

ARTSI IFRACH
ANTHROPOLOGIST FASHION DESIGNER

Artsi, whose name means "my country" in Hebrew, was born in Jerusalem, Israel, and grew up in a Moroccan-Jewish family. From his childhood on, he has been immersed in the arts by first spending time at his father's work, the warehouse of the Israel Musuem, and then at the age of six, he was accepted into the Jerusalem Academy of Dance as a ballet dancer and later switched from ballet to specializing in folkloric dance. In his early twenties, he left behind dance and started traveling, working, and exploring different cultures, which was the creative spark to begin his fashion line.

Artsi, who never studied fashion, began his fashion line, ARTĊ, while living in Amsterdam for six years. After returning to Israel he was named one of the most influential designers of the last 100 years in Tel Aviv. From there he moved to Paris, where he showed a collection at Haute Couture during Paris Fashion Week, represented by 2m Bureau with Sylvi Grumbach. He eventually settled in Marrakech living in the old Jewish quarter of the city, called the Mellah. Artsi's home in Marrakech has belonged to his Moroccan-Jewish family for more than 250 years, and so he has kept the structure and architectural elements untouched to sustain the feelings of history and memories.

Artsi defines his fashion collection as one-of-a-kind pieces with a rich mélange of colors and diverse prints and patterns, often retro or ethnic, in an eclectic range of silhouettes, exuding confidence, yet also a feeling of nostalgia. His main sources of inspiration are his memories and imagination. He tries to manifest a particular memory or relive a moment from the past through his beautiful design. Artsi is continually inspired by traveling to exotic places where vibrant culture can be found in the streets and he can source ideas from local artisans.

One of Artsi's favorite collections is Uthopia, which he created specially to represent Morocco in an event held in Addis Ababa, the capital of Ethiopia. He was the only invited foreign designer amongst the Ethiopian designers in the event which celebrated 20 years of African trade. "Uthopia" is a word play on Ethiopia and the collection reflects a time of grandeur and decadence, but also portrays the sense of hope and youthfulness that exists in the country today. Artsi's striking designs are made by combining pieces of vintage fabrics with new materials to create wholly original, yet identifiable garments. The opulent gowns, for example, were made from a fusion of wax cloth fabrics and delicate lace and cropped jackets were crafted from old Persian rugs.

Living in Marrakech, Artsi finally feels like he has come home. Nowhere else in the world has he felt such nostalgia, freedom, independence, and creativity. He is able to sustain a relatively anonymous persona in Marrakech and have a quality of life that allows him to create his fashion on his own timeline. With the low cost of living in the city, he has the extra income to continue to travel and explore the world.

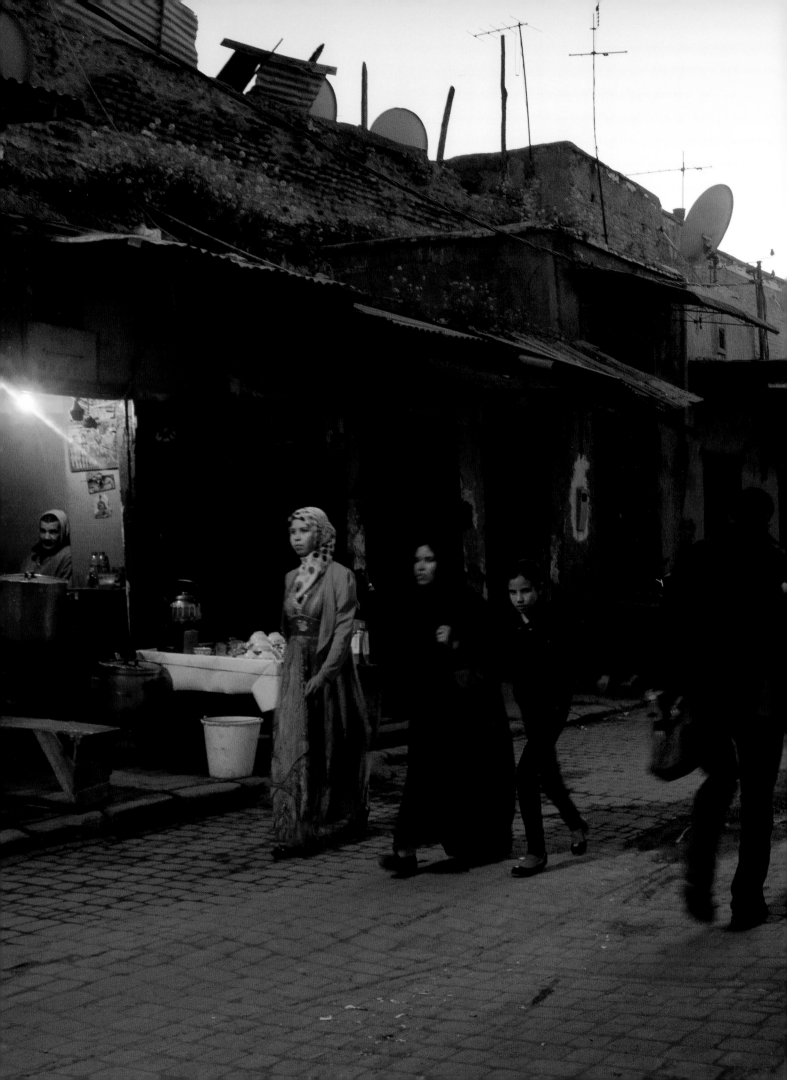

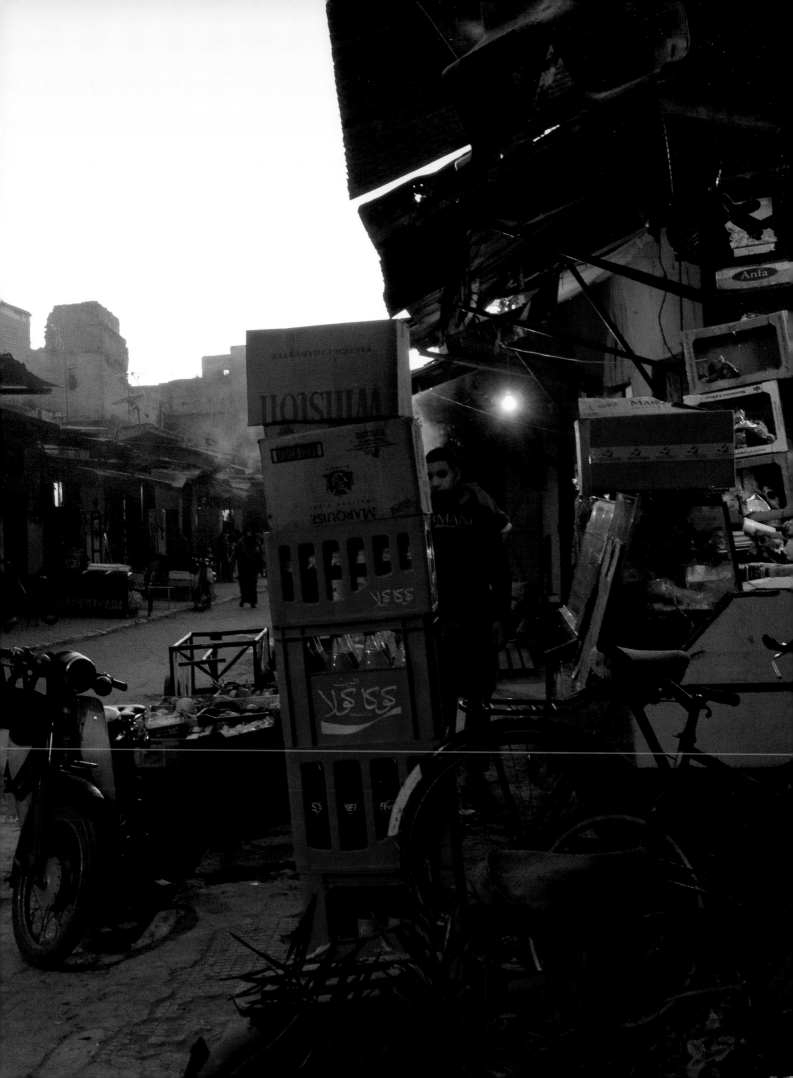

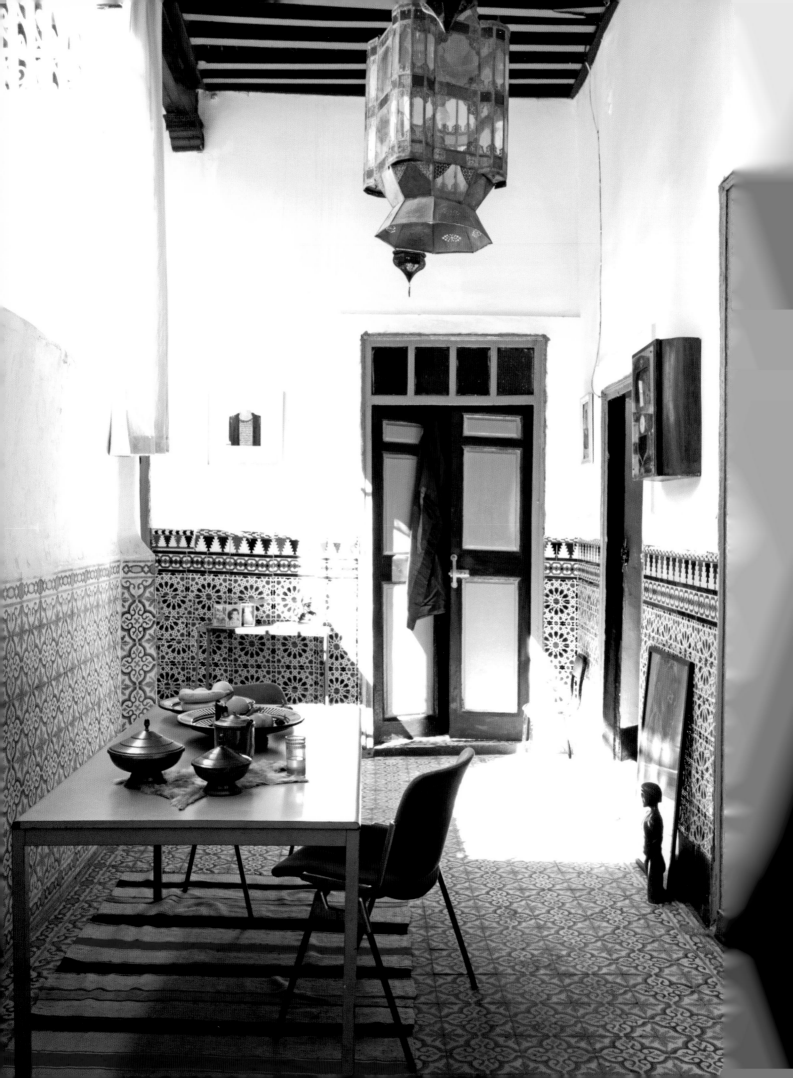

"I CALL MARRAKECH A LIVING MUSEUM—A PLACE WHERE THE CULTURE STILL LIVES ON THE STREET AND THE ARTISANS ARE IN FRONT OF YOU DAILY."

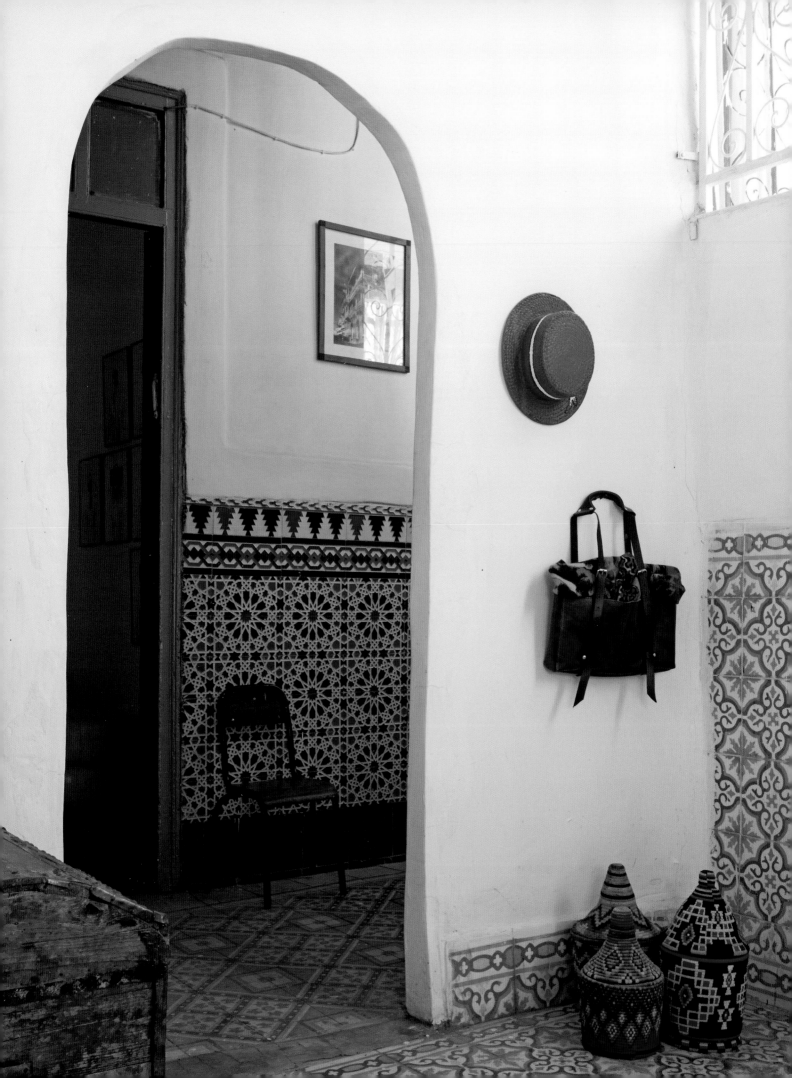

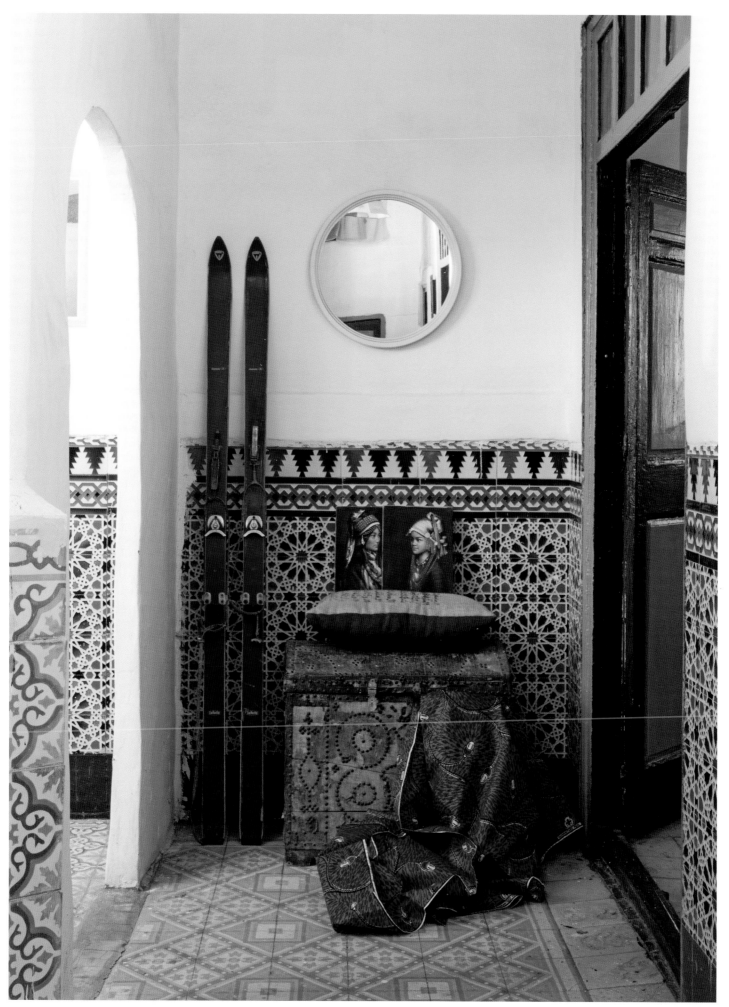

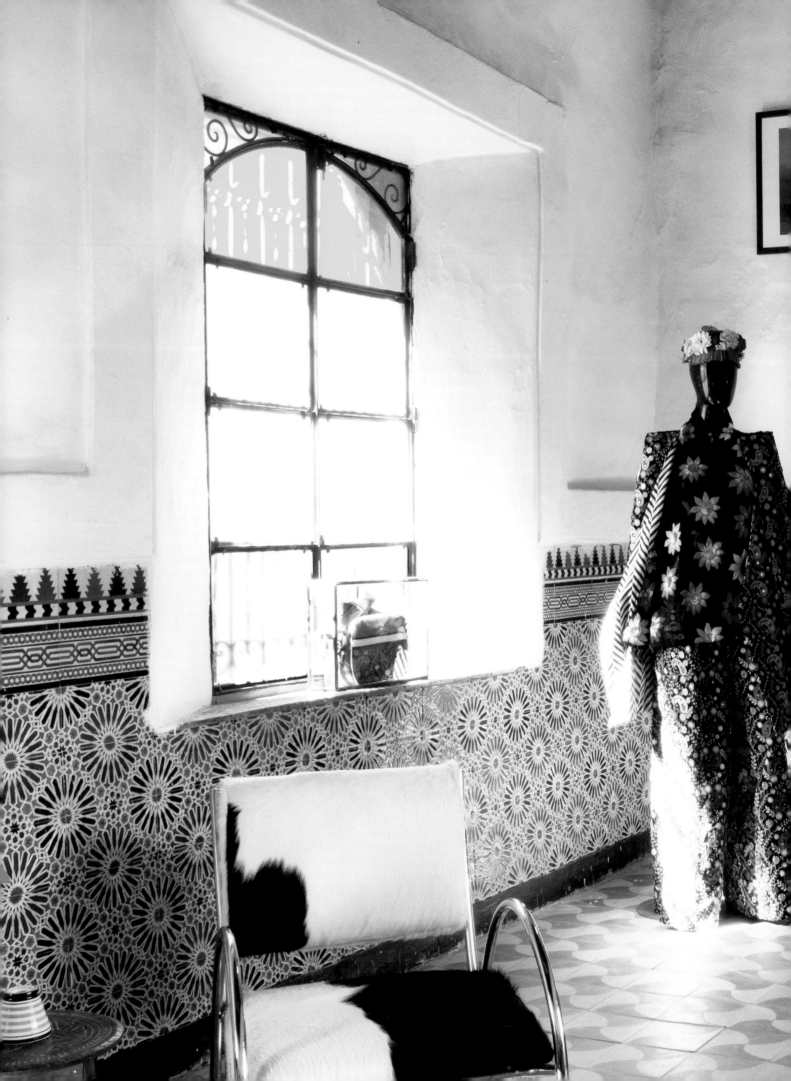

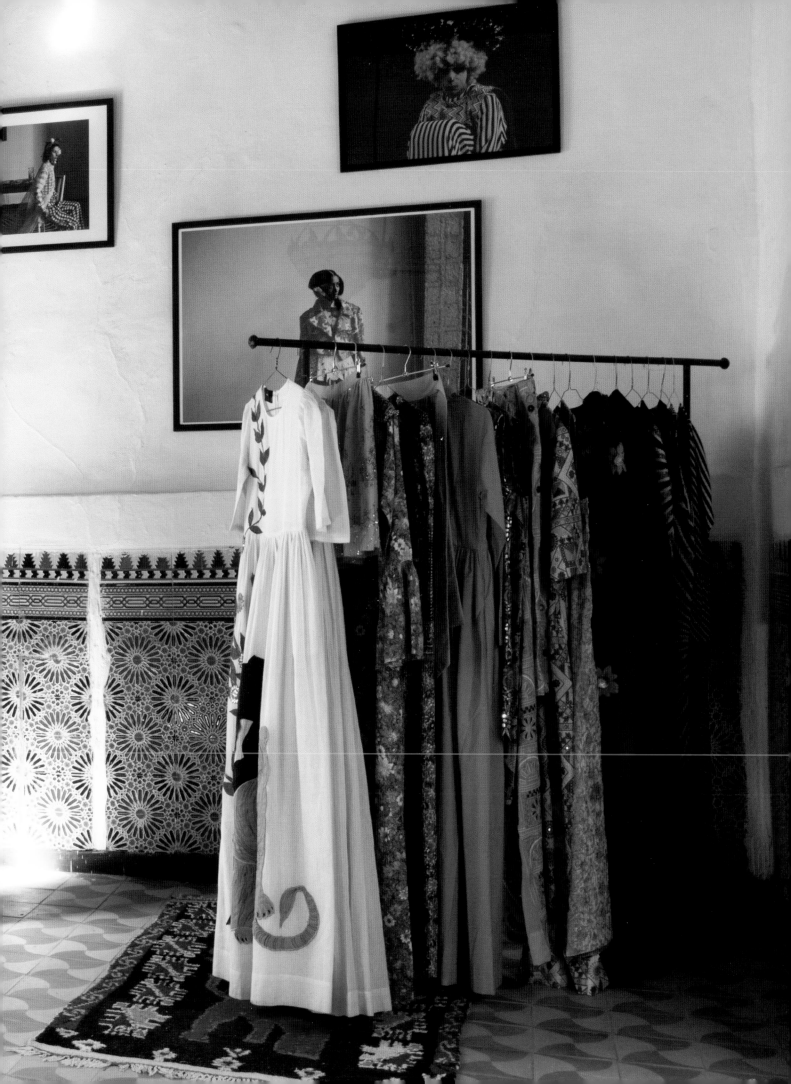

MOROCCO IS THE ONLY AFRICAN COUNTRY THAT IS NOT A MEMBER OF THE AFRICAN UNION.

FRENCH ARTIST JACQUES MAJORELLE TRADEMARKED THE NAME OF THE SPECIAL SHADE OF COBALT, MAJORELLE BLUE, WHICH WAS EXTENSIVELY USED IN THE DESIGN OF HIS MAJORELLE GARDEN IN MARRAKECH.

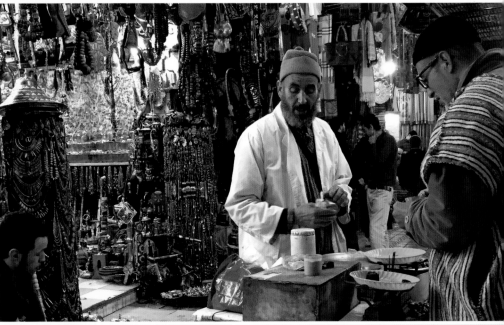

THE OLD CITY OF MARRAKECH, THE MEDINA, IS SURROUNDED BY WALLS BUILT IN THE 12TH CENTURY.

MARRAKECH IS NICKNAMED THE "RED CITY" FOR THE DISTINCTIVE RED CLAY USED TO BUILD THE FORTIFIED WALLS AND MANY OF ITS BUILDINGS.

MARRAKECH IS HIGHLY IDENTIFIED BY ITS MOORISH AND ISLAMIC ARCHITECTURE, WITH ITS 'HORSE-SHOE' ARCHES, INTRICATE GEOMETRIC PATTERNS, AND COLORFUL TILE WORK.

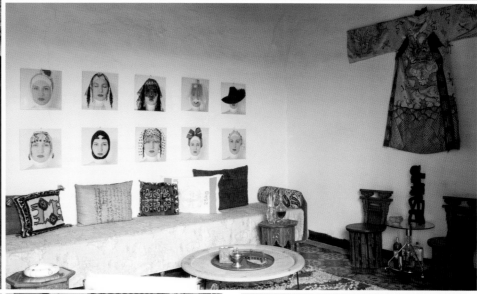

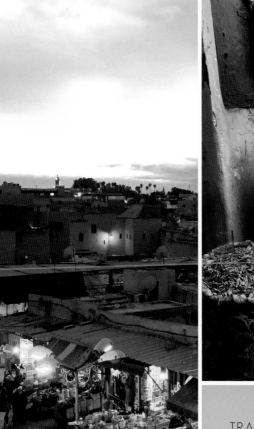

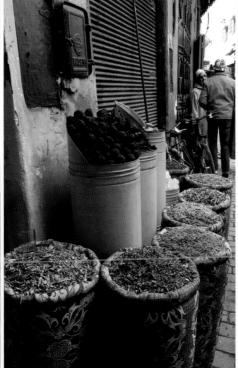

BERBER RUGS AND RICH MOROCCAN DECORATIVE OBJECTS, COLOR PALETTE, PATTERNS, AND TEXTILES ARE SOURCED BY INTERIOR DESIGNERS AROUND THE WORLD.

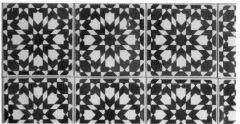

TRADITIONAL MOROCCAN HOMES WITH AN INTERIOR GARDEN OR COURTYARD ARE KNOWN AS RIADS—WHOSE CENTRALIZED PLAN HAS BECOME A GLOBALLY-ESTABLISHED DESIGN FEATURE IN ARCHITECTURE.

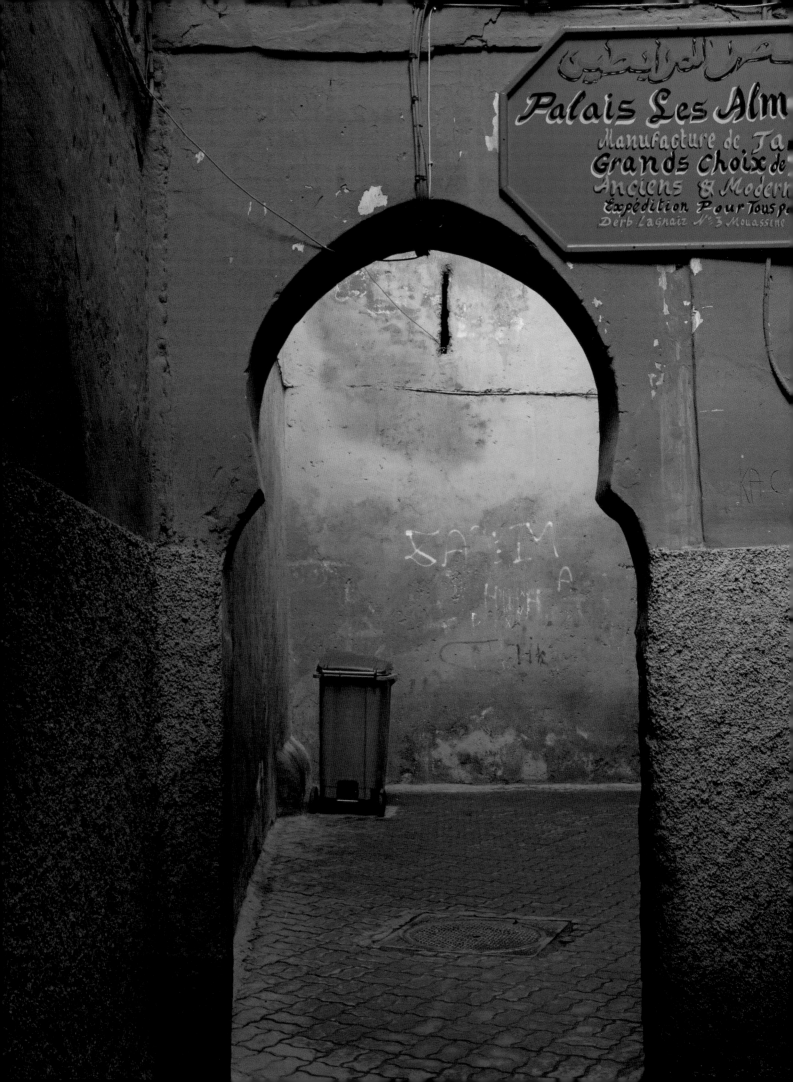

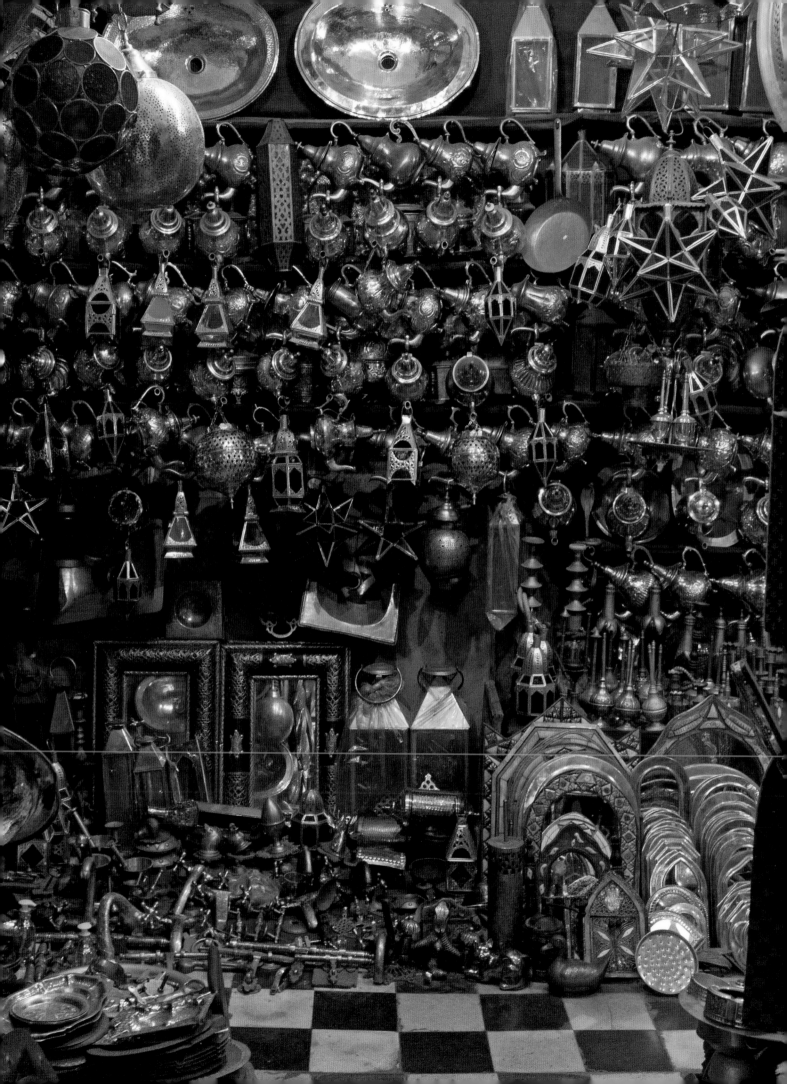

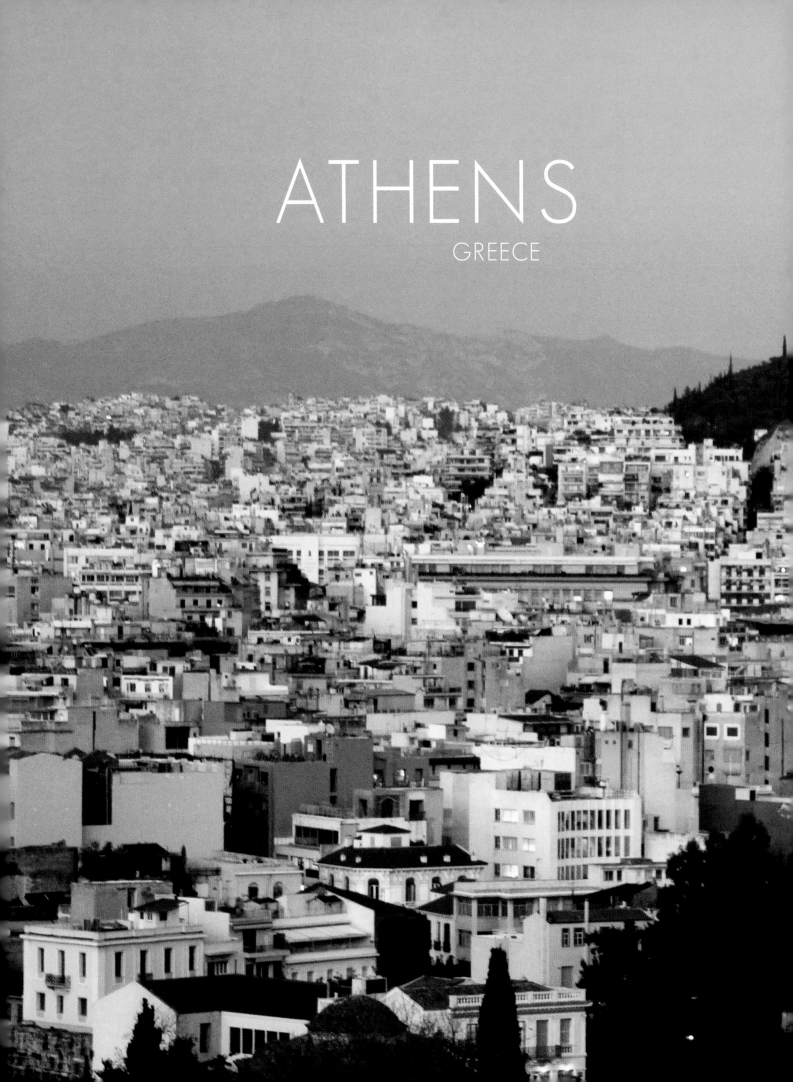

ATHENS
GREECE

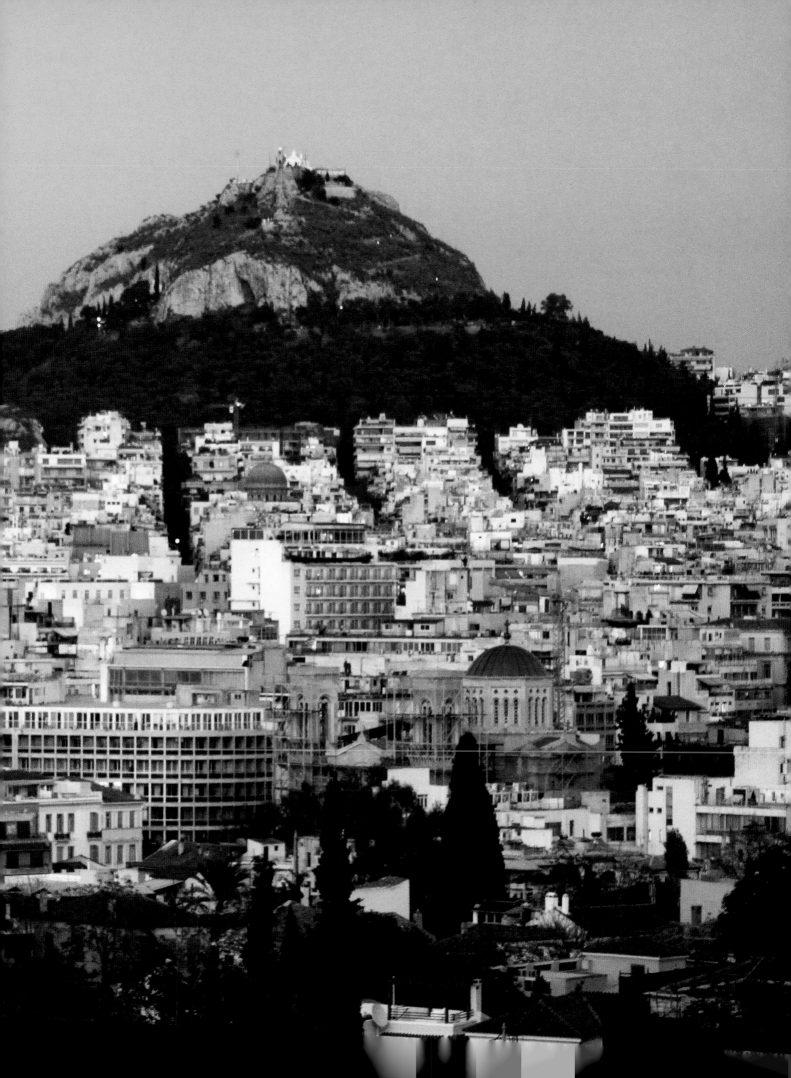

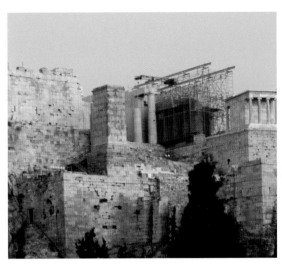
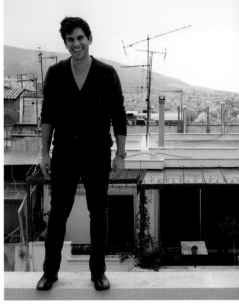

DIMITRIS KARAMPATAKIS
CONTEXTUAL ARCHITECT

Dimitris was born and raised in Athens. His father is an architect and has a construction company and his mother is a designer. Design was often talked about in their home and Dimitris' father brought him and his brother to job sites to encourage their interest in architecture. When Dimitris and his brother, Konstantinos, were in their teens they had a formative experience working together renovating their family summer home. Both brothers then moved to London to study at one of the most prestigious and competitive architecture schools in the world, The Bartlett School of Architecture, and after graduating, worked for modernist British architect, Will Alsop.

After living in London for seven years, Dimitris returned home to Athens with his brother to start their architecture practice: k-studio. During this time, Greece was in an economic crisis, but they viewed the situation as an opportunity to start their careers in a city with less rules and structure. Even though there is a lack of government support for young architects in Greece, Dimitris and Konstantinos had the opportunity to experiment and make mistakes while developing their practice. This is an opportunity that they probably would not have had in a major design city where the standards for excellence and competition are very high.

k-studio has a diversified portfolio of innovative projects including commercial, residential, furniture, and lighting projects. Their projects include designing Pizzeria Trattoria Capanna, located in the center of Athens, with floor-to-ceiling windows that can slide upwards and open up the restaurant to the street when the weather is warm; designing a summer house in the Greek islands, made up of horizontal planes that provide different levels for sunbathing, sleeping, and eating; and renovating the bedrooms of the luxury spa hotel, Bill & Coo, located on the Greek island of Mykonos.

Growing up with a Greek heritage, Dimitris values the quality of natural materials and the history of place as seen throughout classical Athens. He also likes the "honesty" of the Athens' skyline of antennas and architectural clutter that frames it as a modern day city—a study of many contrasts between the remnants of ancient Greece and today's organized urban chaos.

Working as an architect in Athens is both challenging and opportunistic. With the lack of structure and rules, the upside is that young architects such as Dimitris and his brother can transition from design concept to actual construction much faster than in other countries. The downside is the lack of support and vulnerability for relatively inexperienced architects; therefore, creating a need to be very self-sufficient, educated, and confident. Through it all, Dimitris and Konstantinos remain hopeful about the future of Greece.

"ATHENS IS A CITY OF MANY CONTRASTS. IT IS DIRTY WHITE AND BRIGHT BLUE, UGLY BUT BEAUTIFUL, ANCIENT AGAINST MODERN, CHARMING BUT DIFFICULT. IT SMELLS OF BITTER ORANGE BLOSSOMS IN THE SPRING AND FESTERING GARBAGE IN THE SUMMER."

ATHENS' INTERNATIONAL
CONTEMPORARY ART
FAIR, ART ATHINA, IS ONE
OF THE LONGEST LASTING
ART FAIRS IN EUROPE.

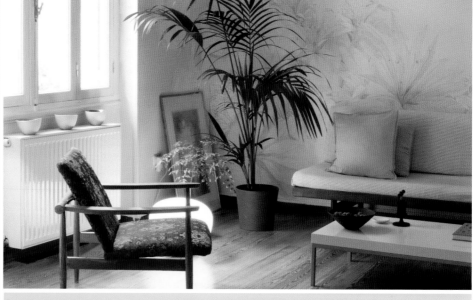

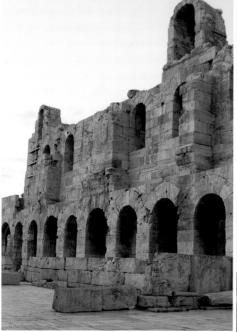

AN ANCIENT TEMPLE DEDICATED TO THE GODDESS ATHENA,
THE PARTHENON IS REGARDED AS AN ARCHITECTURAL
MASTERPIECE OF GREEK CLASSICISM.

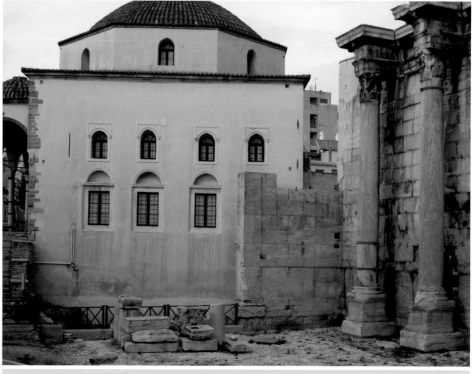

THE PANATHENAIC
STADIUM, HOME OF THE
FIRST MODERN OLYMPIC
GAMES IN 1896, IS
THE ONLY ARENA BUILT
ENTIRELY OUT OF MARBLE.

KNOWN FOR ITS RICH ARCHAEOLOGICAL AND CULTURAL
HISTORY OF THE BEGINNINGS OF WESTERN CIVILIZATION,
ATHENS IS ONE OF THE WORLD'S OLDEST CITIES.

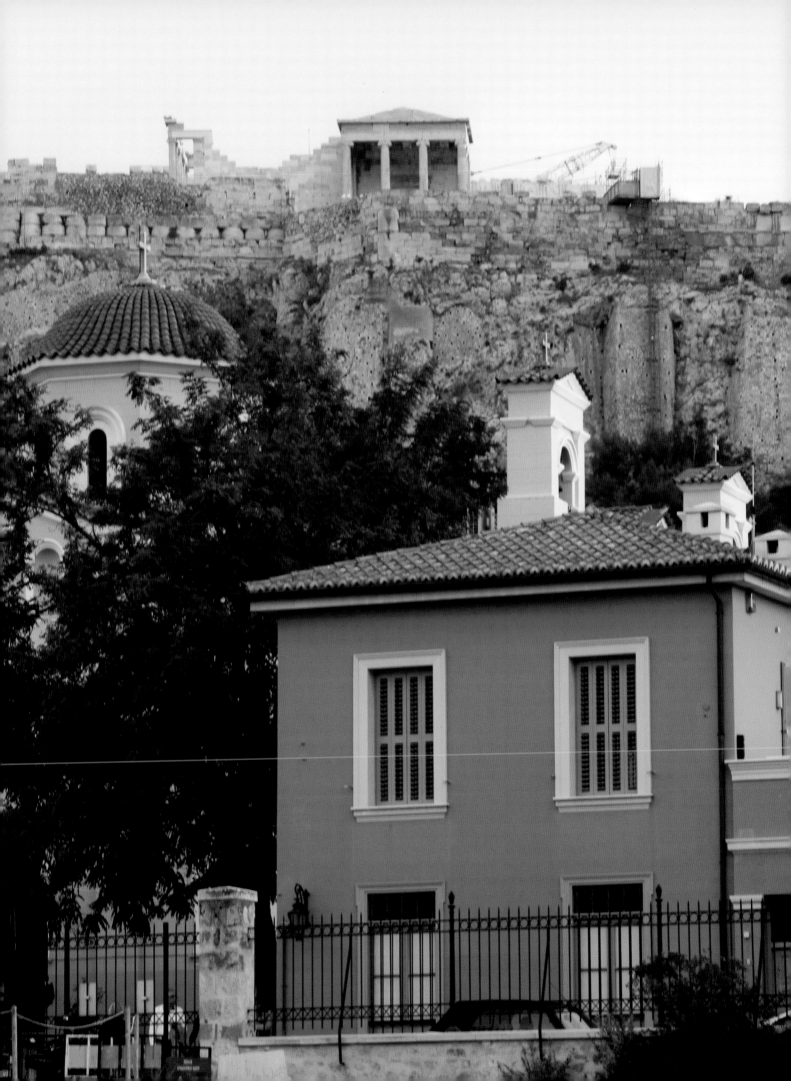

GUADALAJARA

MEXICO

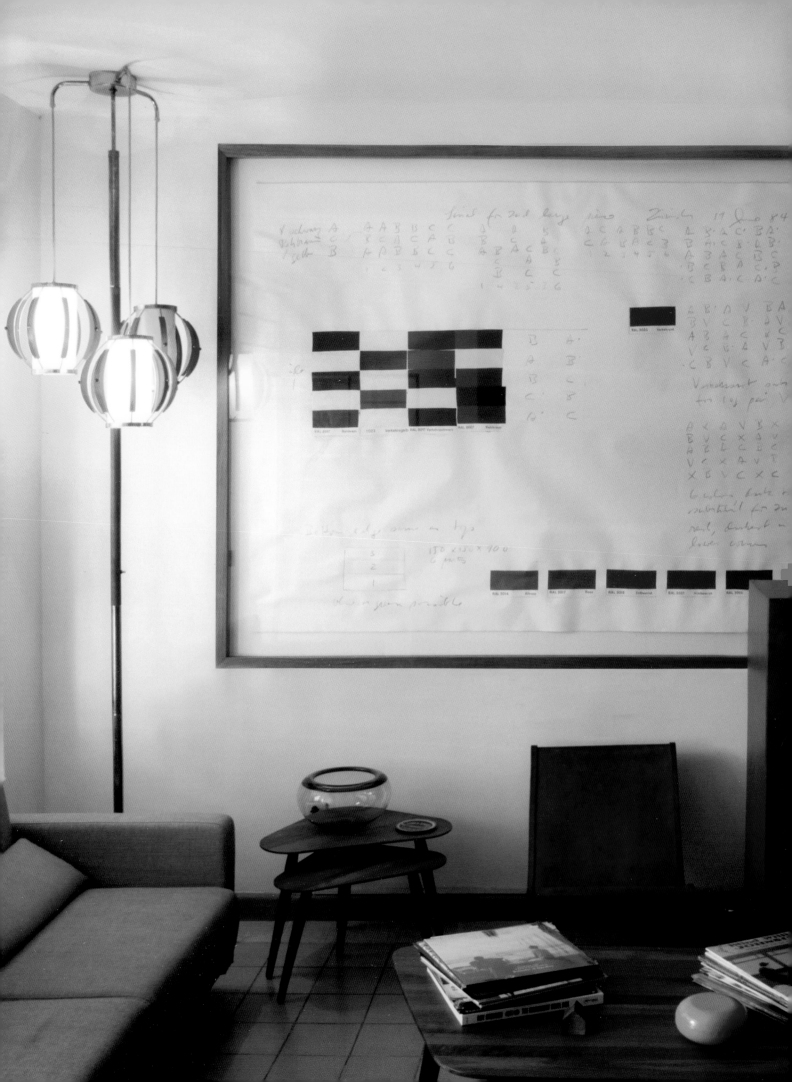

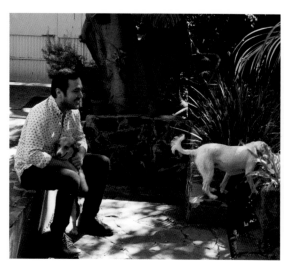

JOSE DÁVILA
SCULPTOR

Jose was born and raised in Guadalajara and studied architecture at ITESO in Guadalajara. He originally preferred to study art, but couldn't afford to attend a university outside of the city. So, instead, he took summer classes in sculpture and photography at Escuela de Bellas Artes in San Miguel de Allende, Mexico. He ultimately did not choose the traditional path of a career in architecture, but decided to create art in the medium of sculpture, with his work oftentimes relating back to his architecture background. Jose learned about art history from reading books and is particularly inspired by the work of artists Josef Albers and Richard Serra.

His first project was a group show at the Museo de las Artes of the University of Guadalajara. He used ceramic casts to create 200 small identical buildings, which both mirrored and criticized the government housing at the time. Jose is also known for a series of photographic works entitled, *Cut Outs*, in which he takes well-known images and extracts the main subject leaving the viewer to insert the subject from their own memory. Jose is also known for his sculptures that use two raw materials, such as marble slabs or glass, set at a diagonal leaning away from each other and being held together by ratchet straps. An upcoming major project is for the next edition of *Pacific Standard Time: LA/LA*, an initiative of the Getty Museum which is a collaboration of arts institutions across Southern California focusing on the 'dialogue' between Los Angeles (LA) and Latin America (LA). Jose's work

will include an urban sculpture with pieces spread out throughout very particular areas of Los Angeles.

During Jose's beginning years as an artist, he was finding it difficult to locate any galleries in Guadalajara that were showing current contemporary art. Therefore, he decided to open one of the first artist-run project spaces, Oficina para Proyectos de Arte (OPA), with two other artists. They invited international artists to come to Guadalajara and produce their work in the city with complete freedom to produce and exhibit their art in the way they preferred—a luxury you would not find working with a museum. Some of the works have included radical ideas such as bringing a horse up in the elevator to the top floor of the OPA office building, where it was photographed. The mission of the artist-run space was to give young people in Guadalajara an opportunity to see really interesting art in person versus only in books.

Because most of the federal budget for culture is allotted to Mexico City, Guadalajara's art scene is built on experimentation rather than influence from the government or art galleries. Artists in the city are coming out of university with backgrounds in various other disciplines, such as architecture. Guadalajara is also unique in that many traditional artisanal craftsmen still remain who produce in all types of materials, and contemporary artists are able to connect with them to create an informed and inspiring perspective of true artisanship.

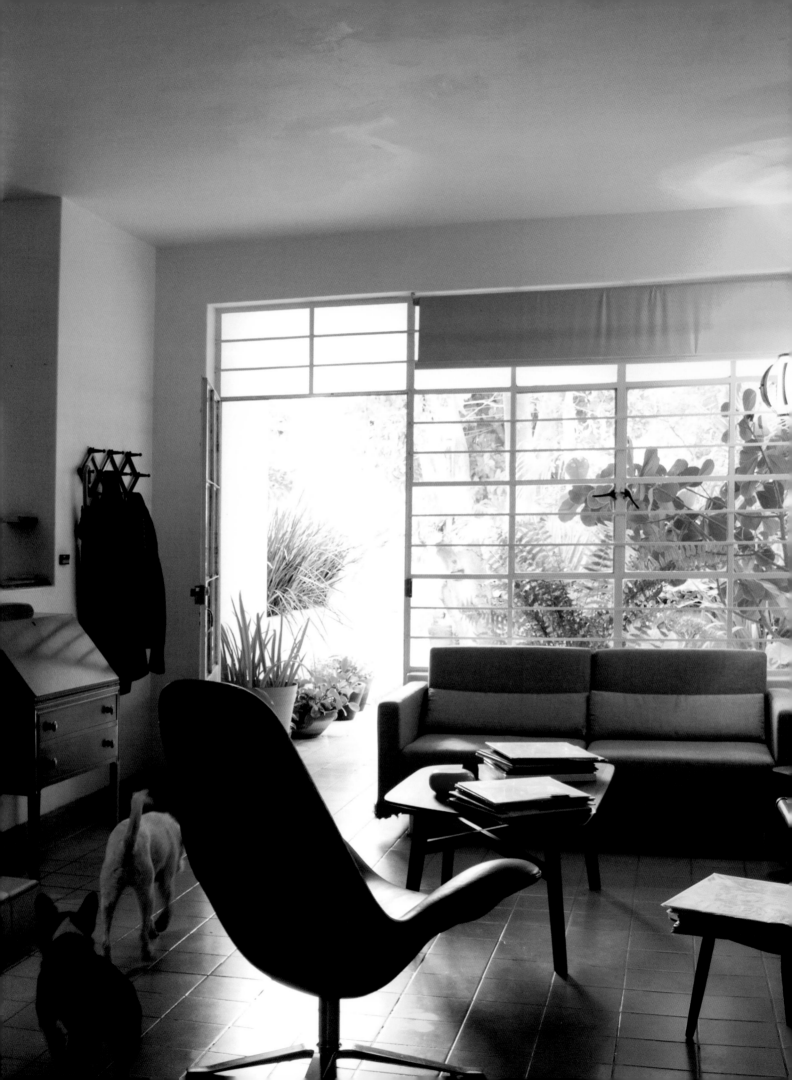

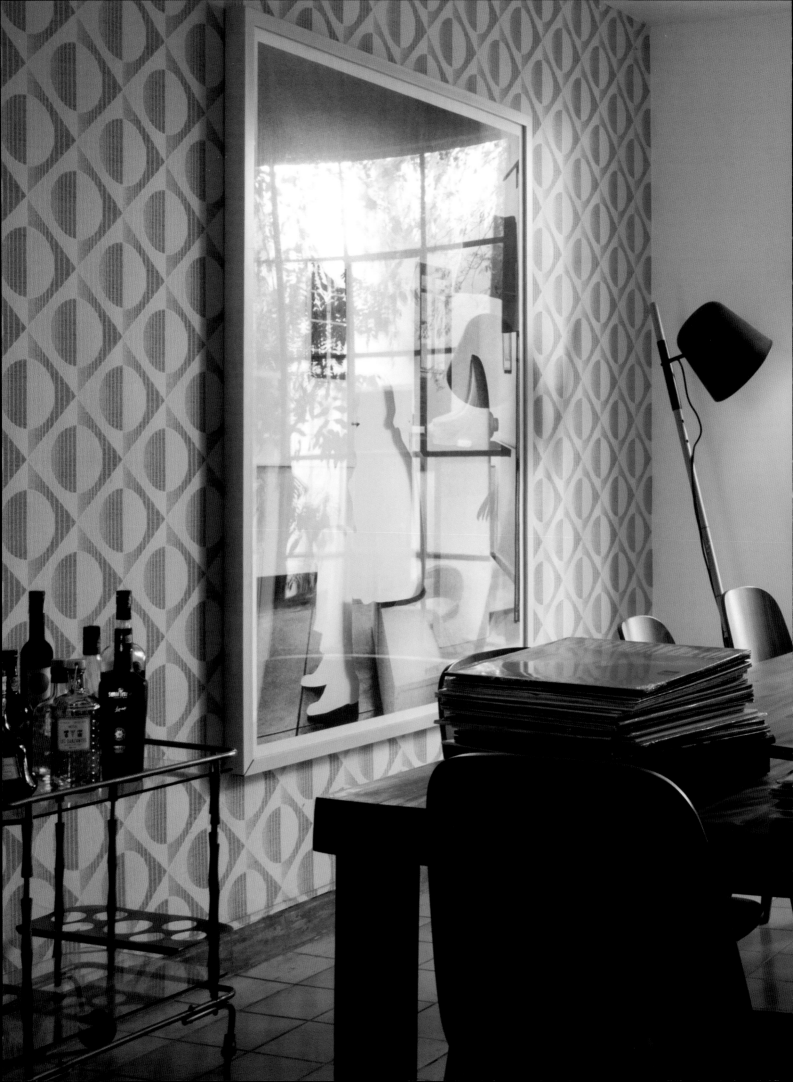

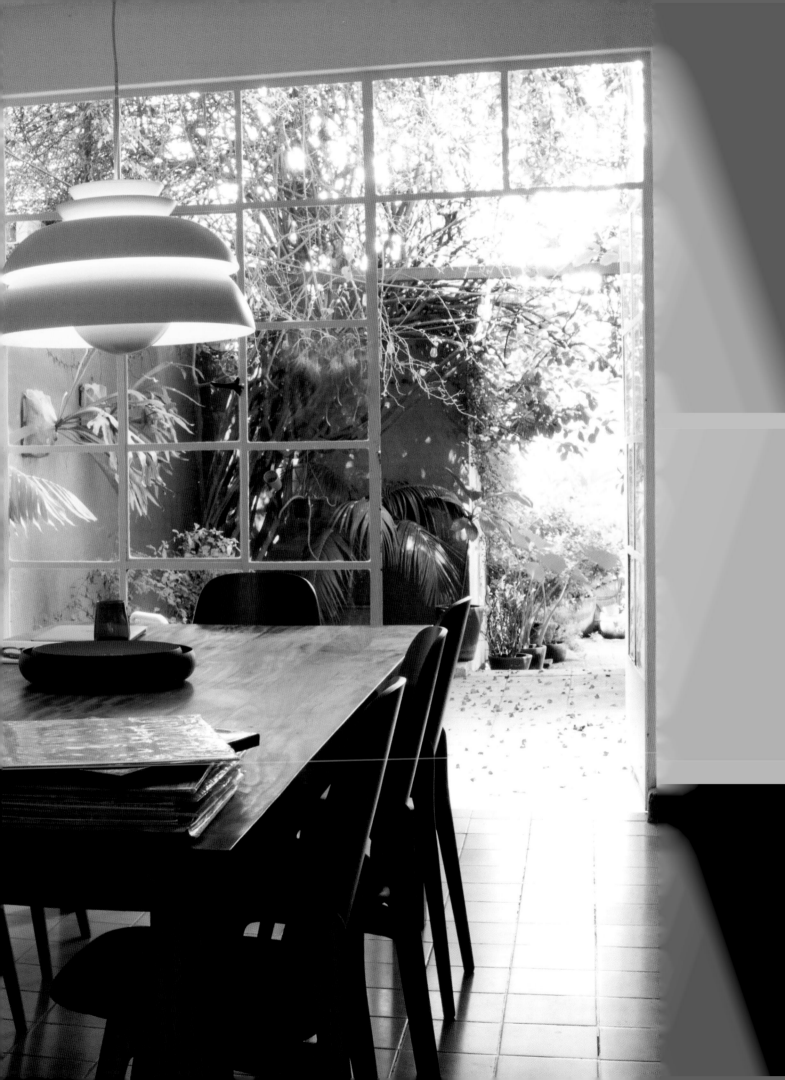

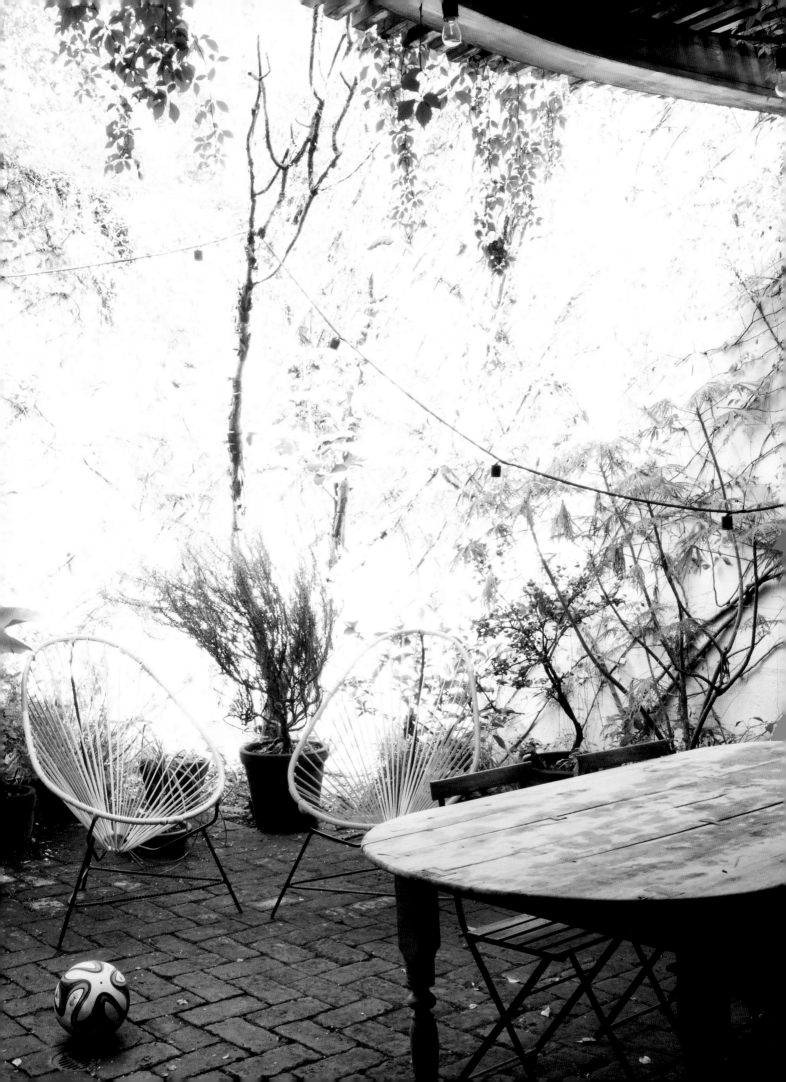

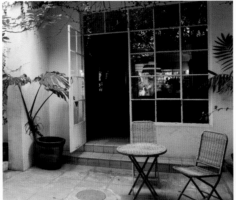

GUADALAJARA IS MEXICO'S SECOND LARGEST CITY.

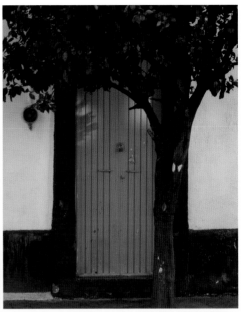

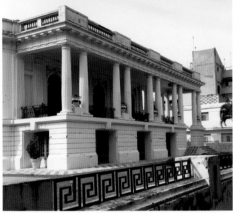

THE CABAÑAS CULTURAL INSTITUTE CONTAINS MURALS BY ARTIST JOSÉ CLEMENTE OROZCO, WHO WAS A LEADER IN THE MEXICAN MURALIST MOVEMENT.

MINIMALIST ARCHITECT LUIS BARRAGÁN WAS BORN IN GUADALAJARA AND DESIGNED OVER A DOZEN HOMES IN THE HISTORIC COLONIA AMERICANA NEIGHBORHOOD.

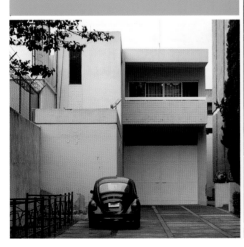

THE GUADALAJARA INTERNATIONAL BOOK FAIR IS THE SECOND LARGEST BOOK FAIR IN THE WORLD FOLLOWING FRANKFURT.

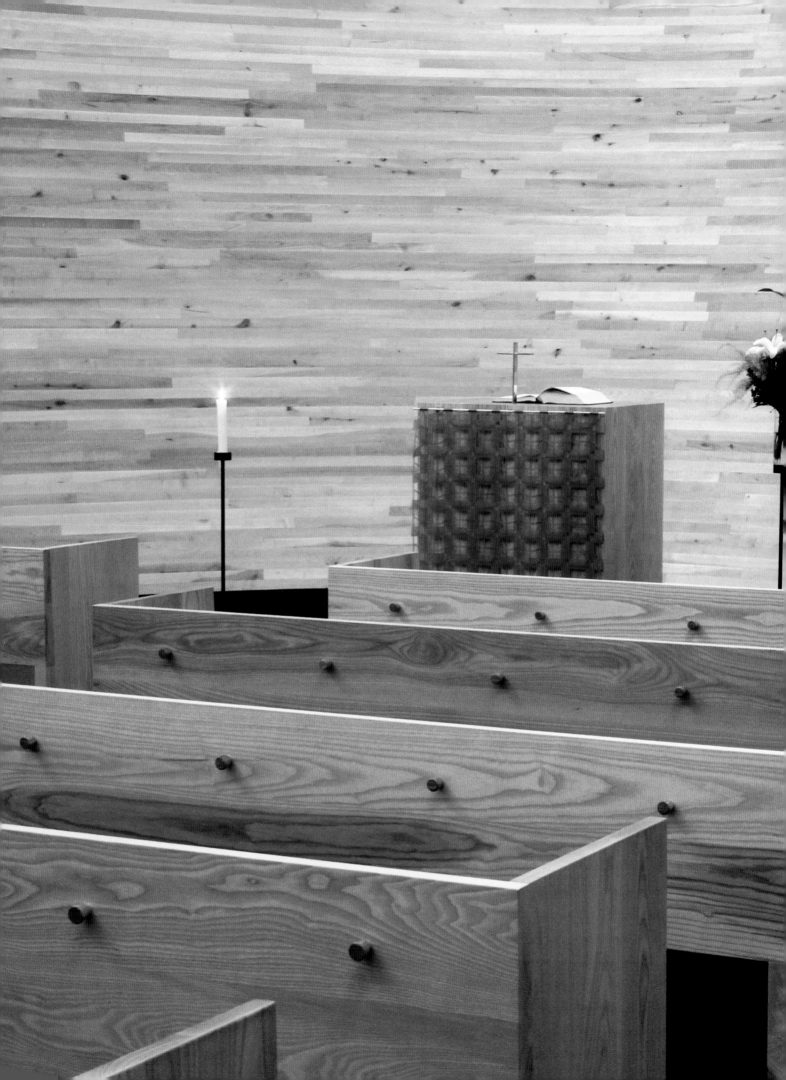

HELSINKI
FINLAND

TANJA SIPILÄ
DESIGNER

Tanja spent her early years in the small town of Kemi, Finland, and also lived in Sweden for a few years. She had an interest in the arts from a young age and developed a talent for drawing and painting, later studying to become an art teacher at the University of Lapland in Rovaniemi, Finland. After a few years, she realized she had a passion for design over art, so she moved to Helsinki to study design at the Aalto University School of Arts, Design and Architecture.

Initially working as a designer for a few years, Tanja received international attention for her Newton Cream and Sugar Set product design. After which, she decided to work more in the capacity of working with designers as opposed to practicing design on her own. In 2011, Tanja also started working with Design Forum Finland, an organization that promotes Finnish design, and began managing the Design Forum Shop. For 13 years, she has also been a part of Design Migration association, which is made up of a group of designers that organize exhibitions in Finland and abroad. Tanja recently completed a large project for Design Forum Finland and Iceland Design Centre called WE LIVE HERE, which debuted at Stockholm Design Week. The project consisted of an apartment in Stockholm entirely decorated with furniture and objects from contemporary Icelandic and Finnish designers. Another important collaboration is PasPas

Finland, a design company Tanja co-founded with another designer, Mari Isopahkala, in which they reuse leftover textiles and other materials for their products, as well as import vintage rugs from Turkey.

Tanja lives in the westernmost district of Helsinki called Pitäjänmäki. Her home was built in 1934 and was actually designed by the well-known Finnish architect Selim A. Lindqvist. He had designed and built the house for himself, but, because he died in 1936, he was never able to live in the house, and it was subsequently rented out to poor families. When Tanja purchased the house, she decided to restore it to its original and unique pre-World War II architectural character.

The strong design traditions in Finland continually influence and inspire Tanja, and, furthermore, the city of Helsinki is constantly and actively seeking ways in which design can improve its services and buildings, and help to make the city better overall. One recent example of innovative thinking in Helsinki is the development of a number of special events such as Restaurant Day, which has become an international success. Restaurant Day happens four times a year in which pop-up restaurants, set up by anyone wanting to become a restaurateur for a day, appear all around the city for the public to enjoy.

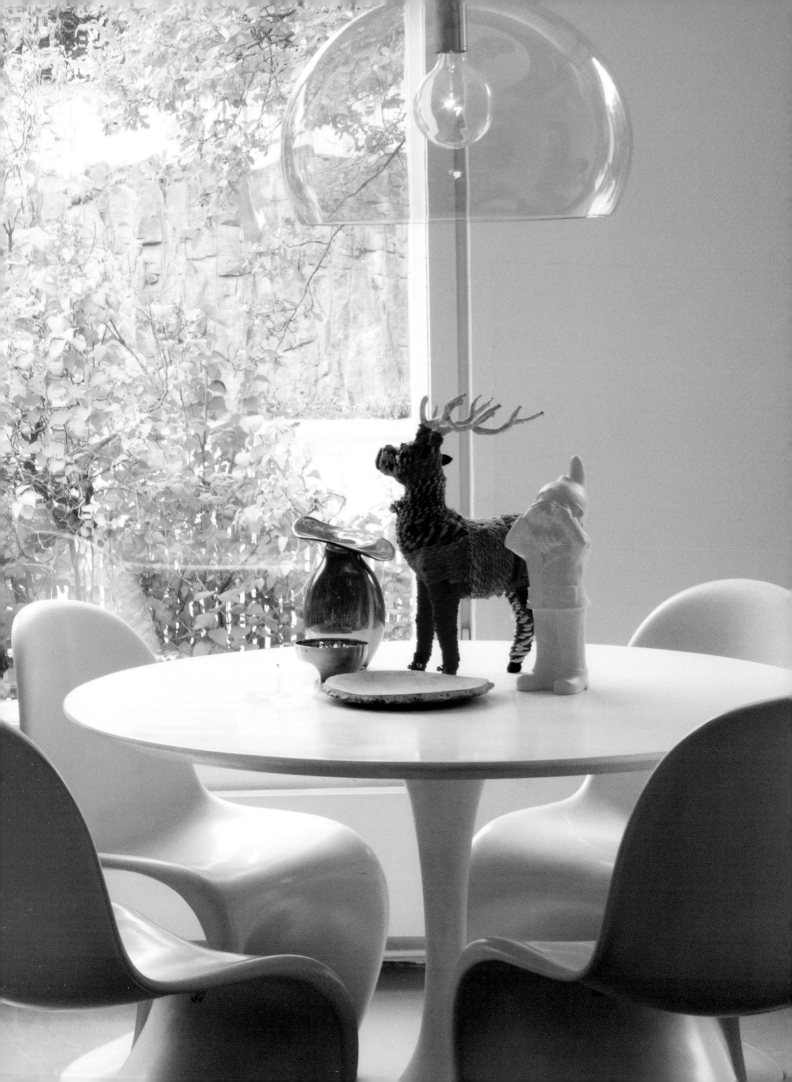

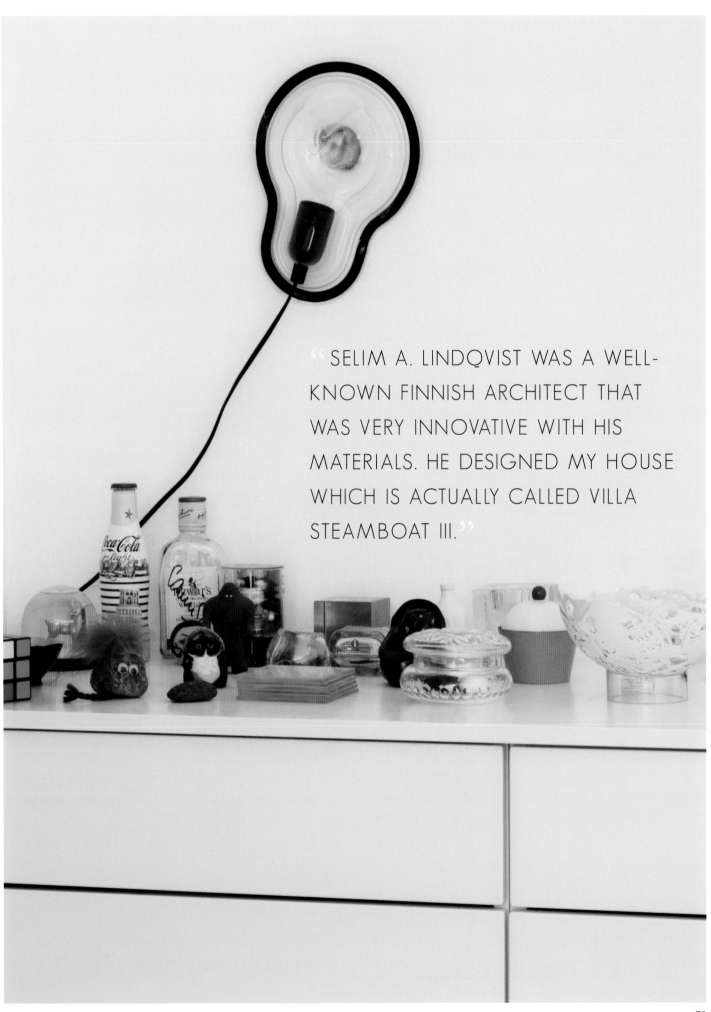

"SELIM A. LINDQVIST WAS A WELL-KNOWN FINNISH ARCHITECT THAT WAS VERY INNOVATIVE WITH HIS MATERIALS. HE DESIGNED MY HOUSE WHICH IS ACTUALLY CALLED VILLA STEAMBOAT III."

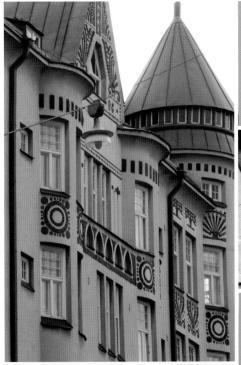

HELSINKI WAS NAMED THE WORLD DESIGN CAPITAL BY THE INTERNATIONAL COUNCIL OF SOCIETIES OF INDUSTRIAL DESIGN (ICSID) IN 2012.

NOTABLE FINNISH DESIGNERS INCLUDE ARCHITECT AND FURNITURE DESIGNERS EERO SAARINEN, ALVAR AALTO, TEXTILE DESIGNER MAIJA ISOLA, AND INTERIOR AND FURNITURE DESIGNER, EERO AARNIO.

PIONEERING FINNISH DESIGN BRANDS INCLUDE ARTEK, IITTALA, AND MARIMEKKO.

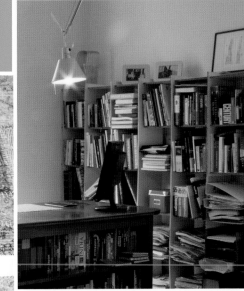

TEMPPELIAUKIO CHURCH AND KAMPPI CHAPEL ARE CONSIDERED INSPIRATIONAL ARCHITECTURAL LANDMARKS.

FINNISH ARCHITECTURE STYLES—WOODEN ARCHITECTURE, JUGENDSTIL (ART NOUVEAU), AND FUNCTIONALISM—HAVE HAD INTERNATIONAL INFLUENCE.

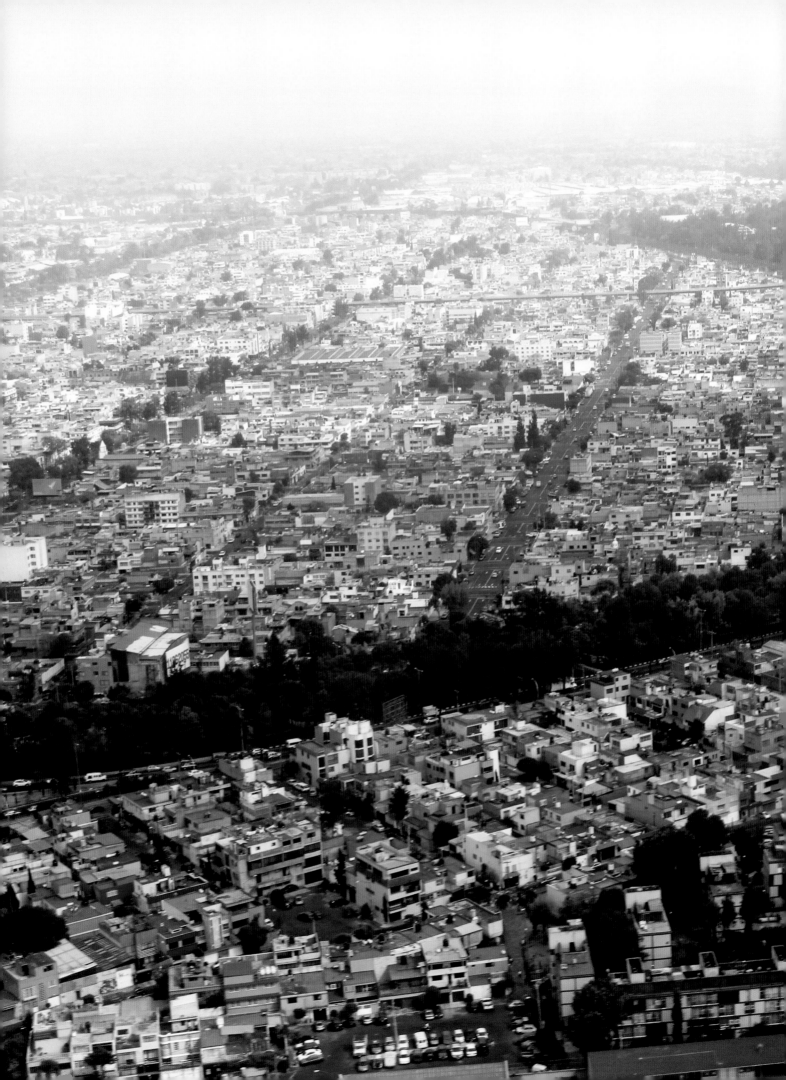

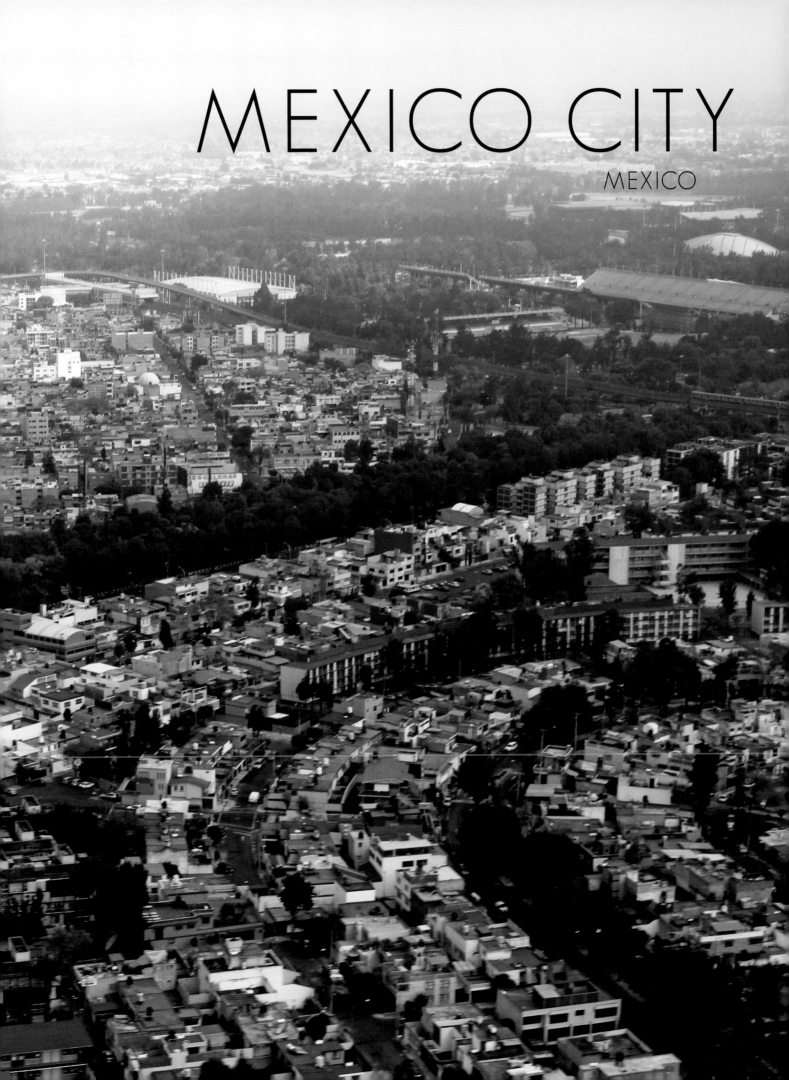

MEXICO CITY

MEXICO

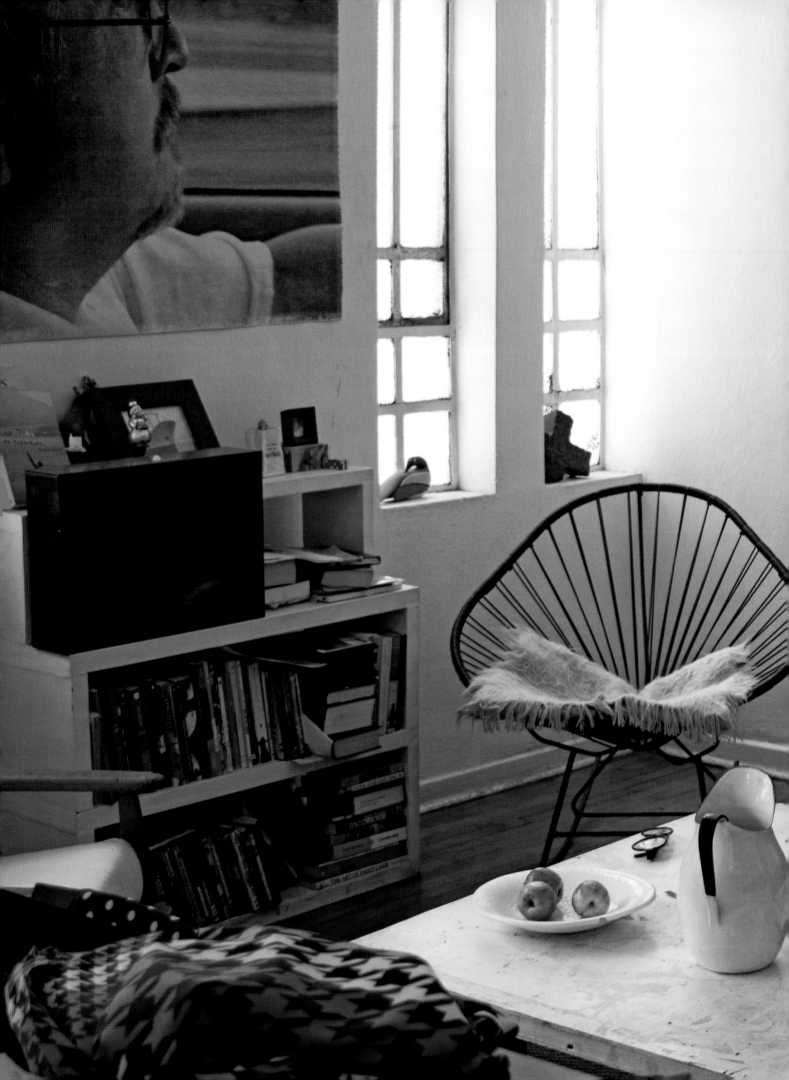

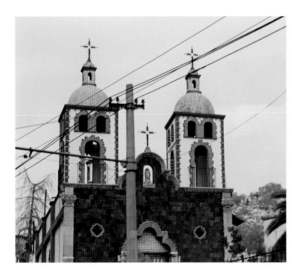
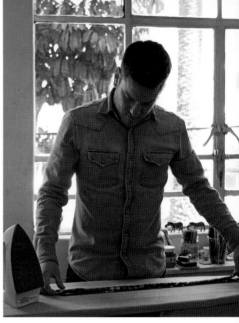

PAUL LOZANO
TIE MAKER

Paul was born to a Mexican father and grew up in Canada. When he was two years old, his father registered him and his brother as Mexican citizens at the embassy in Canada, thinking that they may want to live in his home country one day. Paul always felt more Latino than Canadian somehow, so he decided to get his passport to travel to Mexico to see what his father left behind at a young age, and then return to Canada. But once he landed in Mexico City, he fell in love with the city and never left.

In Mexico City, Paul worked in the hotel and public relations industry for 5 years, and while he enjoyed this line of work, he wasn't growing as a person or the artist that he wanted to become. He then left his job to start his handmade tie and accessory company, Señorito Corbatas ("young gentleman ties"), in which he designs and sews contemporary, reversible ties for both men and women, taking the idea of a traditional tie and reinterpreting it into a more playful accessory. Paul never attended design school, but his mother had a Singer sewing machine and showed him a few basic techniques. The design patterns, including polka-dots, camouflage, floral, checkered, and striped, in addition to vibrant colors, are bold and youthful, reflecting the overall lively atmosphere of Mexico City.

Paul currently lives and works out of a 1950s apartment in the middle-class neighborhood of Narvarte, at the southern edge of Mexico City. Many of his friends asked why he didn't move to the more trendy areas of La Condesa or Colonia Roma, but he is very happy with his apartment as these more popular neighborhoods have become more commercialized and expensive over time, as his rent has remained stable.

Corruption still exists, but sadly, it has become an everyday part of life, even though Mexico City is deemed the safest city in the country. If you are living in the city, it is not unusual for a policeman to accept a bribe if you are pulled over in your car, for example. Kidnapping is a problem, but more so for the rest of the country than Mexico City, and Mexico as a whole is making a consistent effort to change its reputation.

Hard to find in many other places, a special *joie de vivre* exists within the young creative community in Mexico City that gives Paul the freedom and opportunity to try new ideas and draw from both the city's rich and diverse cultural history. Many artists from around the world visit Mexico City to explore its emerging design, art, and culinary scenes. And architecture students are attracted to the city to see all the contrasting types of architectural styles—from Mesoamerican to Colonial to Spanish Baroque to Moorish to Modern—in one place.

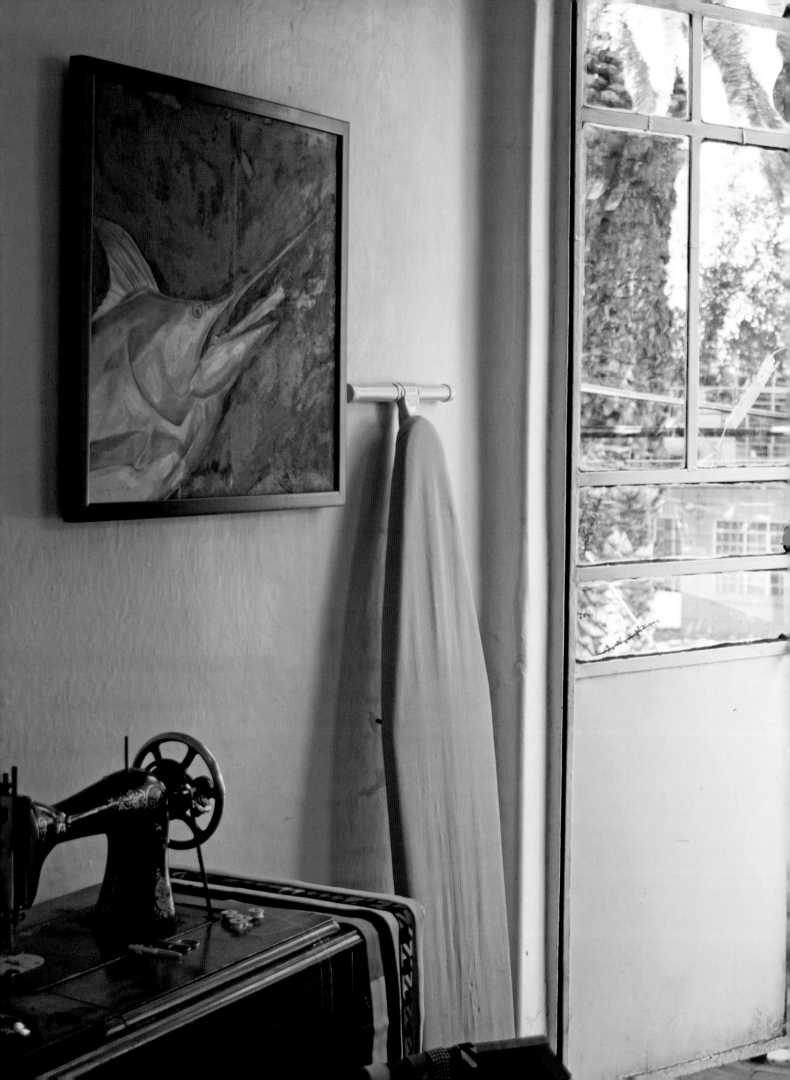

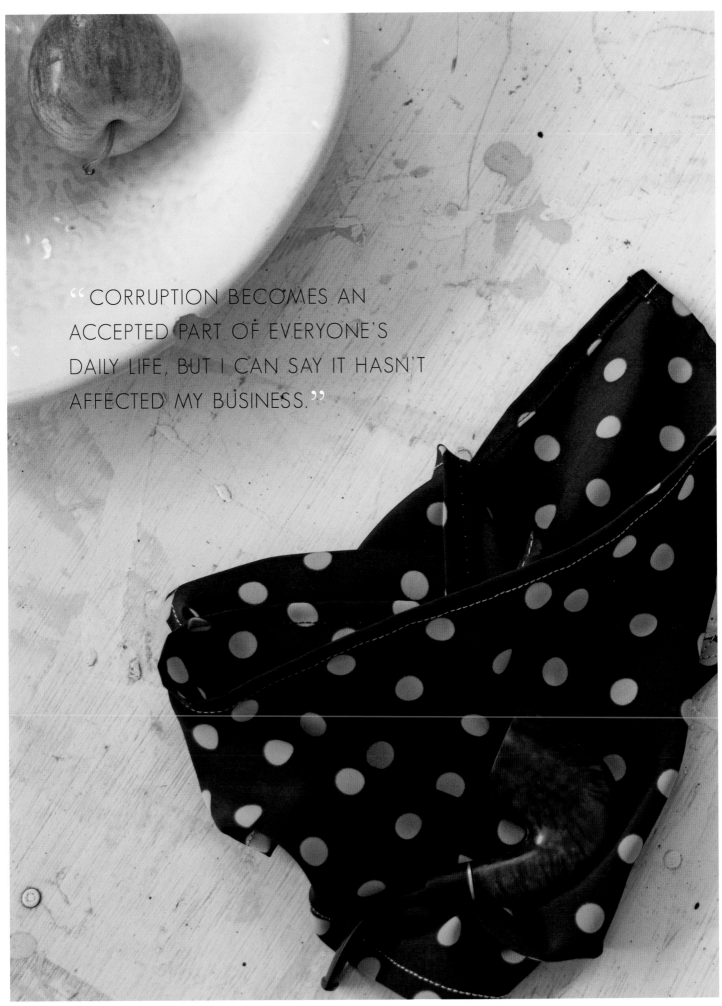

"CORRUPTION BECOMES AN ACCEPTED PART OF EVERYONE'S DAILY LIFE, BUT I CAN SAY IT HASN'T AFFECTED MY BUSINESS."

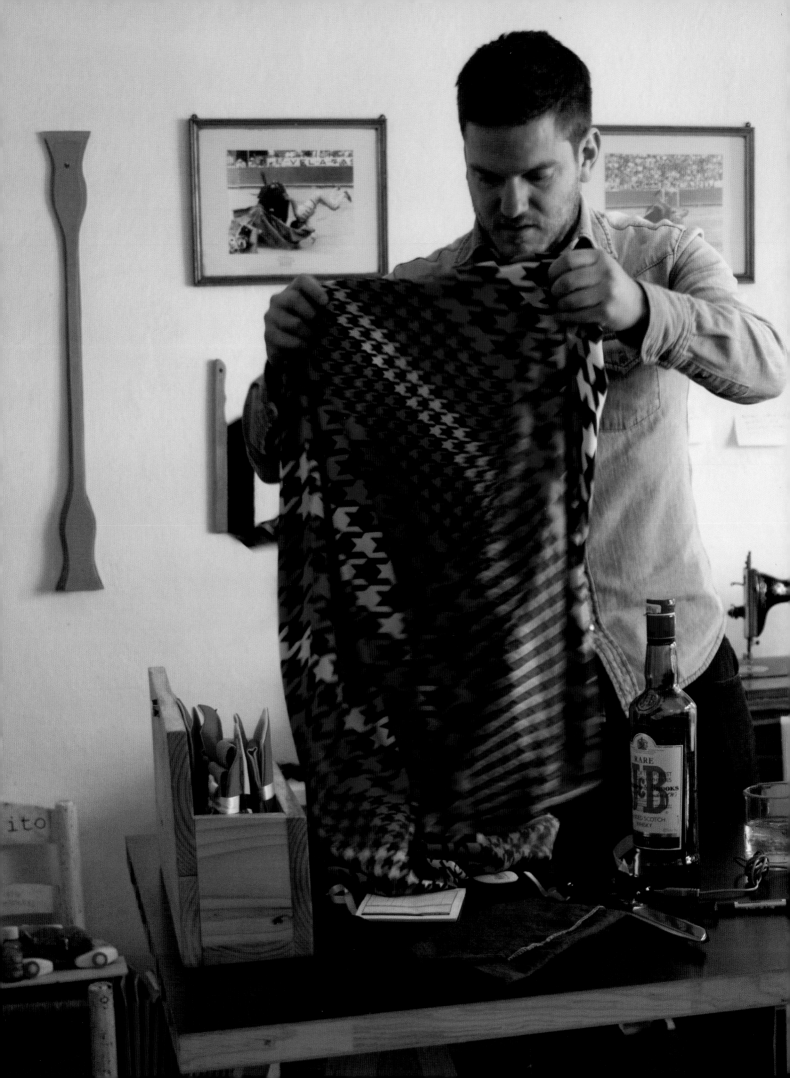

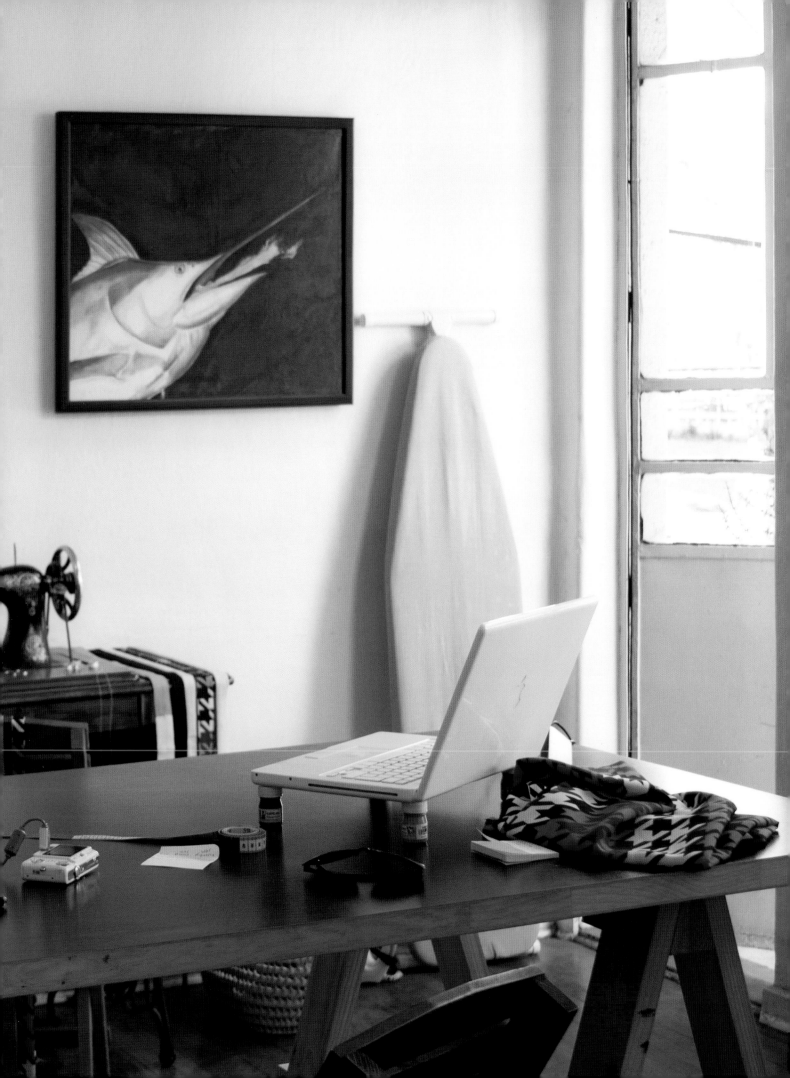

MEXICO CITY HAS A POPULATION OF OVER 21 MILLION PEOPLE.

MEXICO CITY WAS HOME TO CELEBRATED MARRIED MEXICAN ARTISTS DIEGO RIVERA AND FRIDA KAHLO.

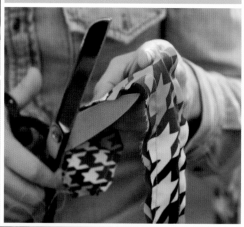

MEXICO CITY HAS APPROXIMATELY 160 MUSEUMS, 100 ART GALLERIES, AND 30 CONCERT HALLS.

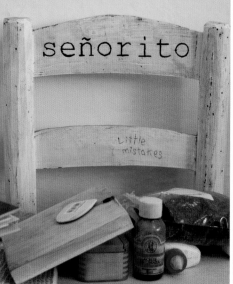

señorito

Little mistakes

MINIMAL AND ANGULAR WITH WALLS PAINTED IN PASTEL PINKS, BLUES, AND YELLOWS, CASA LUIS BARRAGÁN WAS NAMED AN UNESCO WORLD HERITAGE SITE AS A MASTERPIECE OF MODERN ARCHITECTURE.

MEXICO CITY WAS BUILT ON THE FORMER LAKE TEXCOCO, WHICH SOMETIMES CAUSES UNSTABLE FOUNDATIONS AND SINKING BUILDINGS.

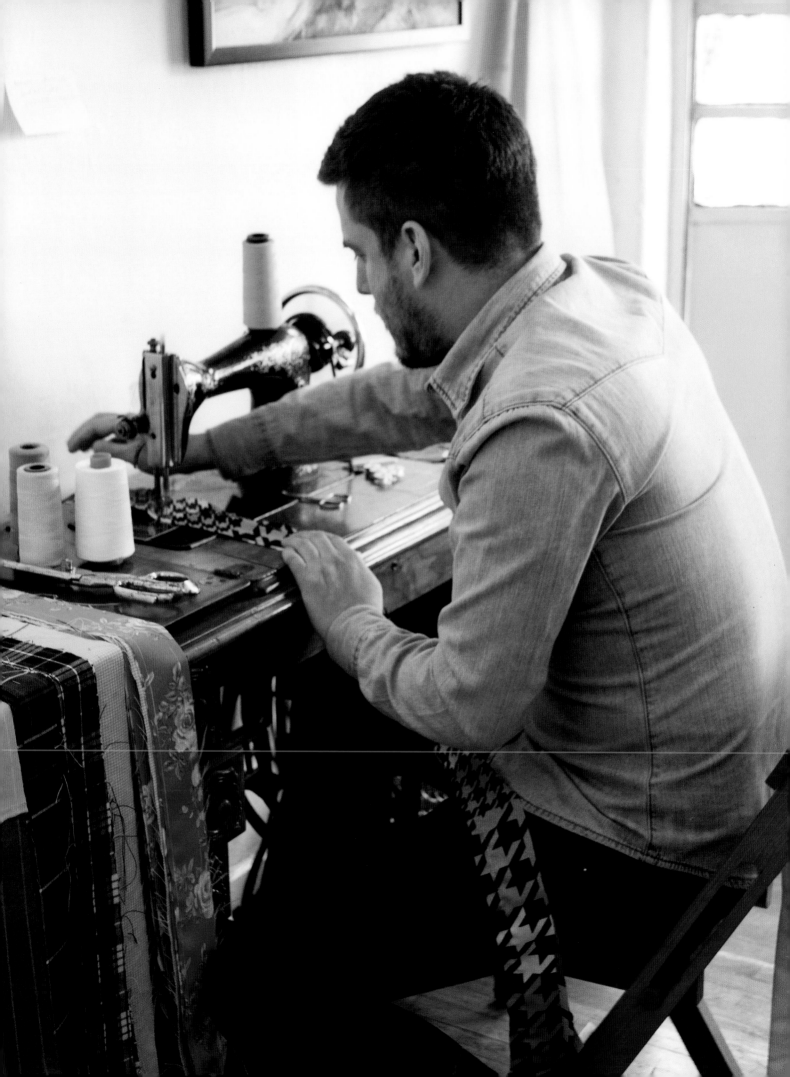

LONDON
ENGLAND

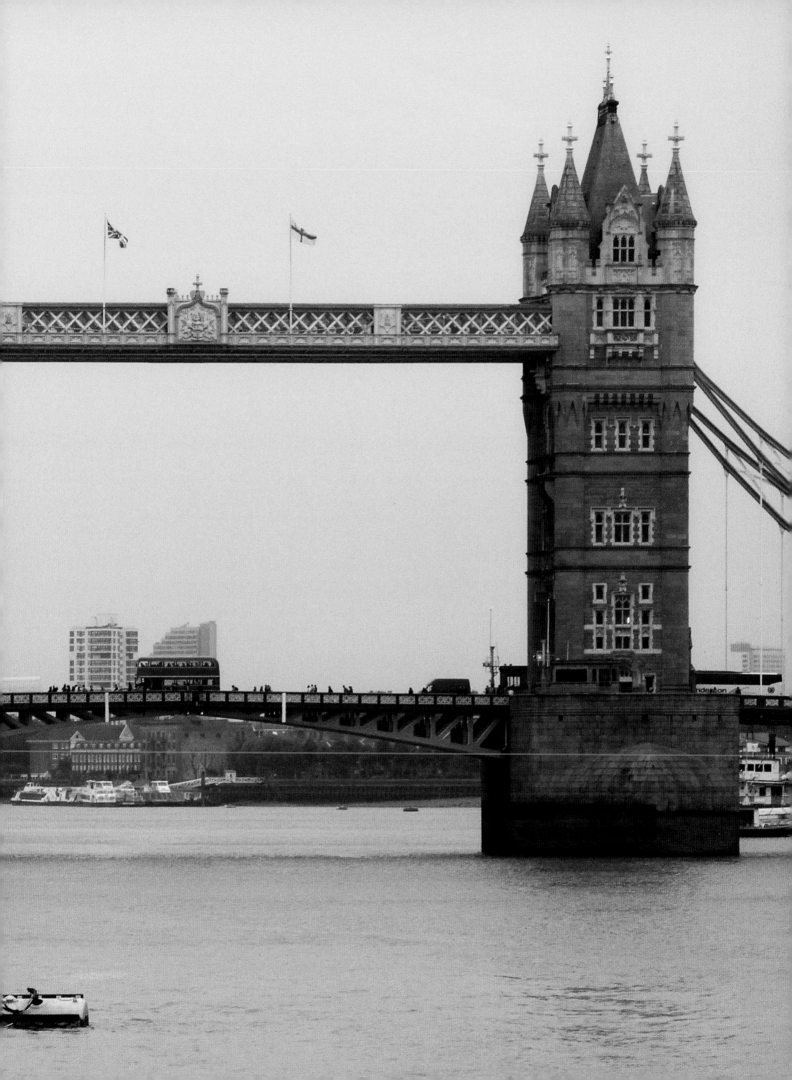

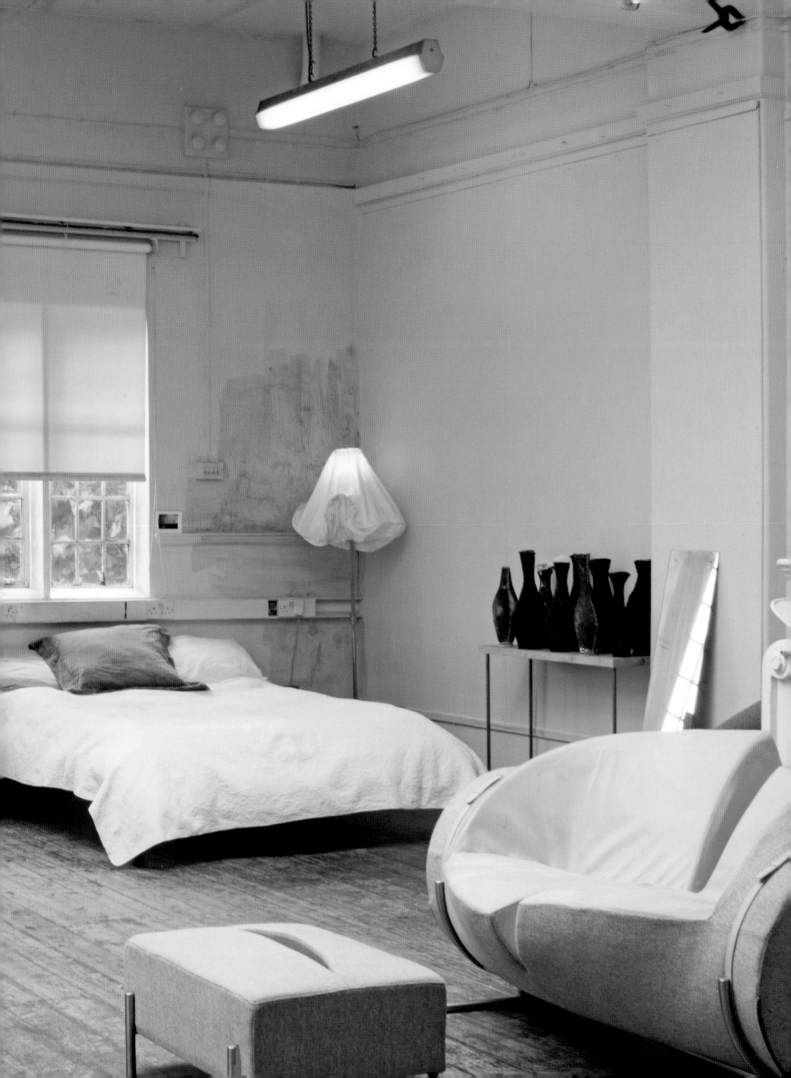

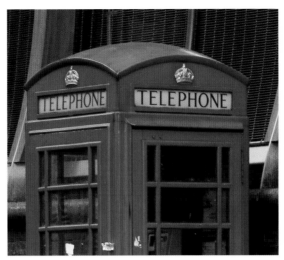
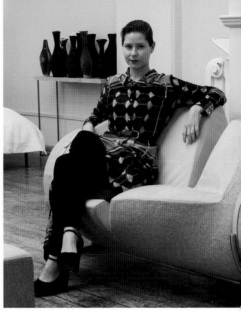

CHARLOTTE KINGSNORTH
INDUSTRIAL ARTIST

Charlotte was born and raised in London. Both of her parents were photographers, so creativity was ingrained in her from a very early age. She trained at Buckinghamshire New University in the Contemporary Furniture and Product Design program, and afterwards studied under industrial product designer Tord Boontje at the Royal College of Art.

Charlotte's work as an industrial designer can be described as merging the practical and the sculptural. Her designs are imbued with her artistic preoccupation with materiality and biomorphic forms. There is often a narrative around each piece that pushes accepted values in design and boundaries of conventional taste. For example, some of her conceptual furniture pieces include "Slashed," which is a love seat and ottoman set made of upholstered foam and a stainless steel frame that each appear to have a knife slash that has cut through the seat and cushion, revealing the hidden layers inside like an open wound. Charlotte's "At One" collection was inspired by a trip to Mexico where she found generic white broken plastic chairs that were "fixed" by using braided palm leaves to hold together the cracked pieces. She appreciated how the two materials relied on each other. The "At One" collection is meant to be a malleable furniture "experience" between a sofa and its occupant. When a person sits on the sofa, the soft chair 'flesh' spills and bulges over the wooden frame and this new combination between chair and sitter forms a new shape, which gives meaning to the furniture piece's name, "At One."

Charlotte lives and works in an old abandoned school in the Maida Vale residential district, an affluent area of west London. Amongst the wide, tree-lined streets and late Victorian and Edwardian mansion flats, her building stood abandoned before being rented out to artists. Her flat is the old art room of the school, which was quite filthy when she moved in, but slowly Charlotte has adapted the space into the perfect live/work studio as vast amounts of light pours into the large room—both features that enable her to work on multiple projects at the same time.

In addition to its rich history, which adds a special dimension to its overall cultural landscape, London is a modern global city with a lot of newness to discover as well. For Charlotte, the diversity of cultures all jumbled together in one city is an endless source of inspiration for her work. There are the many museums and art galleries in the city, but also little pockets of creativity in the more remote industrial areas. Emerging artists have taken on a somewhat nomadic lifestyle as they are constantly challenged to come up with creative ways to afford living and working in the city.

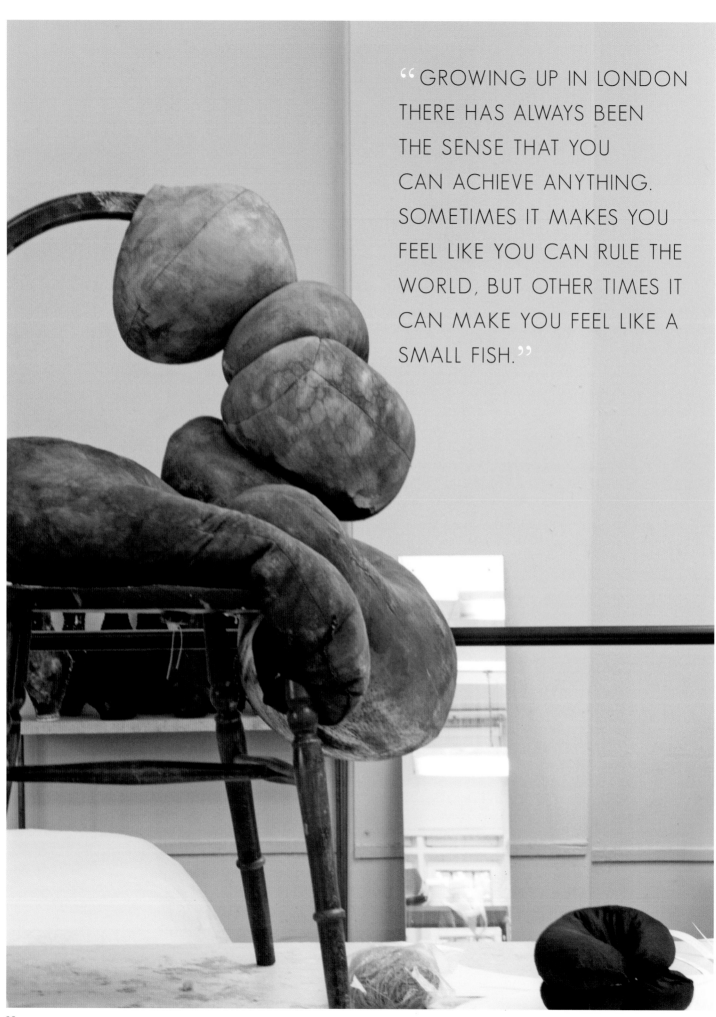

"GROWING UP IN LONDON THERE HAS ALWAYS BEEN THE SENSE THAT YOU CAN ACHIEVE ANYTHING. SOMETIMES IT MAKES YOU FEEL LIKE YOU CAN RULE THE WORLD, BUT OTHER TIMES IT CAN MAKE YOU FEEL LIKE A SMALL FISH."

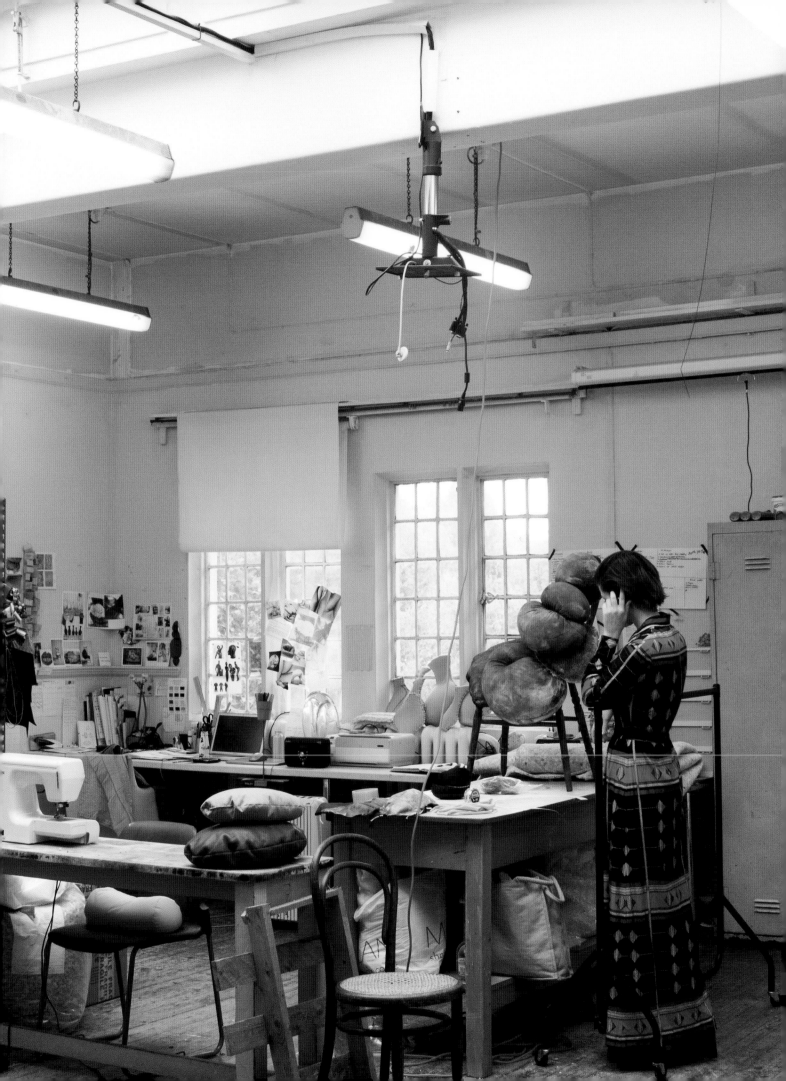

ICONIC BRITISH DESIGNS ARE EASILY RECOGNIZABLE THROUGHOUT THE WORLD— SUCH AS THE RED PHONE BOX, DOUBLE-DECKER BUS, THE UNION FLAG, AND THE CLASSIC BLACK AUSTIN FX4 FAIRWAY TAXI CAB.

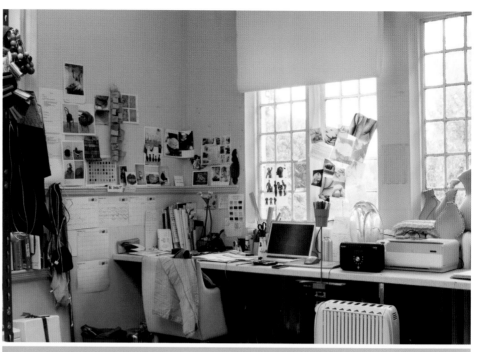

THE LONDON UNDERGROUND (THE 'TUBE') IS THE OLDEST METRO SYSTEM IN THE WORLD.

LONDON-BASED *WALLPAPER* MAGAZINE AND *FRIEZE* MAGAZINE ARE HIGHLY INFLUENTIAL DESIGN AND ART WORLD PUBLICATIONS.

LONDON IS HOME TO SOME OF THE WORLD'S MOST PROGRESSIVE CONTEMPORARY ARCHITECTS—NORMAN FOSTER, ZAHA HADID, AND RICHARD ROGERS.

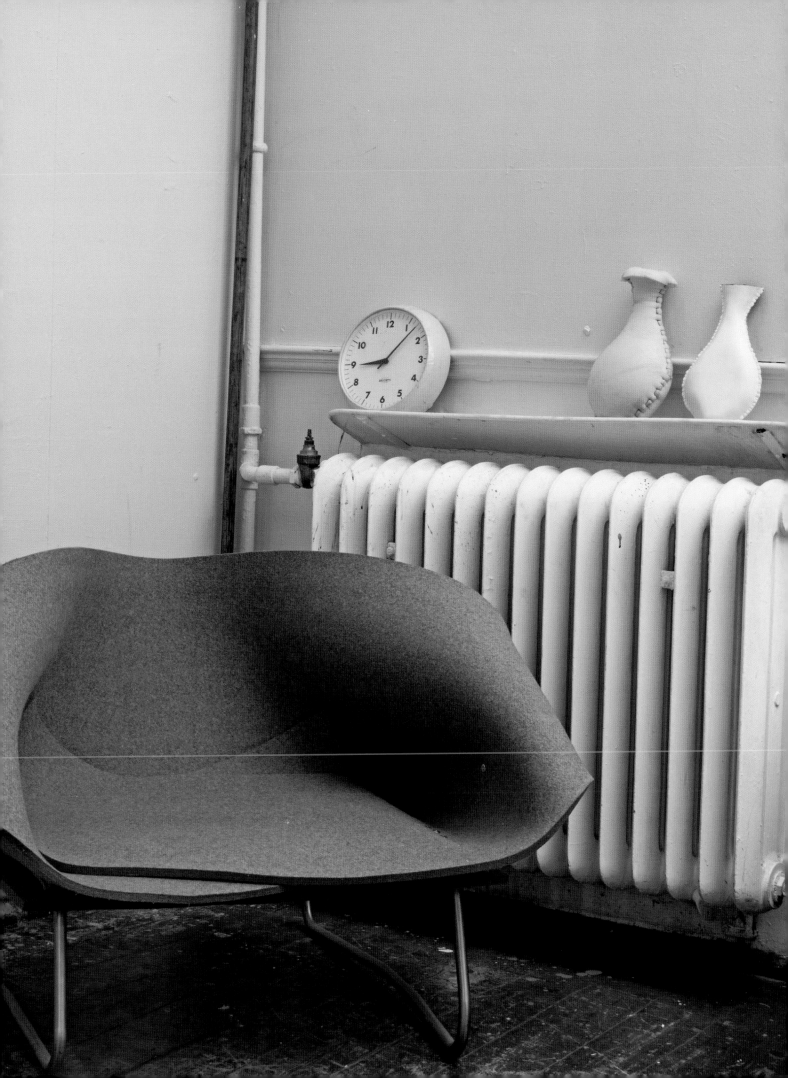

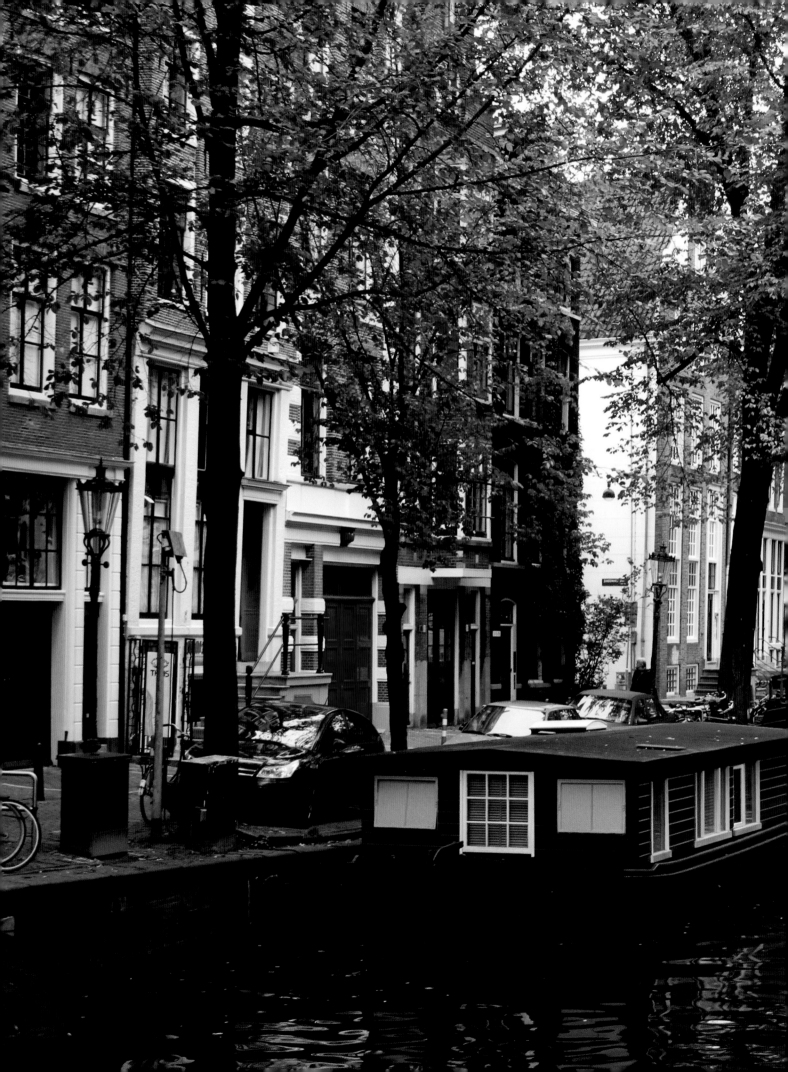

AMSTERDAM

NETHERLANDS

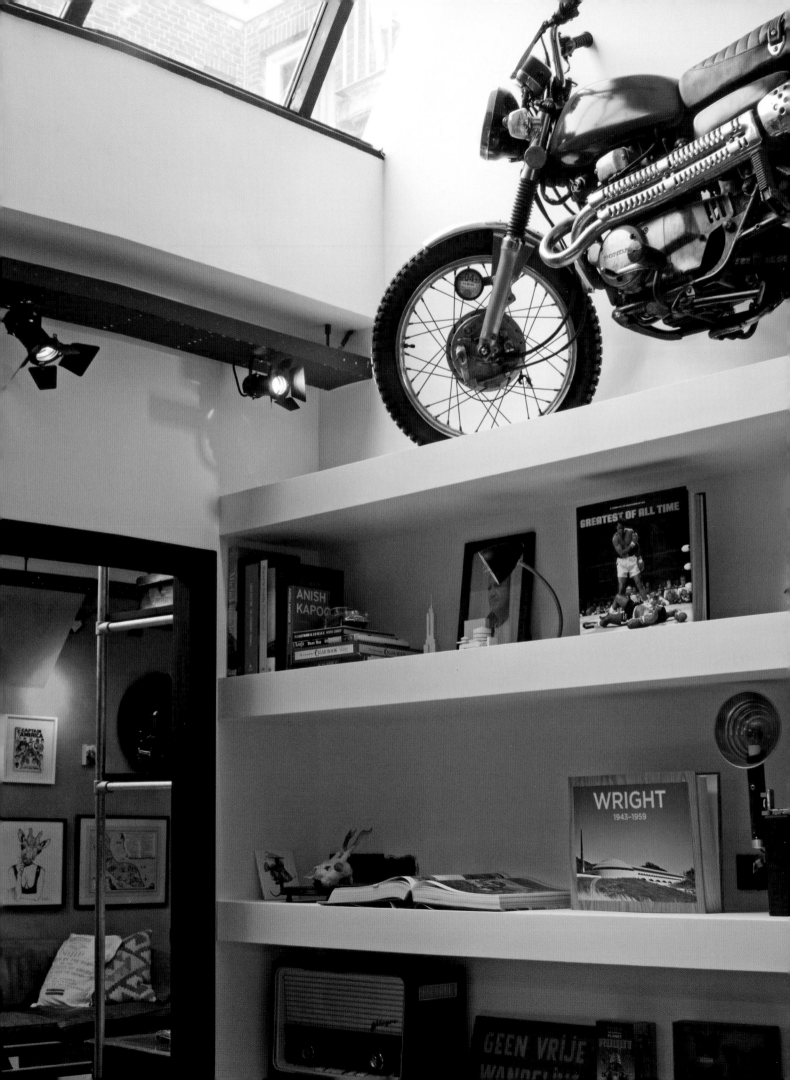

JAMES VAN DER VELDEN
INTERIOR ARCHITECT & SPATIAL DESIGNER

James van der Velden spent his early years growing up in the countryside of England and the Netherlands. His mother was a sculptor, so he was raised in a home with art and books and would play in his mother's studio in the back garden. His father was a banker, but liked to be creative working with his hands and had a talent for carpentry. Holidays were spent visiting museums and traveling throughout the United States, which was the beginning of James' affinity for America.

After several years of working for a prominent interior designer, James opened his design business, BRICKS Amsterdam, in 2010—an interior design studio with an architecture and furniture design element. Some of his design projects include such inventive novelties as the use of pink flamingos as hanging pendant lights over a restaurant bar. Van der Velden also styled the lobby of the citizenM hotels in New York City, London, and Rotterdam. Residential design projects closer to home include the classic Amsterdam apartment on the canal.

James approaches his design projects as he would conceiving art, with inspiration coming from varying sources such as images of old sheds, cabins, and tree houses. He is also excited by old motorcycles, both

rebuilding them and using motorcycles as found art in his design schemes. Remembering his childhood trips spent in the United States, James appreciates the vast and varied landscapes of the country and, as well, some of his design ideas were sparked by his fascination with American industrial designs for everyday objects such as the fire truck, camping gear, and tools.

Living and working in Amsterdam has created a unique experience for James. The city's population is only one million, which makes the scale of the city very manageable to get from one destination quickly to the next on a bicycle. This close proximity of various places offers him a flexibility to work on multiple projects at the same time.

Amsterdam's liberal values, such as their open policies on marijuana and prostitution, lend to an atmosphere of unrestricted creativity. Worldwide, Dutch people are known for being very open-minded, and perhaps correspondingly, Dutch design is known for its originality. The city is also very supportive of young entrepreneurs and artists, as their educational institutes nurture designers and artists to produce their art and encourage the promotion of art and culture in Amsterdam.

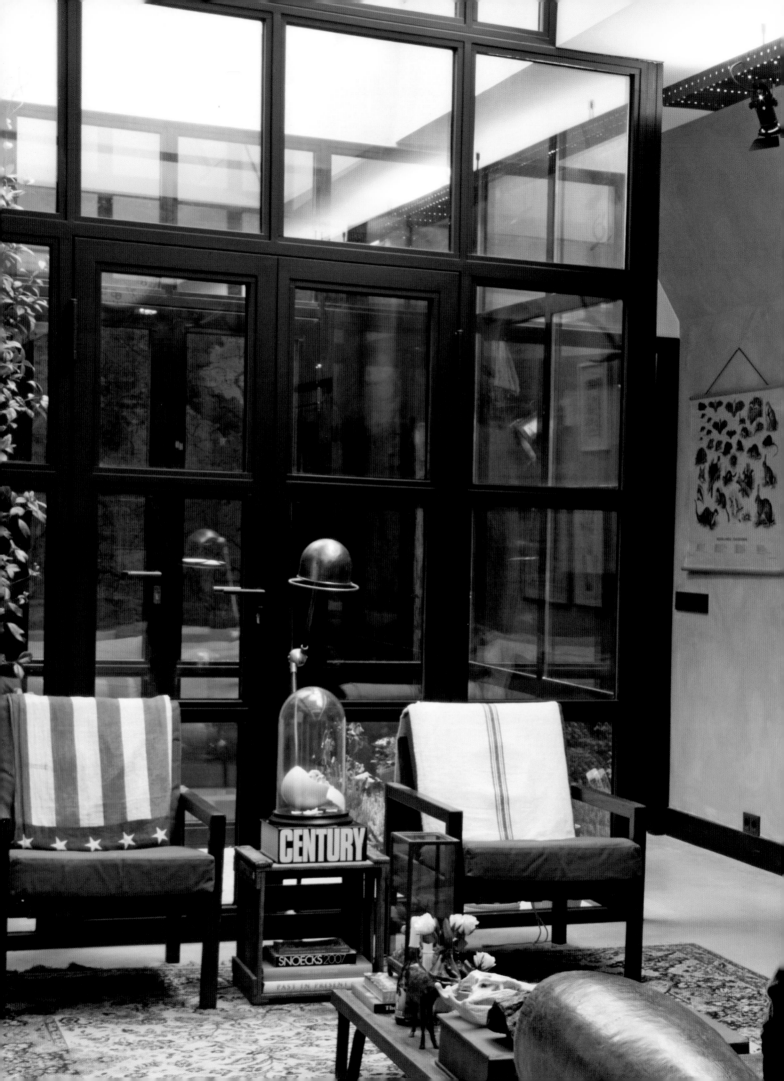

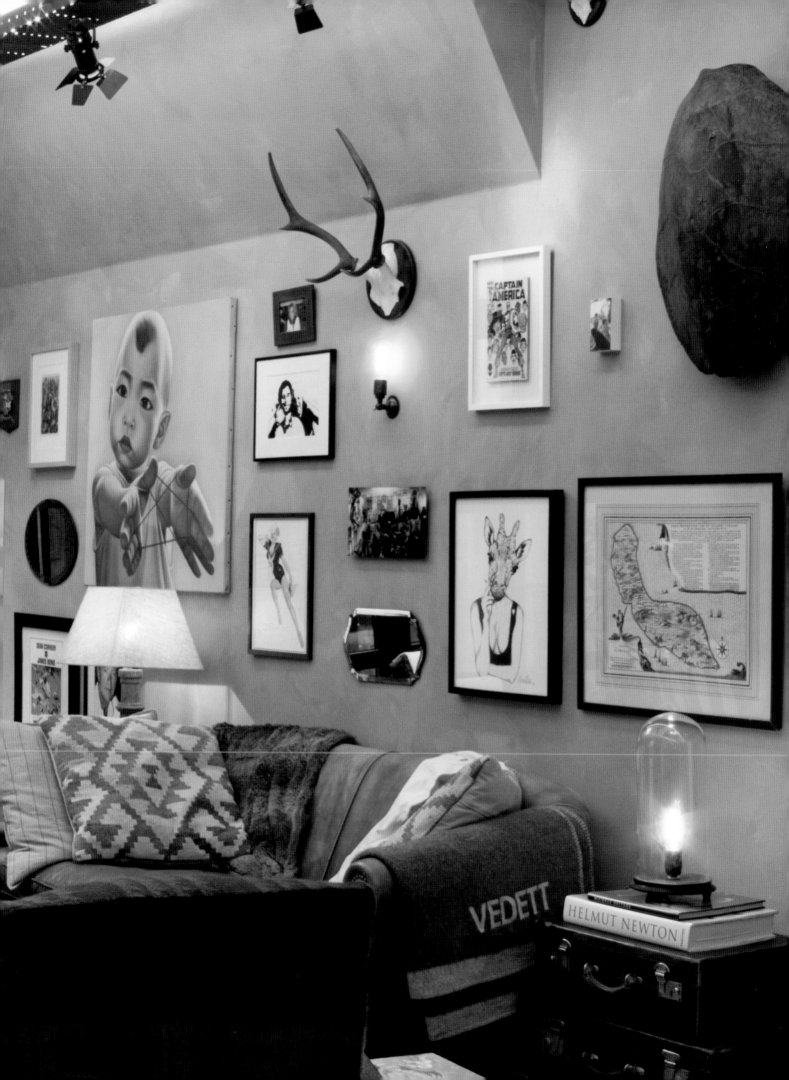

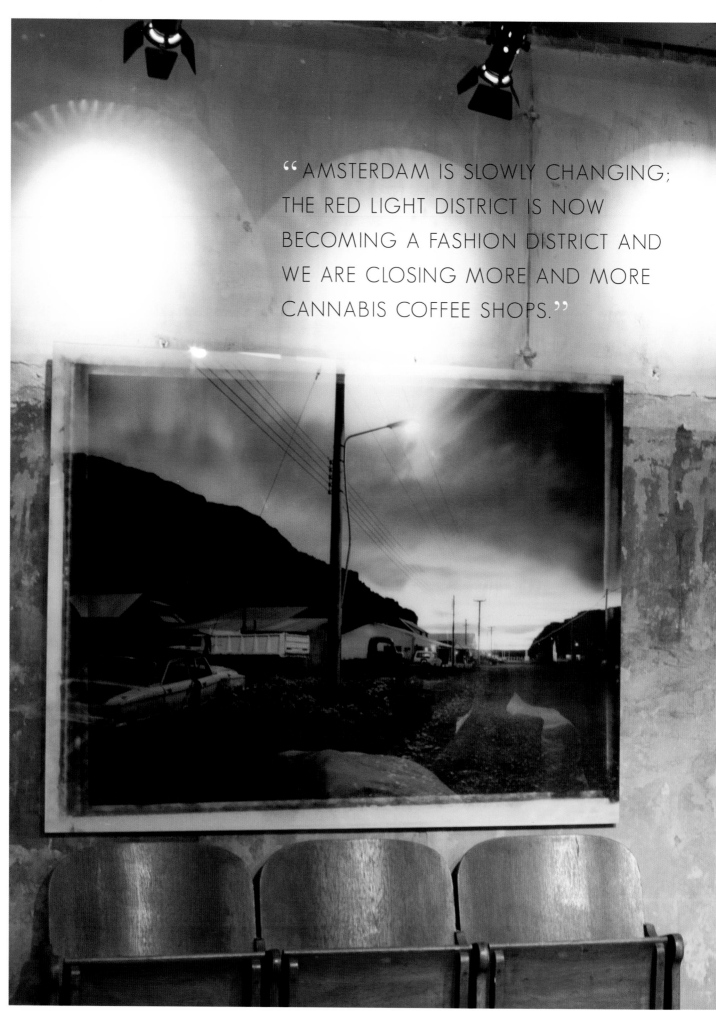

"AMSTERDAM IS SLOWLY CHANGING; THE RED LIGHT DISTRICT IS NOW BECOMING A FASHION DISTRICT AND WE ARE CLOSING MORE AND MORE CANNABIS COFFEE SHOPS."

ACCLAIMED PAST
RESIDENTS INCLUDE
DUTCH PAINTERS
REMBRANDT AND
VINCENT VAN GOGH.

DE STIJL, THE DUTCH ARTISTIC MOVEMENT FOUNDED IN
AMSTERDAM IN 1917, INCLUDES PAINTER PIET MONDRIAN
AND ARCHITECT AND FURNITURE DESIGNER GERRIT RIETVELD.

THE CITY'S DISTINCTIVE
URBAN DESIGN INCLUDES
OVER 100 KILOMETERS
OF CANALS AND MORE
THAN 1,200 BRIDGES.

AMSTERDAM-BASED
FRAME MAGAZINE IS
A CONTEMPORARY
INTERIOR DESIGN
PUBLICATION WITH
DISTRIBUTION IN OVER
70 COUNTRIES.

MOST OF THE RESIDENTS OF AMSTERDAM USE A BICYCLE
AS MEANS OF TRANSPORTATION.

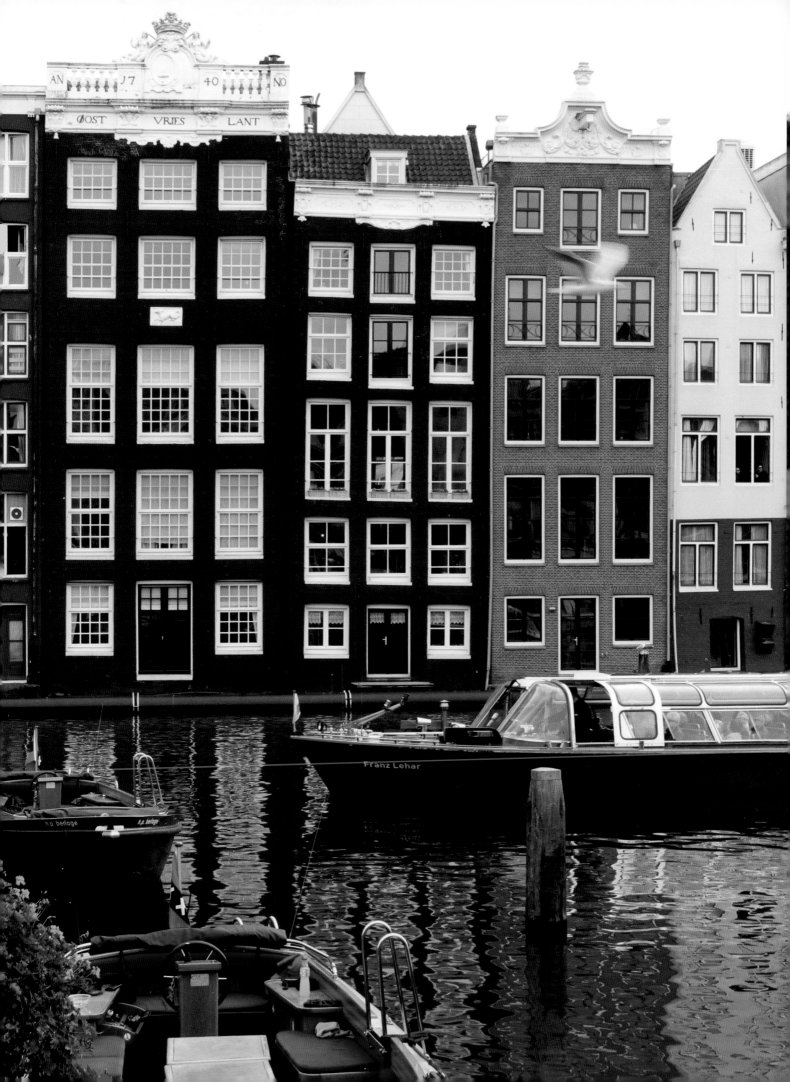

MUMBAI

INDIA

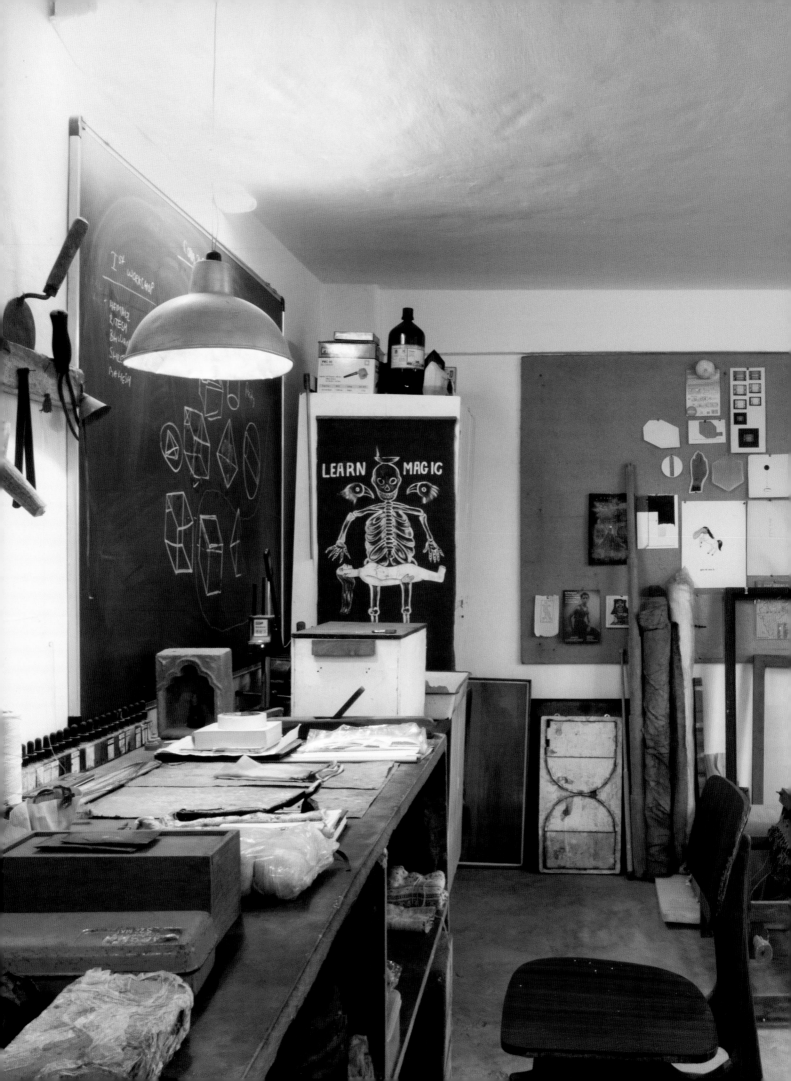

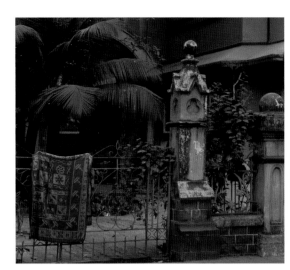
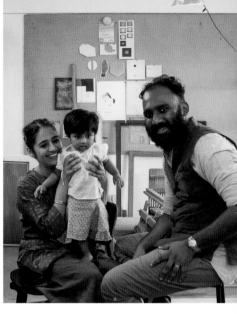

SHREYAS KARLE ARTIST/DESIGNER
HEMALI BHUTA ARTIST/DESIGNER

Hemali and Shreyas are visual designers who were both born and raised in Mumbai. Hemali's parents were living in India during its pre-independence, however, her mother did not speak much about the freedom struggle but, rather, spoke extensively of growing up lower middle class and her determination to study architecture at one of the best colleges in India. Hemali's mother was a practicing architect (before Hemali and her brother were born) and had a fascination with Scandinavian design and for Danish designer Finn Juhl, in particular. She designed their modest family home with small and subtle details that Hemali only came to appreciate after attending art school.

Shreyas has spent his entire life in Mumbai with the exception of five years living in Baroda, which is in the western Indian state of Gujarat. Shreyas studied for his Master's degree at Maharaja Sayajirao University of Baroda, whose motto is: "Love of beauty, Goodness and Intellectual Curiosity." He was raised in a middle-class family, like most people in Mumbai, with a mother working in the clerical department of the textile sector and a father who had a Central Government job, but had an interest in theater, classical music, and literature. Shreyas' grandfather had discouraged his father from choosing an occupation in the arts, so the frustration of an unrealized dream was the catalyst for allowing Shreyas to pursue an art education.

Both Shreyas and Hemali approach their work not as career building, necessarily, but as experiments in everyday living in order to understand the artmaking process at every step. Shreyas works in various artistic mediums such as video, sculptural forms, illustrative/narrative books, and collaborative community projects. His work often involves the use of a visual pun in relation to mundane objects or situations. Shreyas' first solo exhibit, *Karle ki Koshish*, exemplified this concept with a mechanical, metal and motorized "Kicking Leg" piece and a line of 'mountain underwear' humorously presented upside down in different sizes and brown color tones to depict a mountain range. Shreyas has been the recipient of the prestigious FICA (Foundation for Indian Contemporary Art) Emerging Artist Award for India. Most recently, he participated in a group exhibit at the New Museum's 2015 Triennial: *Surround Audience* in New York City, which presented the works of 51 early-career artists from over 25 countries.

Hemali creates work in order to understand the transformation of the found object. Her work was recently shown in *the doorstep* exhibit at Jhaveri Contemporary gallery in Mumbai. The exhibit focused on the metaphysical nature of objects and how we perceive them. Calling her "one of the more intriguing cultural voices to emerge from India," the *New York Times* highlighted one of her works, *Speed*

Breakers/Roots, at the Yorkshire Sculpture Park, an open-air gallery in Yorkshire, England, and the UK's first sculpture park. Hemali created 11 bronze cast replicas of beech tree roots and placed them in the park to serve as "speedbreakers" to cause us to slow down and be aware of our surroundings and think about the surface and ground beneath our feet.

Hemali and Shreyas have also collaborated with the creation of the CONA Foundation. Located in their home, the foundation is an artist residency program that hosts artists from around the world to teach them about the process of making art. They host group discussions of the students' work, hold presentations by young and mid-career artists, and workshops for artists/art students. Shreyas and Hemali are also trying to set up a CONA Design cell which would allow artists to continue to produce their work without succumbing to the particular whims and tastes of the art market.

Shreyas and Hemali live and work in Borivali East, a suburb of Mumbai close to the Sanjay Gandhi National Park. At the end of the day after spending time in the center of Mumbai and feeling completely exhausted of all their senses, they retreat back to the calmer environment of their home and studio, which is in a gated society in a quieter section of the city. Living in Mumbai is very difficult, but over time they have developed a certain fortitude to handle the intense and chaotic urban energy. Mumbai is a city constantly on the move that doesn't allow for relaxation, which, in turn, provides an endless energy stream for artists. Shreyas uses the analogy of "various pieces of music being played from all the directions at the same time which comes to you as sound; it is beyond definition" in her attempt to describe Mumbai. The limitless contrasts between high-rise buildings and slums, the multitude of shades of brown in the city, and vibrant colors of women's saris can not help but to stimulate creativity. In Mumbai, art is deemed a higher creative form than design, but Hemali and Shreyas are doing their best to challenge this norm.

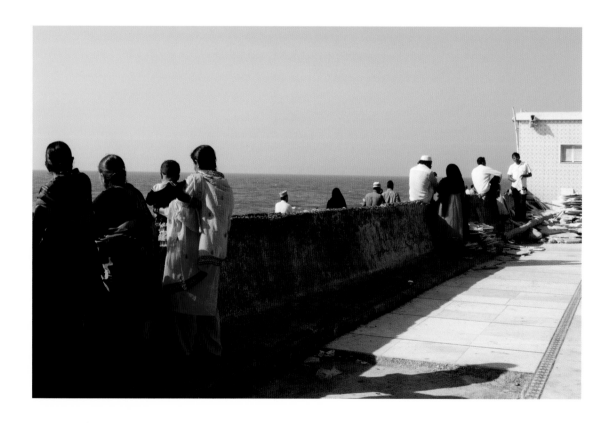

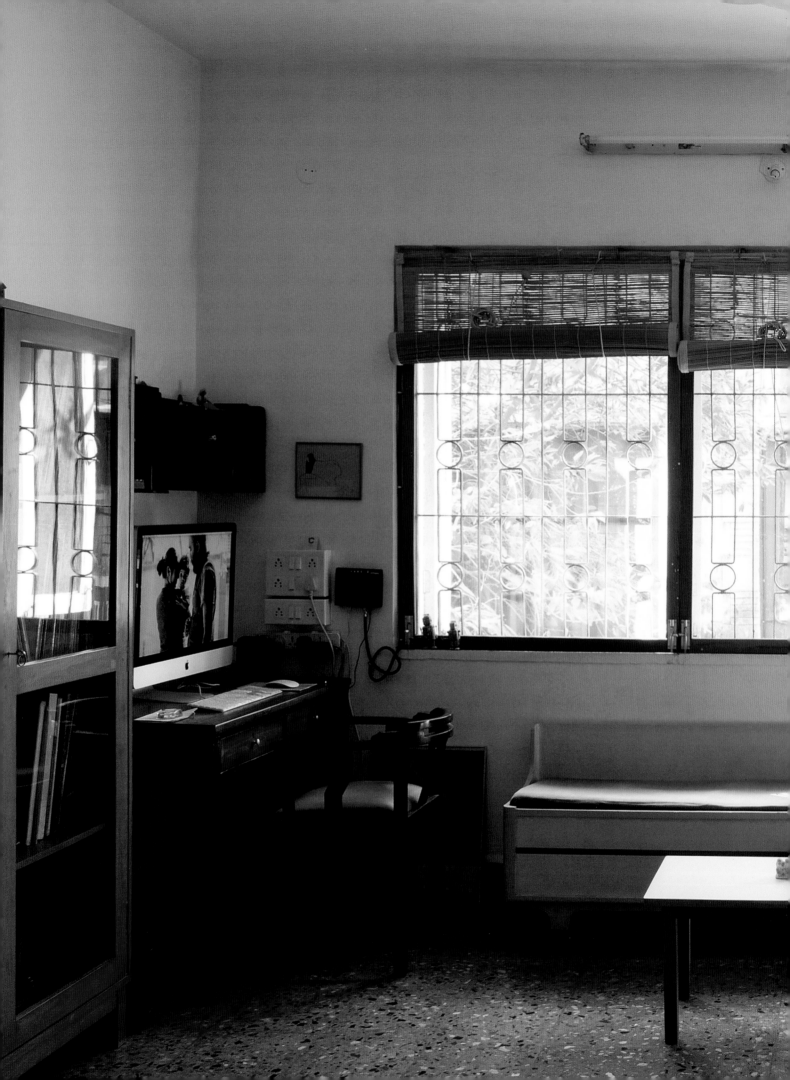

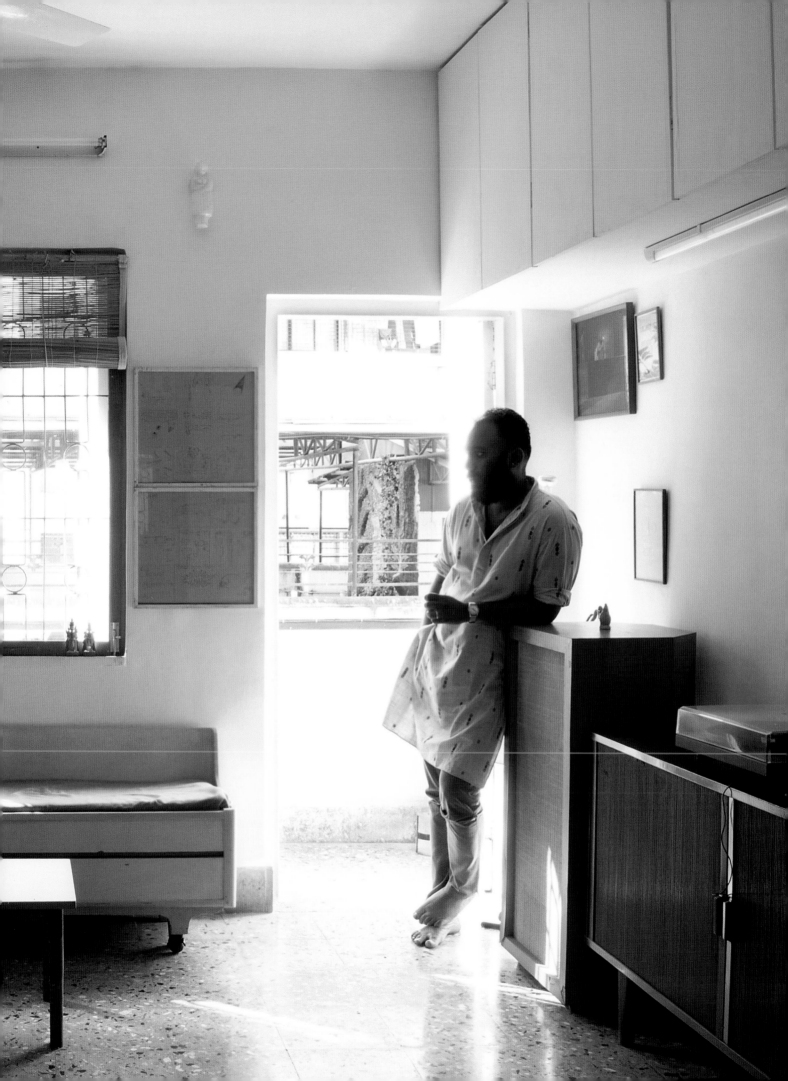

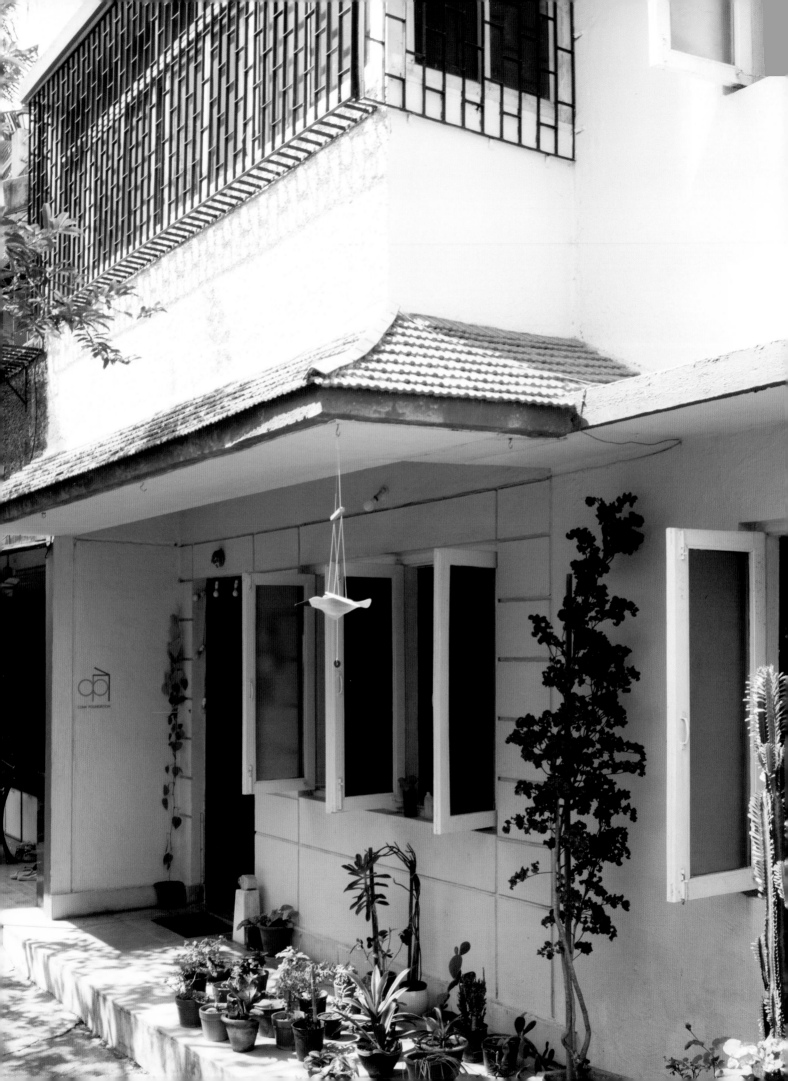

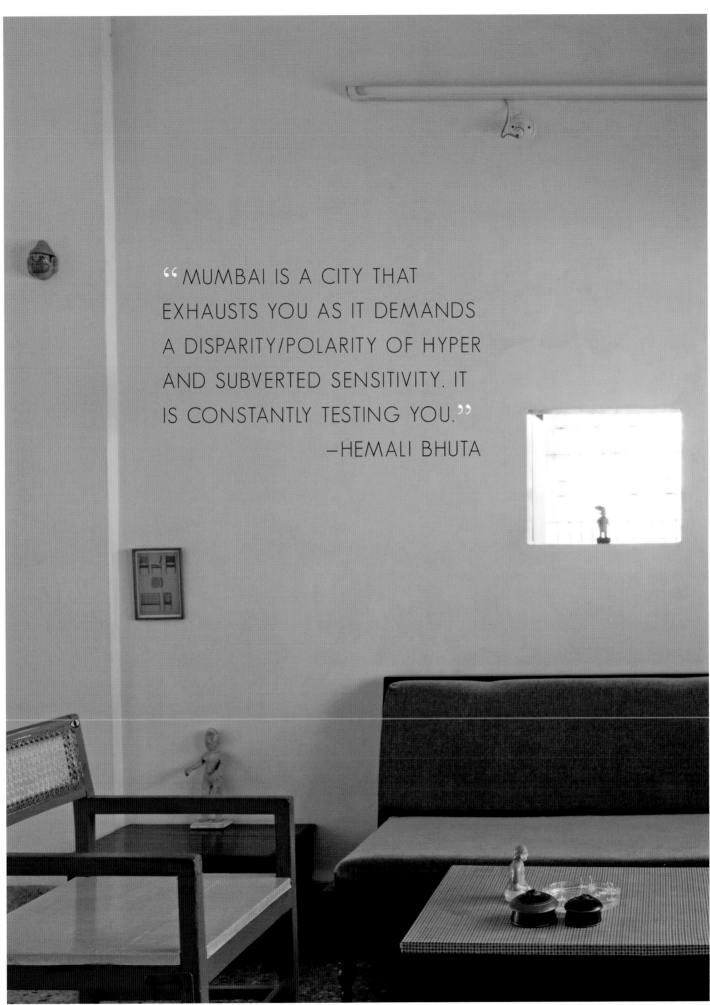

"MUMBAI IS A CITY THAT
EXHAUSTS YOU AS IT DEMANDS
A DISPARITY/POLARITY OF HYPER
AND SUBVERTED SENSITIVITY. IT
IS CONSTANTLY TESTING YOU."
—HEMALI BHUTA

123

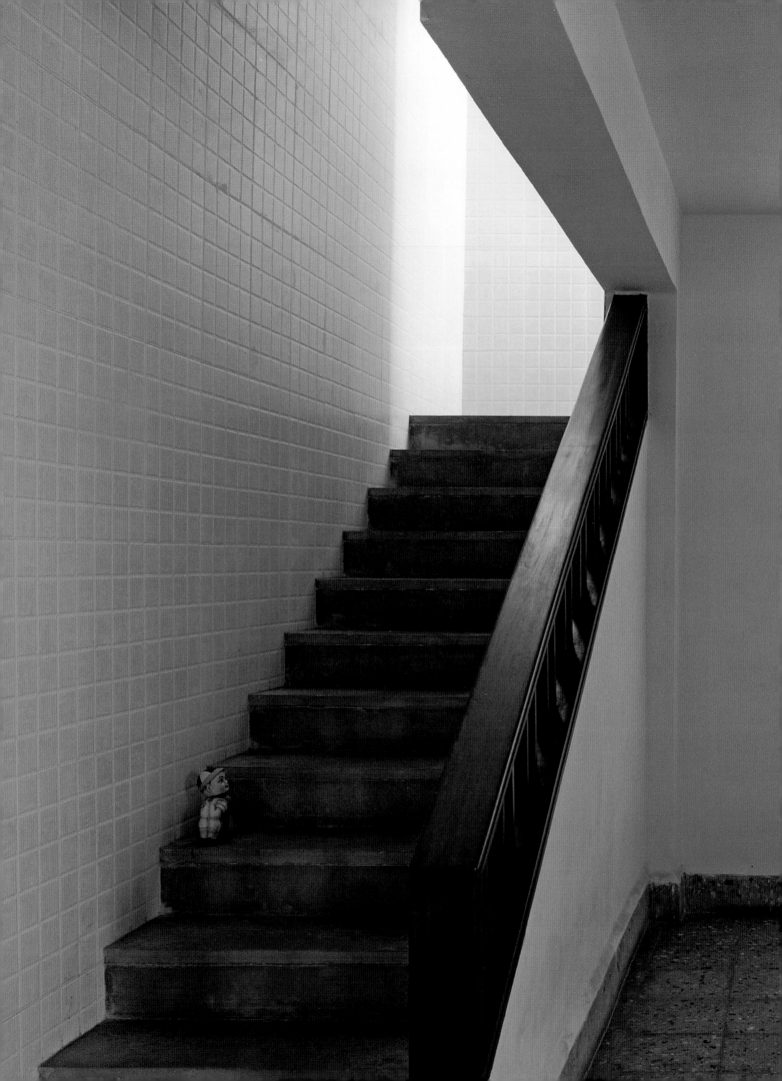

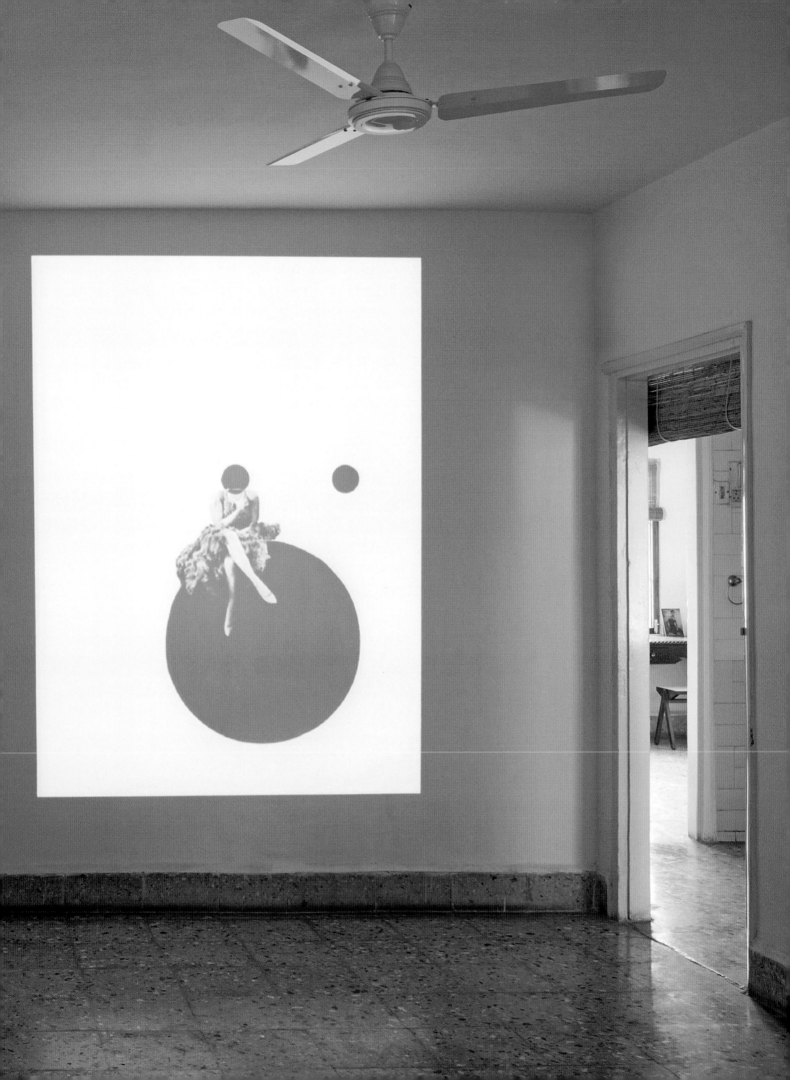

WITH OVER 18 MILLION PEOPLE, MUMBAI IS THE MOST POPULATED CITY IN INDIA, AND ONE OF THE MOST POPULATED CITIES IN THE WORLD.

MUMBAI IS THE WEALTHIEST CITY IN INDIA BUT ALSO HOME TO THE DHARAVI SLUM, THE LARGEST IN THE WORLD WITH 1 MILLION PEOPLE

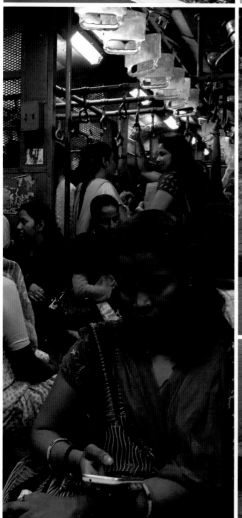

THE ANNUAL KALA GHODA ARTS FESTIVAL CELEBRATES VISUAL ARTS, URBAN DESIGN AND ARCHITECTURE, DANCE, CINEMA, AND LITERATURE.

THE LAUDED SCULPTOR, ANISH KAPOOR, KNOWN FOR
HIS BIOMORPHIC AND ARCHITECTURAL SCULPTURES,
WAS BORN IN MUMBAI.

MUMBAI IS THE BIRTHPLACE
OF INDIAN CINEMA AND
THE HIGHLY-STYLIZED
DRAMAS AND MUSICALS
OF BOLLYWOOD.

MUMBAI HAS A DIVERSIFIED TRANSPORTATION
SYSTEM—FROM THE MONORAIL AND METRO TO TAXIS
AND AUTO RICKSHAWS.

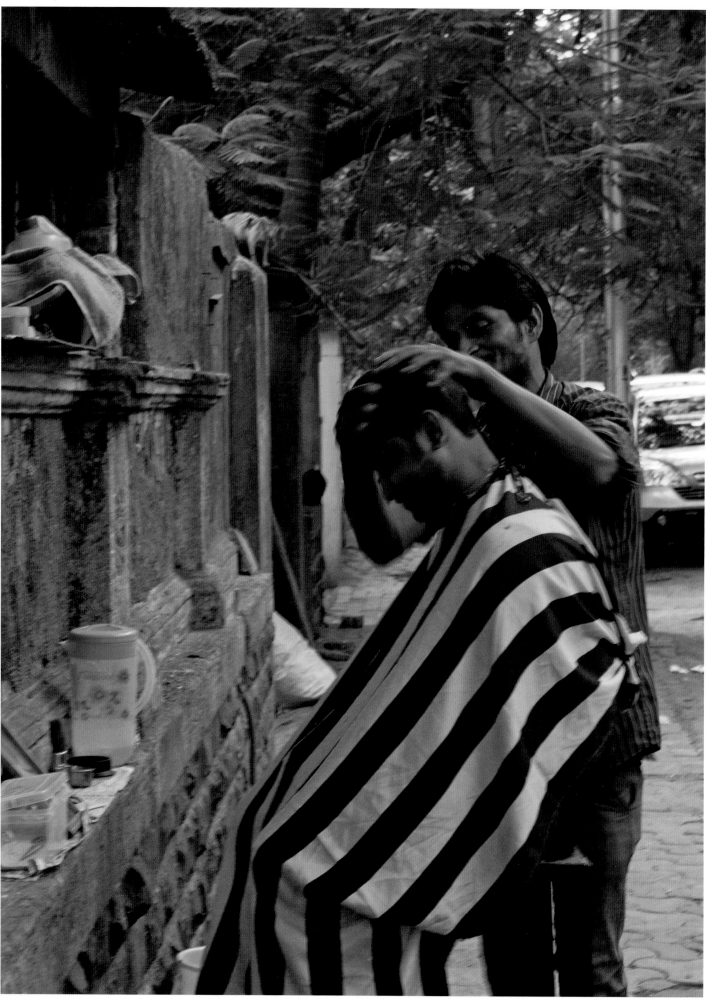

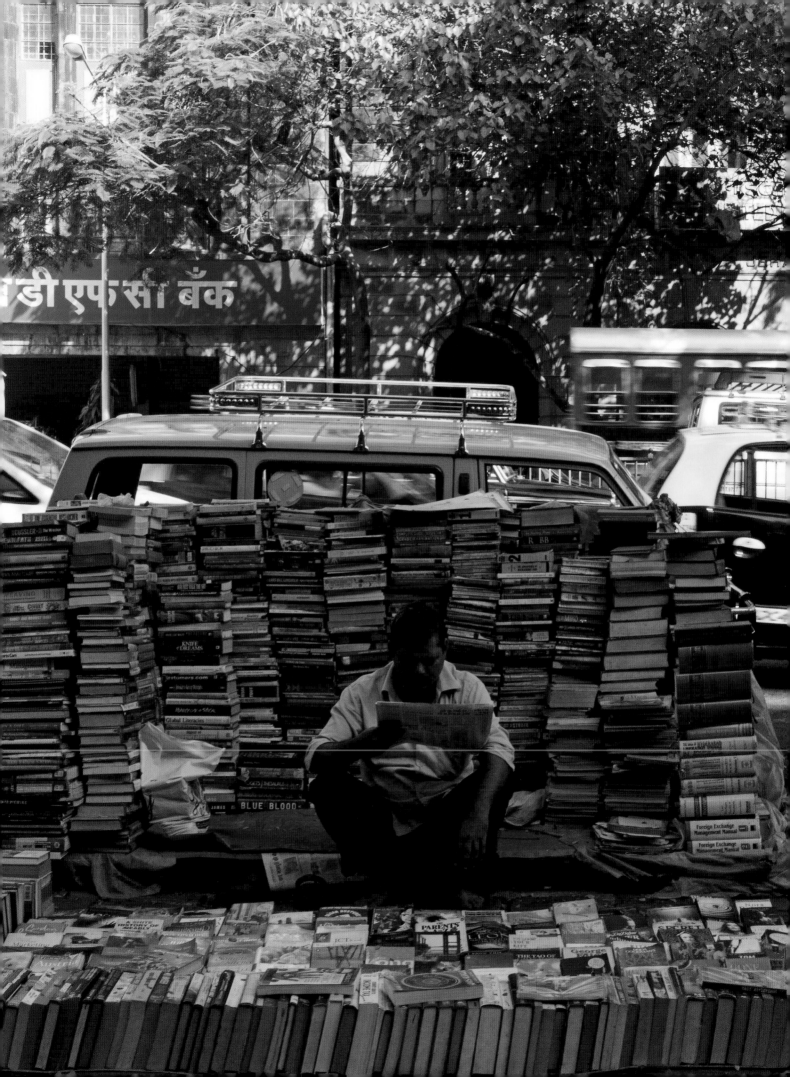

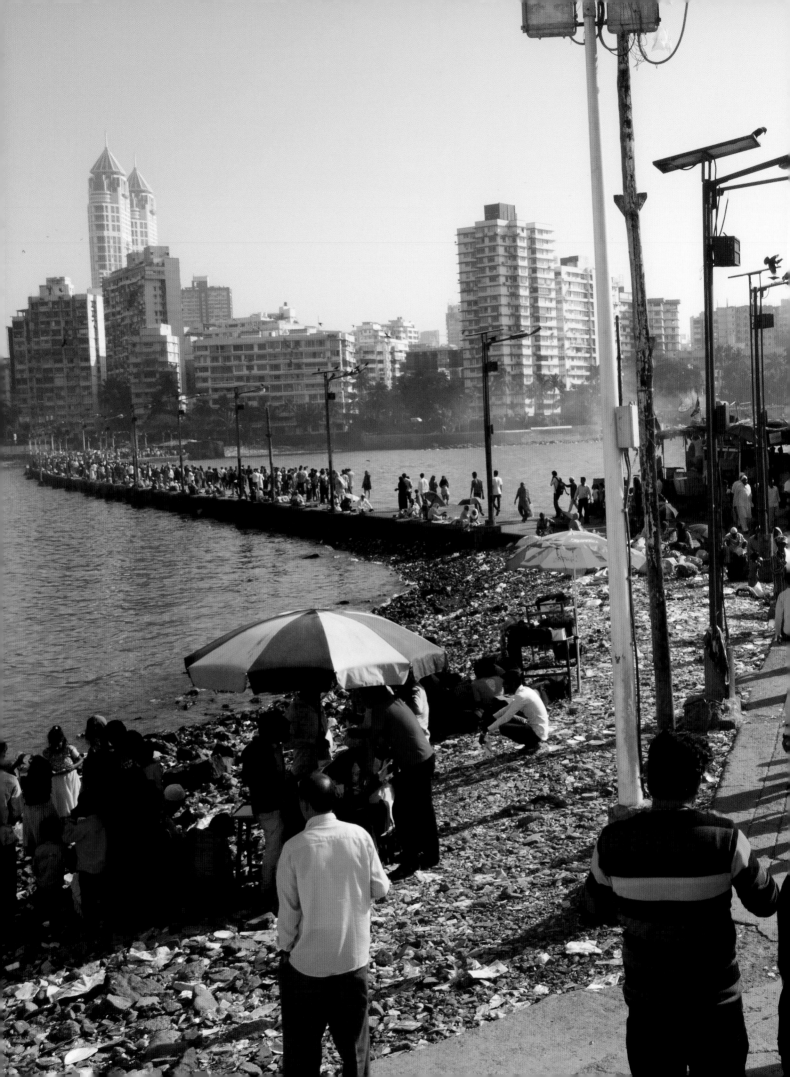

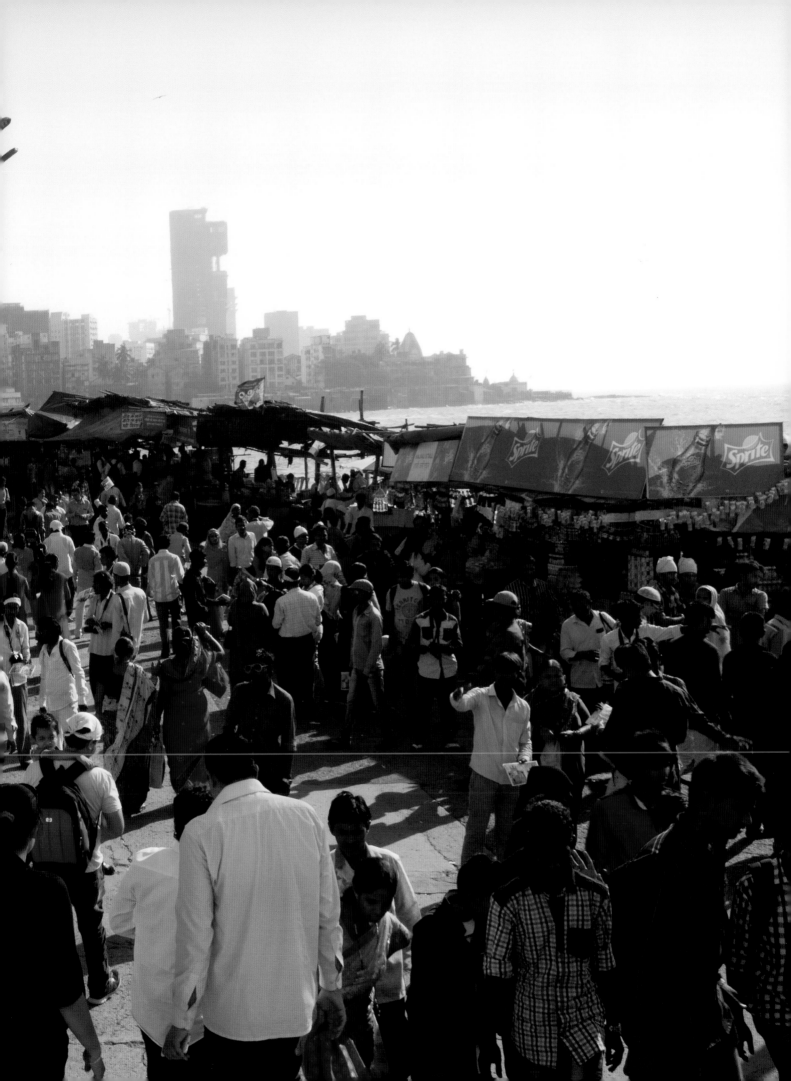

LOS ANGELES
UNITED STATES

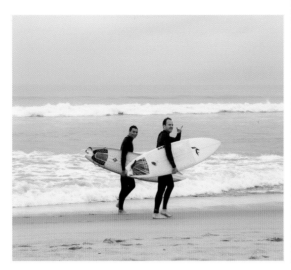
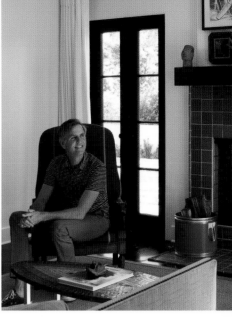

STEVE JONES
HOUSE FLIPPER

Steve spent his childhood just south of Los Angeles in Laguna Beach. Family photos of his youth show days spent surfing and playing in the ocean with his siblings. These iconic Southern California surf culture images show that he was living the sort of idyllic life of sunny weather and beaches that many in the rest of the world only read about.

Being raised near the beach really influenced Steve's design sensibilities, which led to him working at Quicksilver, one of the world's largest manufacturers of surfwear, for 20 years. While at the company he learned how authenticity and integrity is extremely important to brand building. After leaving Quicksilver, he started bettershelter, a house-flipping business, in 2005.

The high real estate prices in Los Angeles left a segment of homebuyers that were being ignored. Often young, but with good design sensibility, these new homebuyers had achieved a certain level of success in their careers, but weren't yet at the place to afford expensive designer homes.

Steve's concept for bettershelter is based on what he calls the "slow flip." He breaks away from the negative persona of the house flipper or developer whose primary concern is turning over homes as quickly as possible using inexpensive and standard materials for maximum profit. Steve's house flipping business is very boutique and niche. He often works in neighborhoods that are being gentrified and buys homes that already have a bit of character. He then remodels the houses in order to highlight their original architectural beauty, while infusing his modern coastal style.

The bettershelter aesthetic has attracted many new homeowners as it has become a very recognizable and desirable brand and culture unto itself. Each bettershelter home is completely styled from Steve's collection of furniture, decor, and art that he has been collecting and accumulating over the years. In fact, he has quite an addiction for hitting up the big flea market every single Sunday (he rarely misses a flea market or ever changes his Sunday shopping plans!).

Los Angeles is a relatively new city compared to the long history of European cities or many others in the rest of the world. Even compared to New York City, designers are calling Los Angeles 'the new frontier.' The city is deemed very progressive and open to new ideologies. For example, the building codes in California are at the forefront of energy and waste concerns.

The city is also a proud representative of seminal mid-century modern design as it is the location of the Case Study Houses of the 1950s and home of the influential and iconic husband-and-wife designers, Charles and Ray Eames. Similar to New York City, Los Angeles has a cultural mix that represents people from almost every country in the world, which is evident in an eclectic, global interior design style that retains its roots in beach culture.

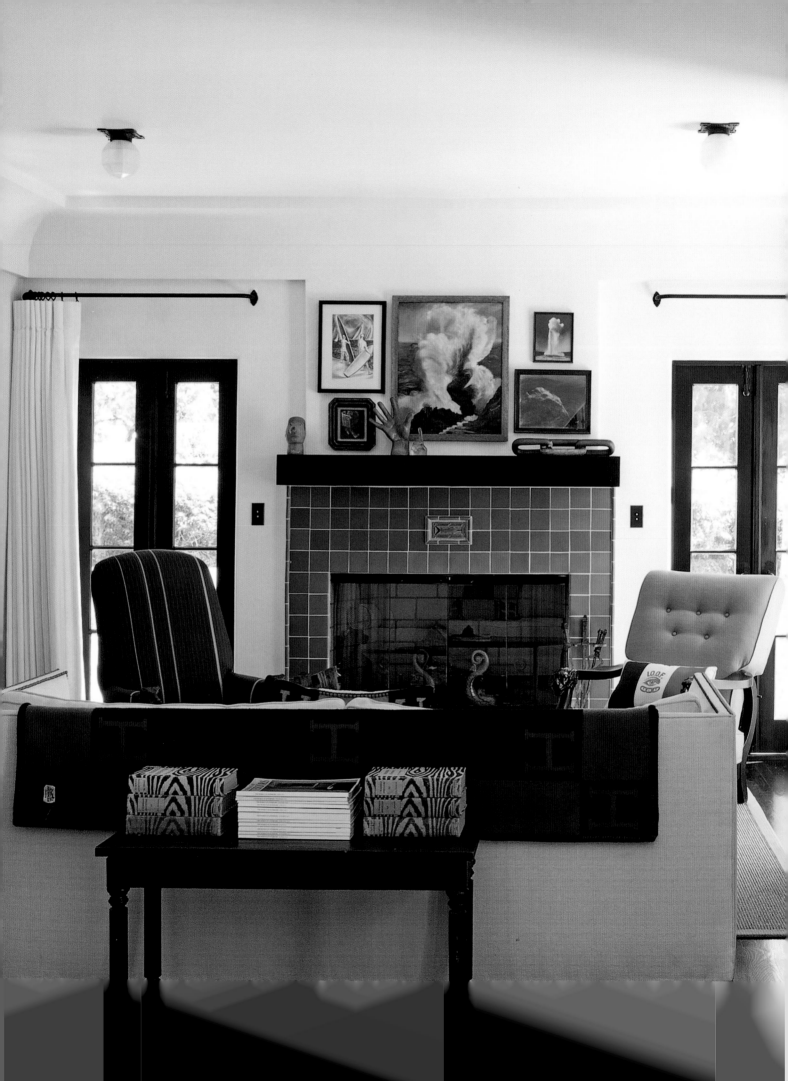

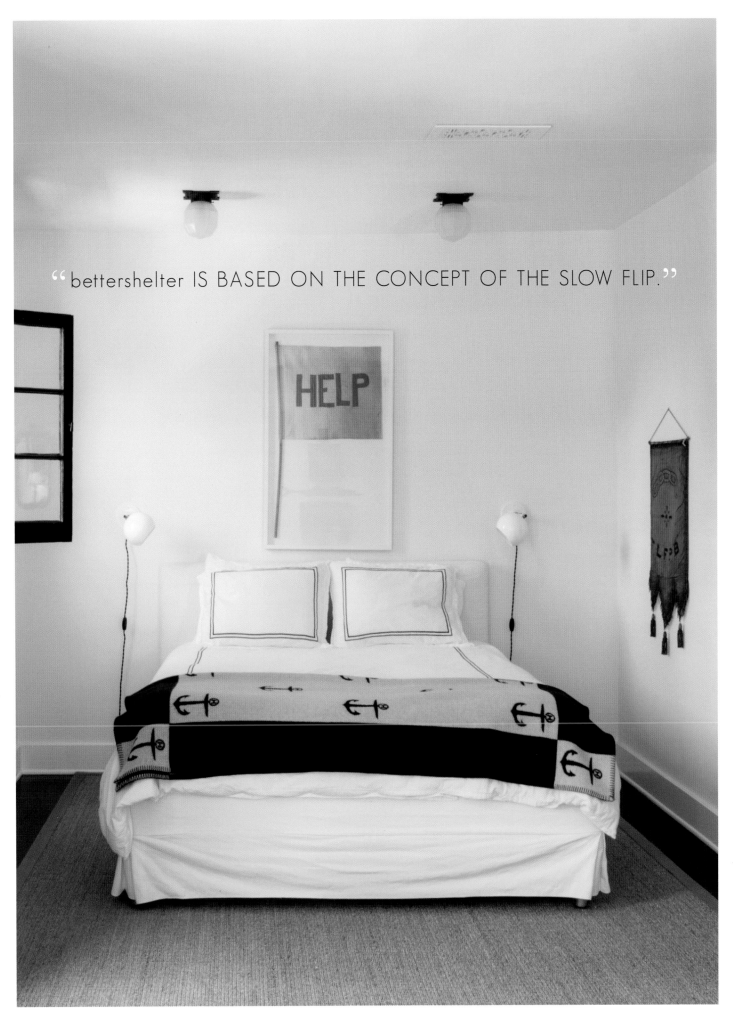

"bettershelter IS BASED ON THE CONCEPT OF THE SLOW FLIP."

JULIUS SCHULMAN'S FAMOUS PHOTOGRAPHY OF THE STAHL HOUSE, ONE OF THE CASE STUDY HOUSES, BECAME AN ICON FOR THE CALIFORNIA MID-CENTURY MODERN AESTHETIC.

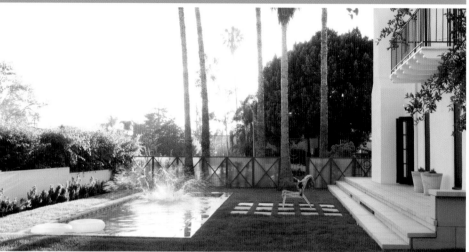

NOTABLE MODERNIST ARCHITECTS THAT HAVE SHAPED THE LOOK OF LOS ANGELES ARE RICHARD NEUTRA, JOHN LAUTNER, RUDOLPH SCHINDLER, AND FRANK LLOYD WRIGHT.

HOME OF AMERICAN MODERNIST FURNITURE, INDUSTRIAL, AND GRAPHIC DESIGNERS, CHARLES AND RAY EAMES.

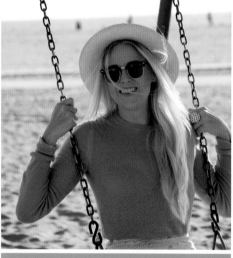

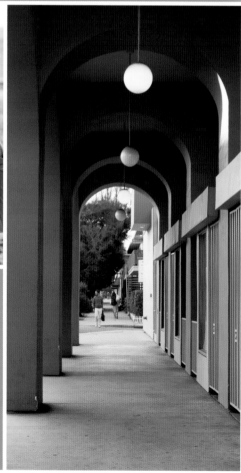

THE SOUTHERN CALIFORNIA SURF AND SKATE CULTURES HAVE INFLUENCED FASHION, ART, FILM, AND MUSIC AROUND THE WORLD.

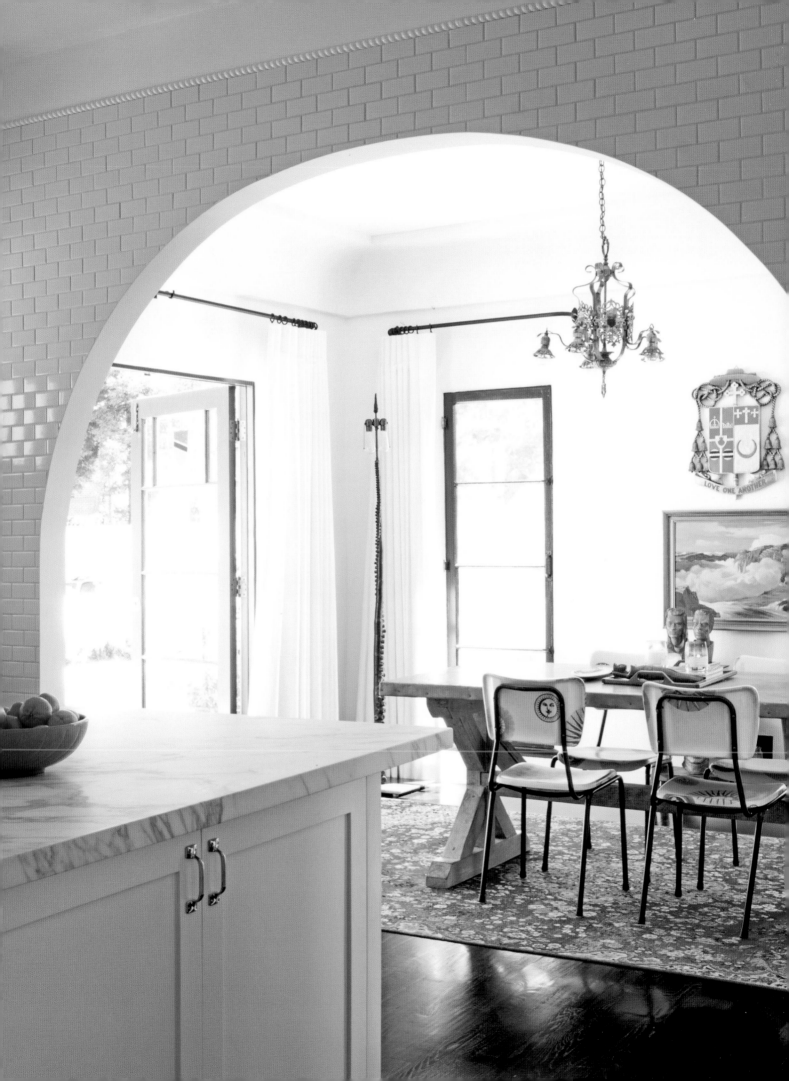

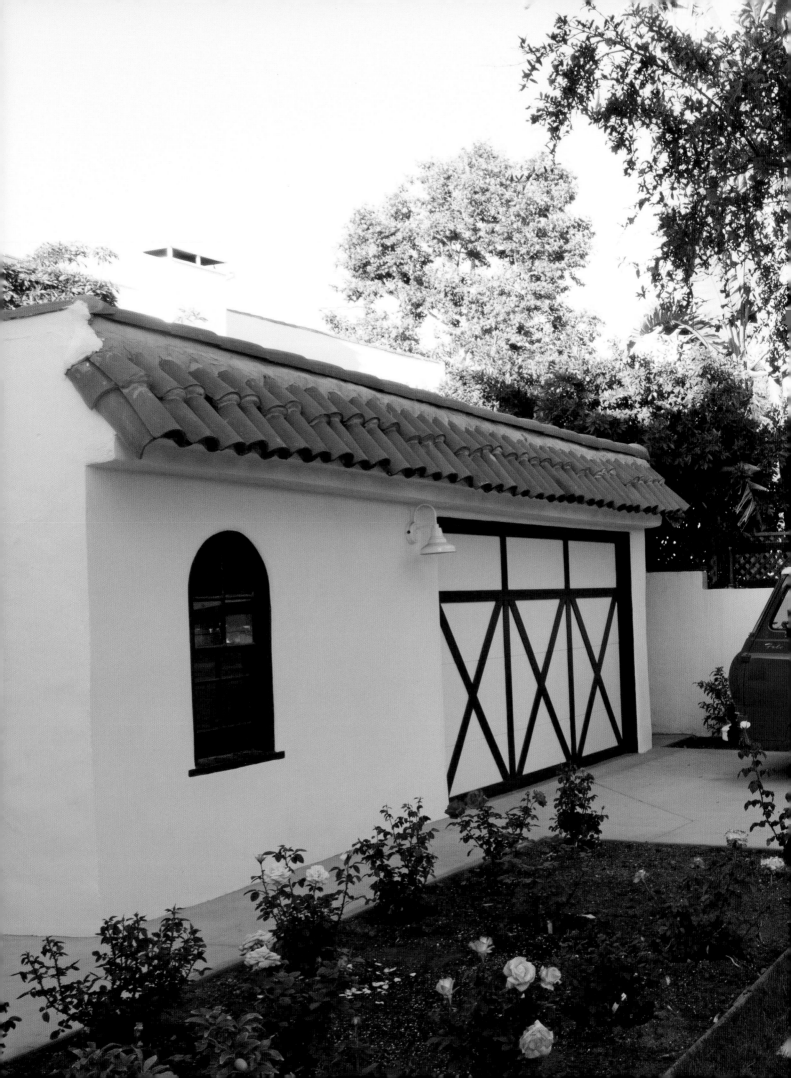

MILAN
ITALY

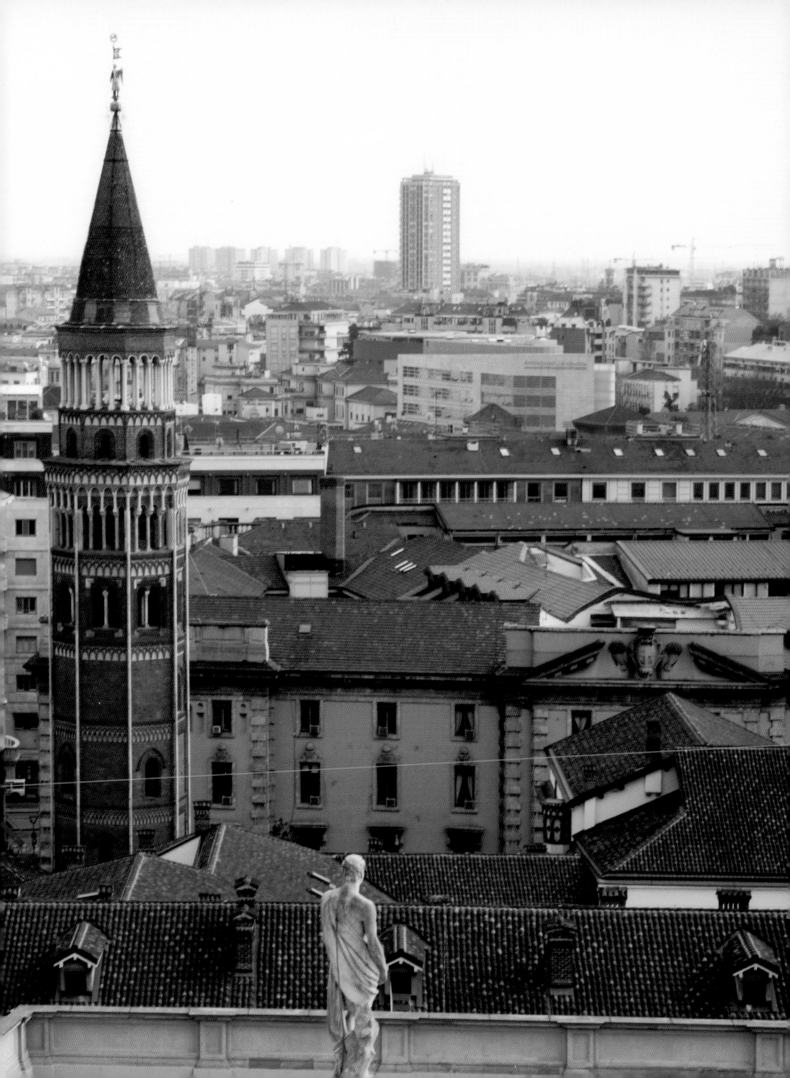

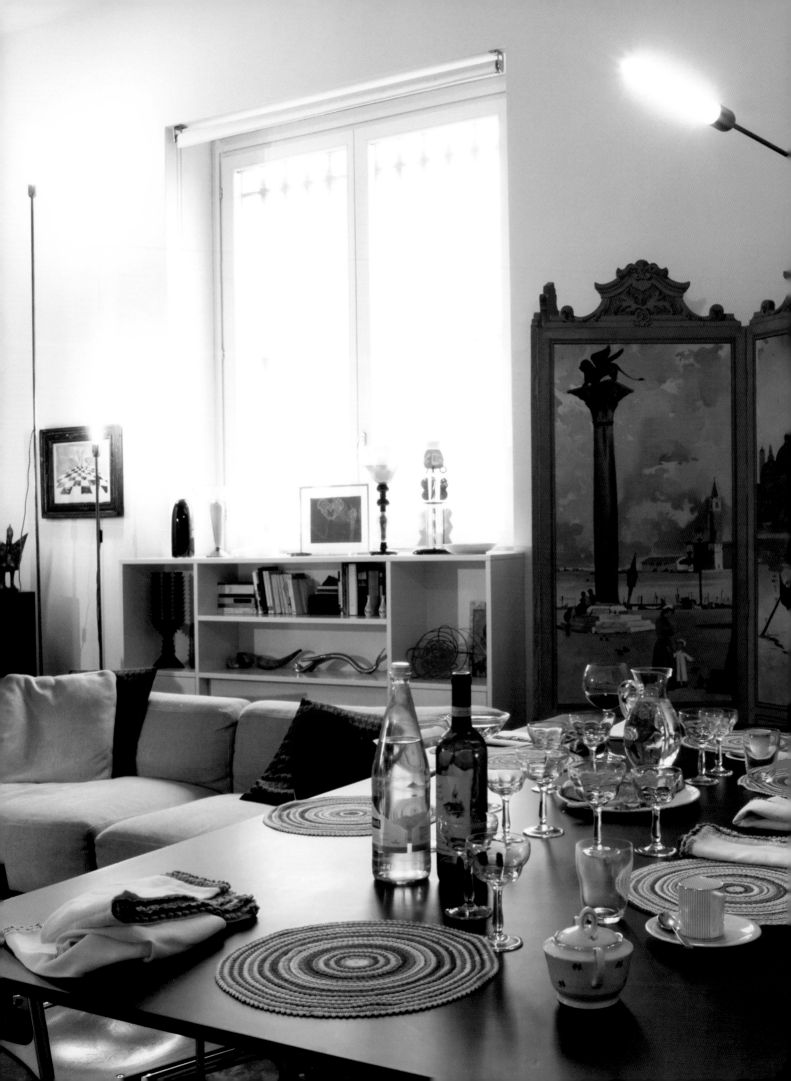

ALBERTO BIAGETTI DESIGNER
LAURA BALDASSARI ARTIST

Designer Alberto Biagetti and artist Laura Baldassari work together to create imaginative, often whimsical, objects, furniture, interiors, and installations in their partnership, Atelier Biagetti. From the moment they met, they were exchanging ideas about each other's work. Collaborating to produce different and challenging projects, they each bring the best of their own "different ways of thinking" with their individual backgrounds in design and art, respectively. Atelier Biagetti's very modern and unusual conceptual design approach merged with the excellence of Italian artisanship makes for a winning combination. They sometimes get strange responses from the traditional artisans, but they truly enjoy producing provocative work.

Atelier Biagetti is a small design studio where each installation, interior, or piece of furniture is "made-to-measure." One of their recent collections, "Body Building," was on the cover of *Wallpaper* Magazine and debuted at the Milan Furniture Fair (Salone del Mobile). Its look is appropriated from typical gym equipment, then reinterpreted as stylish and playful furniture pieces. Some of the other Atelier Biagetti designs include a glass table with brass, copper, wood, and plastic laminates, and hand-caned wooden chairs and a hand-sculpted sofa in high-density Styrofoam from their collection, "One Minute Ago"—everyday objects imbued with a sense of grandeur by fusing industrial and natural materials. Their interior design

work includes the headquarters of the online lifestyle store, YOOX Group Milano/Bologna, the Flagship store in Milan for Venini, the handmade Murano glass company, and their own private residence attached to their studio.

Alberto Biagetti was born in the town of Santarcangelo di Romagna in Emilia-Romagna, Italy. His father was a businessman and a collector of design pieces who passed on his positive attitude that anything is possible to his son, Alberto. Laura was born in the northern Italian city of Ravenna and grew up in a creative environment with a mother who was a painter. Biagetti and Baldassari both believe that being born, raised, and living in Italy is a great privilege that has given them a specialized perspective of art and design. Italy is steeped in layers of undeniable history, culture, and artisanal traditions that are integral to their very beings. As Alberto says, "Italians are creative and vibrant, they think on their feet and improvise. Sometimes they are a bit disorganized, but they always manage to get the job done exceptionally well." With the vast beauty of Italy surrounding Alberto and Laura, they are in constant search of the interesting and the sublime. Working in Milan has given them high standards for design and unique access to master craftsmen. In addition, Milan is set apart from the other major Italian cities because it is more international, industrial, and it is the center for design for the country of Italy.

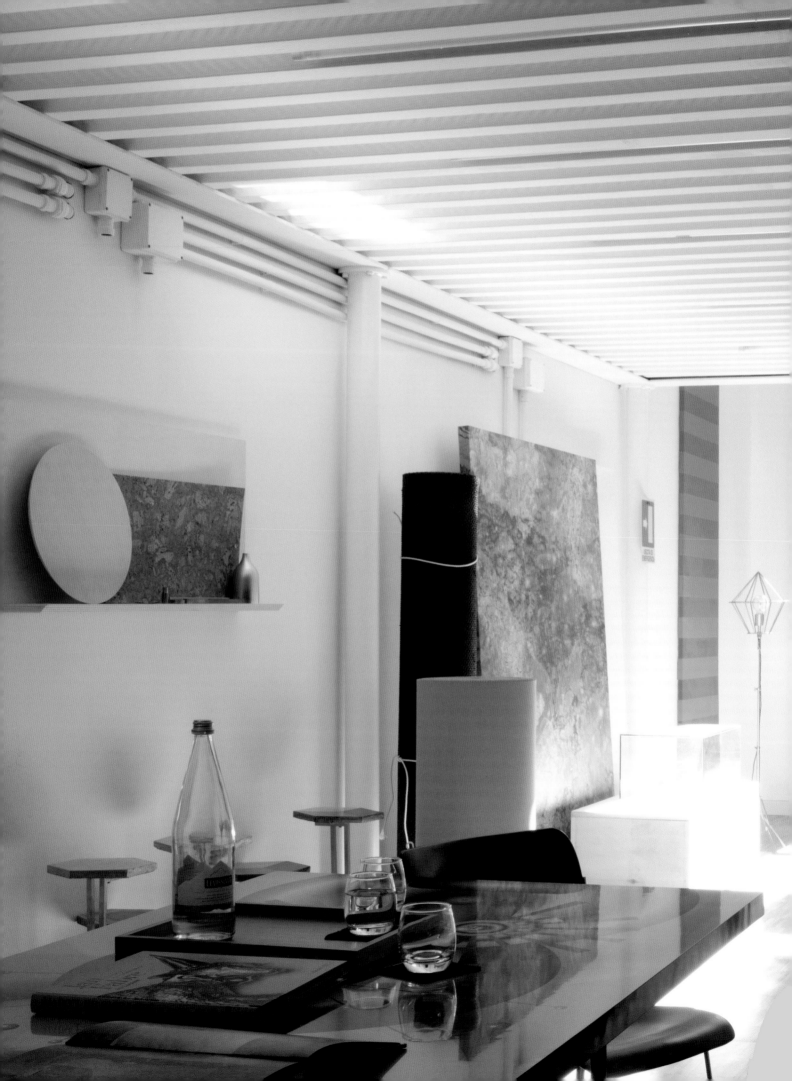

"ITALIANS HAVE VERY HIGH STANDARDS IN DESIGN AND QUALITY, BUT ARE ALSO LUCKY TO HAVE THE ARTISANAL TRADITIONS, MATERIALS, MICROCULTURES THAT CHANGE FROM REGION TO REGION... THE PEOPLE, THE HISTORY, ALL CONCENTRATED AND CONDENSED IN ONE COUNTRY WHICH IS WHAT MAKES THE IDEA OF 'MADE IN ITALY' SO UNIQUE."

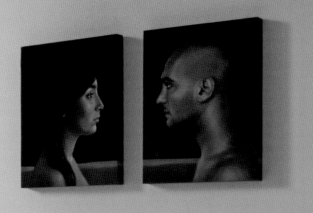

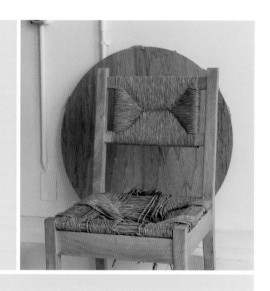

THE MILAN FURNITURE FAIR (SALONE INTERNAZIONALE DEL MOBILE) IS THE LARGEST AND ONE OF THE MOST INFLUENTIAL TRADE FAIRS OF ITS KIND IN THE WORLD.

NOTABLE MILANESE FURNITURE DESIGNERS INCLUDE THE HERALDED AND VISIONARY ARCHITECT AND INDUSTRIAL AND FURNITURE DESIGNER GIÒ PONTI AND ARCHITECT AND PRODUCT DESIGNER MARIO BELLINI.

THE WORLD'S OLDEST BICYCLE MANUFACTURER STILL IN EXISTENCE, BIANCHI BICYCLES, WAS FOUNDED IN MILAN.

ON THE WALL OF THE REFECTORY OF THE SANTA MARIA DELLE GRAZIE CHURCH IS THE MONUMENTAL 15TH CENTURY MURAL, *THE LAST SUPPER*, BY LEONARDO DA VINCI.

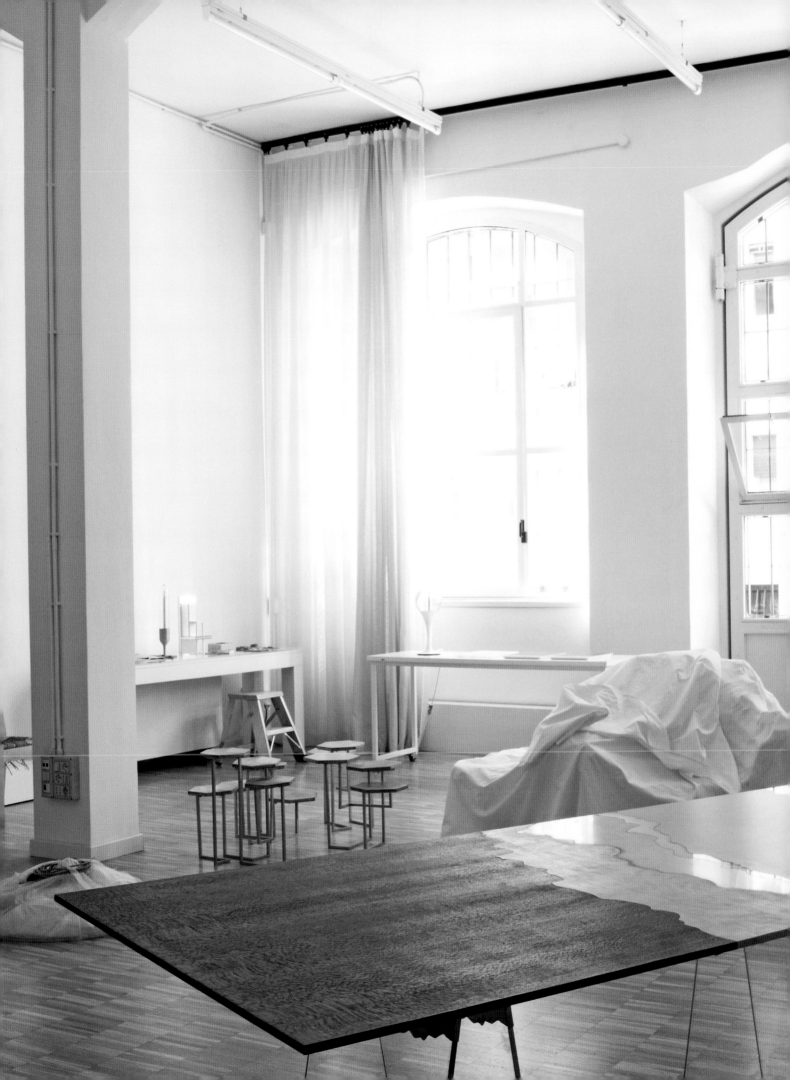

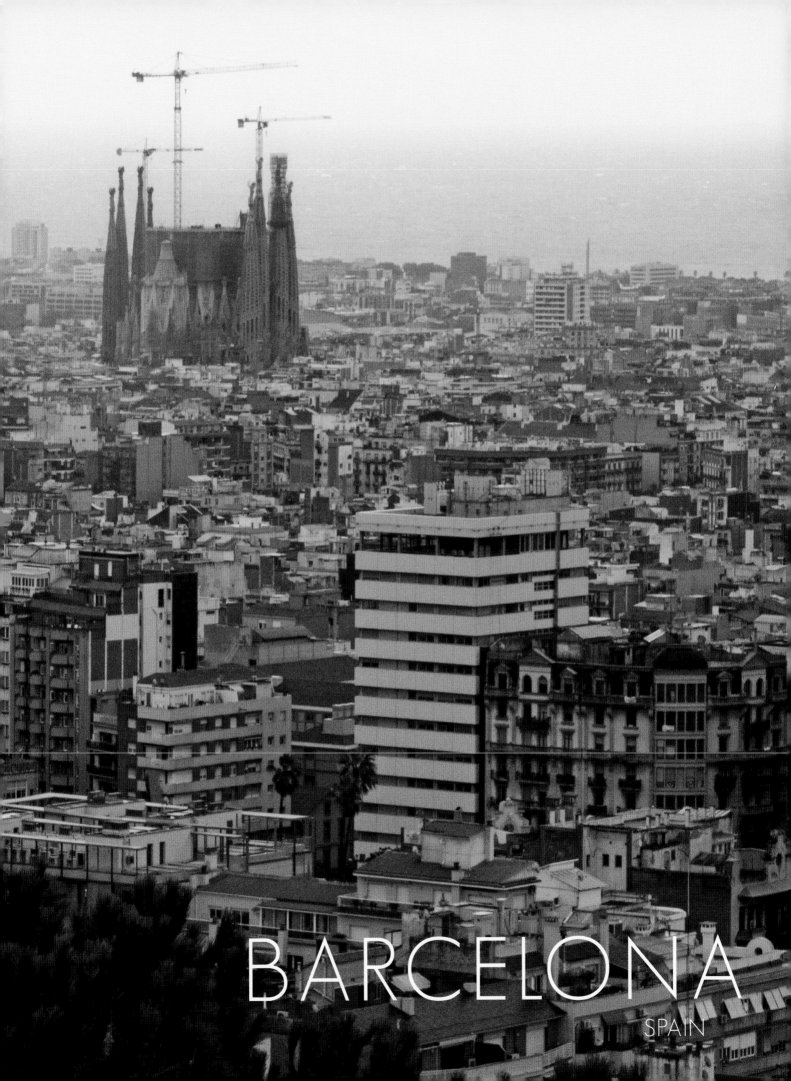

BARCELONA

SPAIN

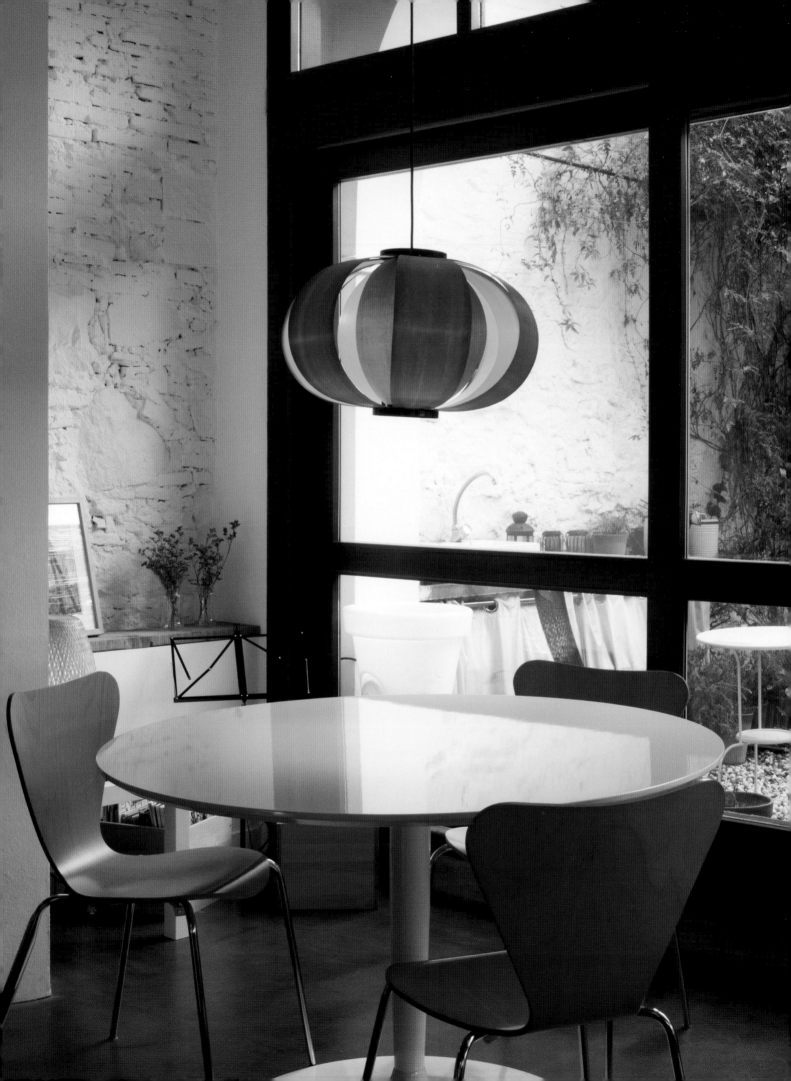

CARLES ENRICH GIMÉNEZ
ARCHITECT & URBAN DESIGNER

Carles was born and raised in Barcelona, but traveled a lot with his scientist parents while growing up. When he was 13 years old, he spent one year living in San Francisco, which gave him a greater perspective on the urban landscape while learning from personal experiences. Other than his time in San Francisco and a brief period for his studies, he has lived in Barcelona his entire life.

Carles has built a career combining his urban and architectural research with his professional work. He collaborated with the Department of Urbanism at the Barcelona School of Architecture (ETSAB) and was a visiting professor at the Massana School of Art and Design in Barcelona. Carles feels very fortunate to have built a number of houses and buildings in his career and he now specializes in the remodeling and refurbishment of old apartments because of his interest in existing structures that have a history to them. Carles' recent project involved the reuse and segregation of an old kindergarten by remodeling the space and creating two separate apartments.

The inspiration for the design of Carles' own home derived from his fascination with Northern Europe, especially the rehabbed old factories and squatter houses in Berlin or London, as well as his interest in Scandinavian design. His apartment in the Gracia district of Barcelona is a converted old laundry room. Carles was challenged by rethinking the space

and how to maximize it by taking inspiration from apartments in Tokyo, where the lack of square footage forces creative space solutions. Also looking to the open and inviting use of a patio as additional living space in Mediterranean culture, he created a similar patio leading out to another structure which houses his studio in the back.

Geographically, Barcelona is a small city between two mountains, two rivers, and the Mediterranean Sea. For Carles, being an architect in this unique landscape provides him a particular inspiration for his work. He is especially intrigued by the urbanism in the city and how it is growing beyond its natural borders. The Eixample district of Barcelona was laid out by visionary urban planner Ildefons Cerdà who thoughtfully planned for an organized city with a strict grid pattern. Cerdà considered many factors for the urban plan such as traffic, sunlight, and ventilation. The design of his octagonal blocks included the widening of streets at intersections for greater visibility and more open spaces for pedestrians and drivers alike.

Beyond its rich architectural history that also includes master Catalan architects Antoni Gaudí and Josep Jujol, Carles believes that Barcelona is still a city of opportunities and is further inspired by an art scene that is considered to have the finest talent in Europe, along with a youthful and vibrant underground scene.

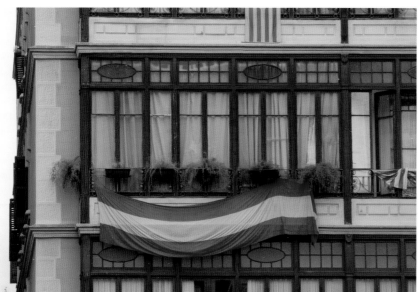

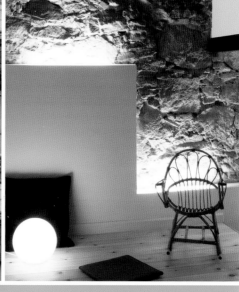

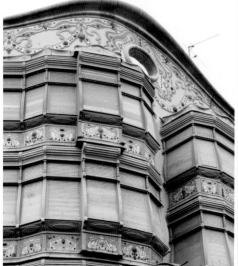

HOME OF MOST OF THE WORKS OF MODERNIST CATALAN ARCHITECT ANTONI GAUDÍ, INCLUDING HIS MASTERPIECE, THE ICONOCLASTIC SAGRADA FAMILIA, THE MOST-VISITED MONUMENT IN SPAIN.

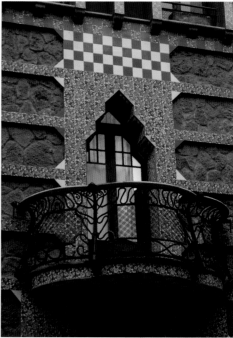

BARCELONA IS THE ONLY CITY TO RECEIVE THE RIBA ROYAL GOLD METAL FOR ARCHITECTURE.

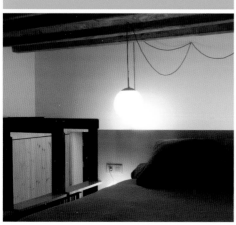

BARCELONA IS WHERE PABLO PICASSO SPENT HIS FORMATIVE YEARS AS AN ARTIST AND WHERE SALVADOR DALÍ HELD HIS FIRST SOLO EXHIBITION.

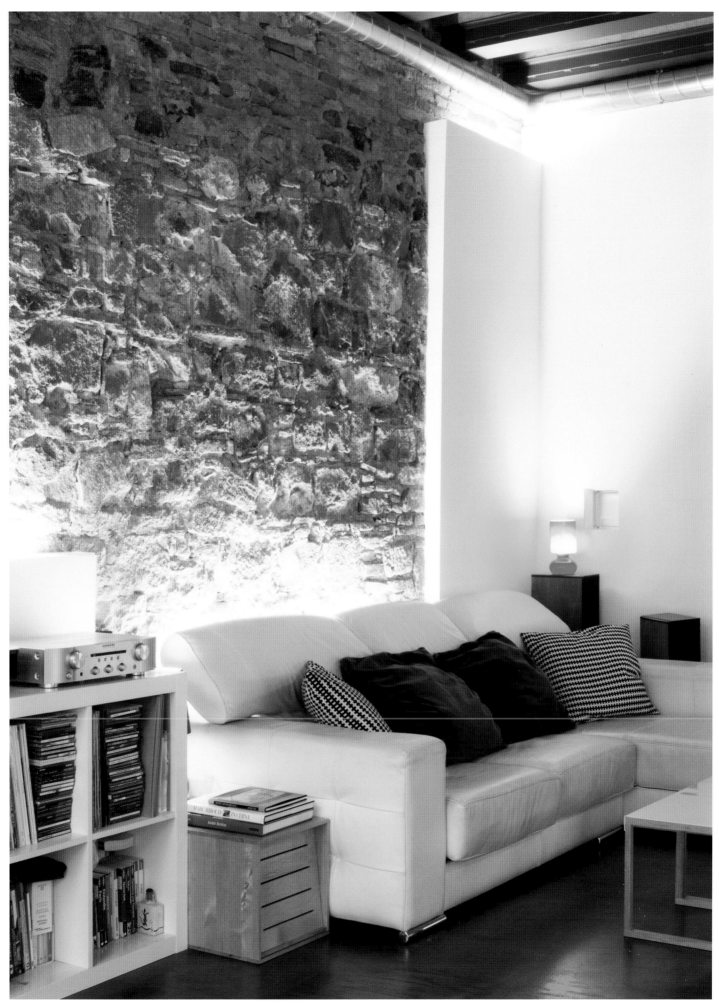

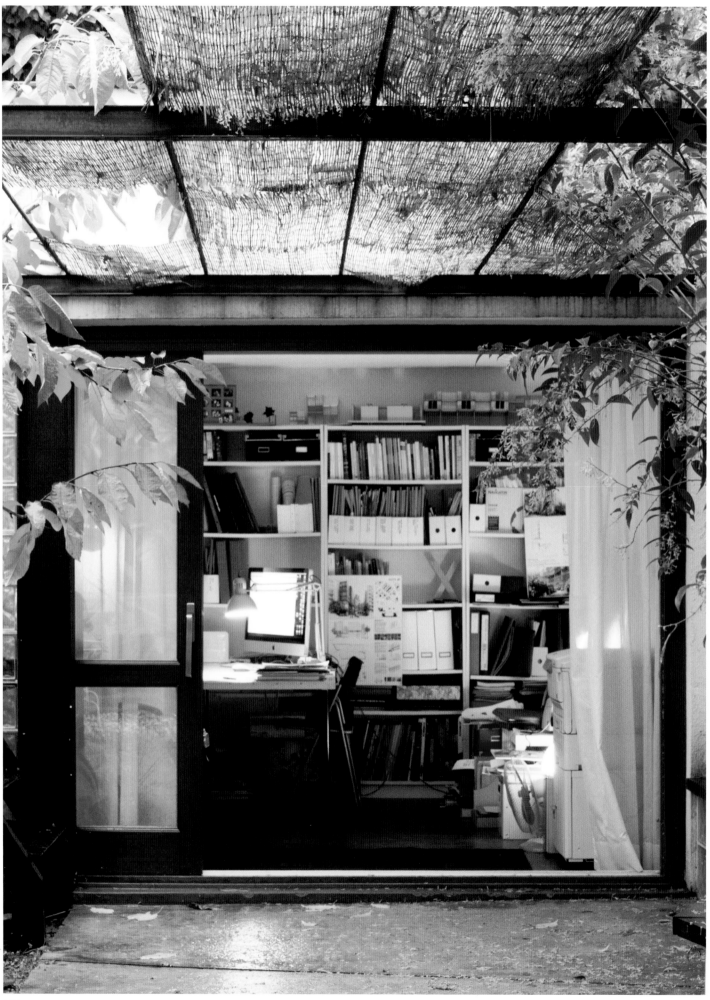

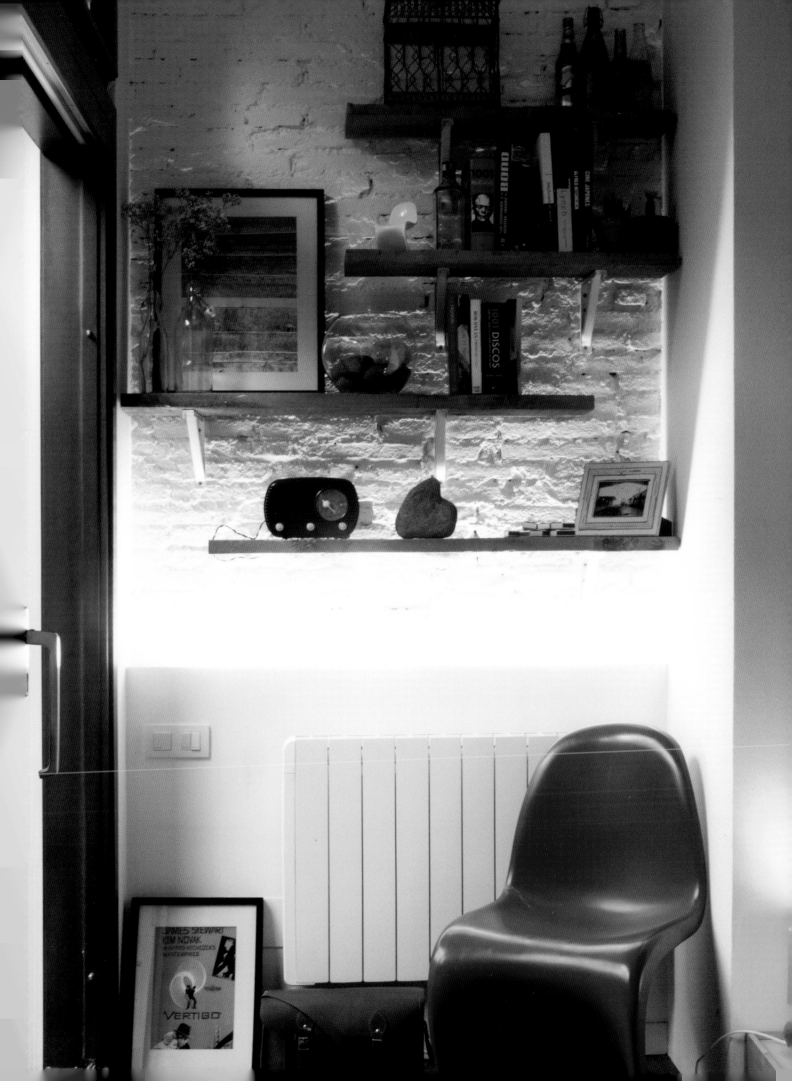

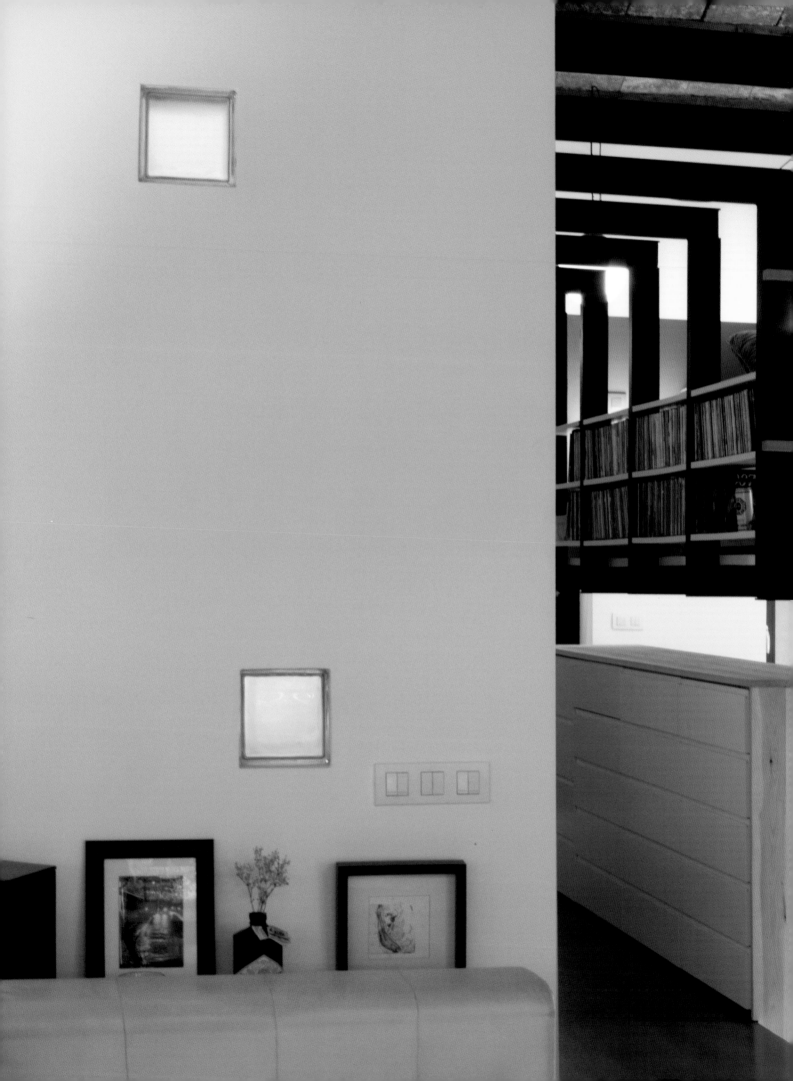

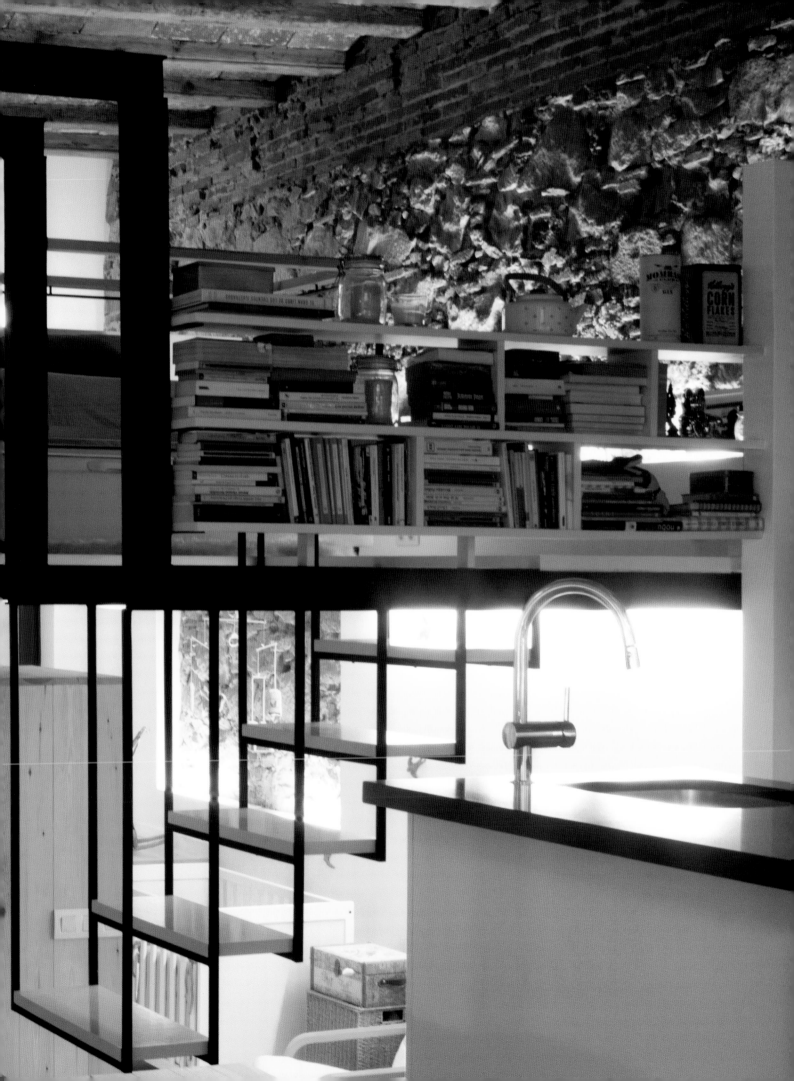

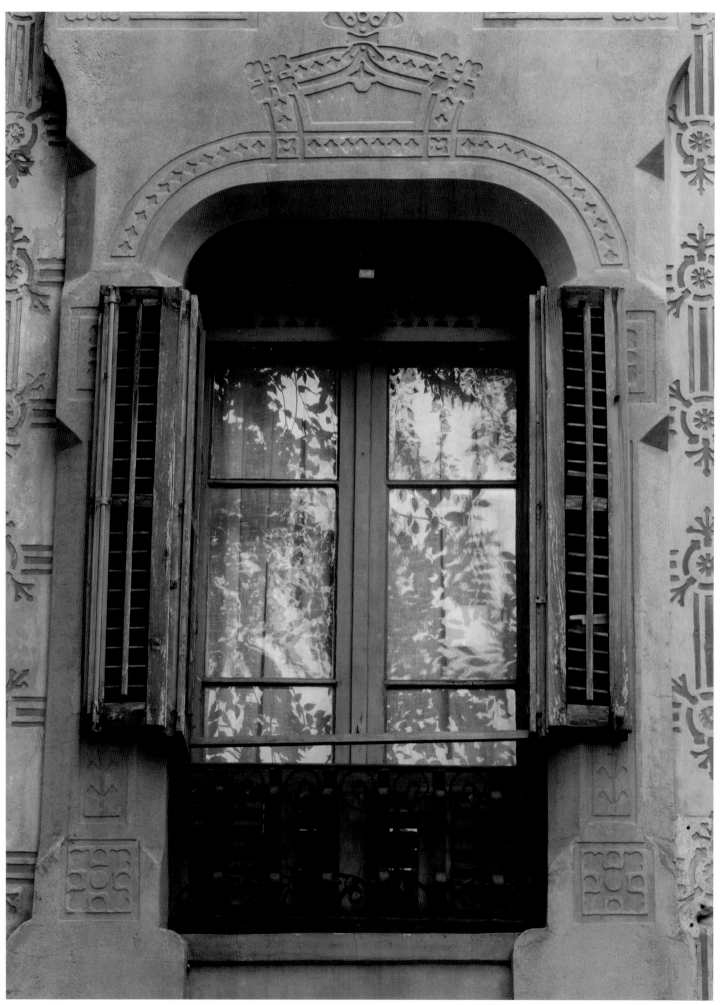

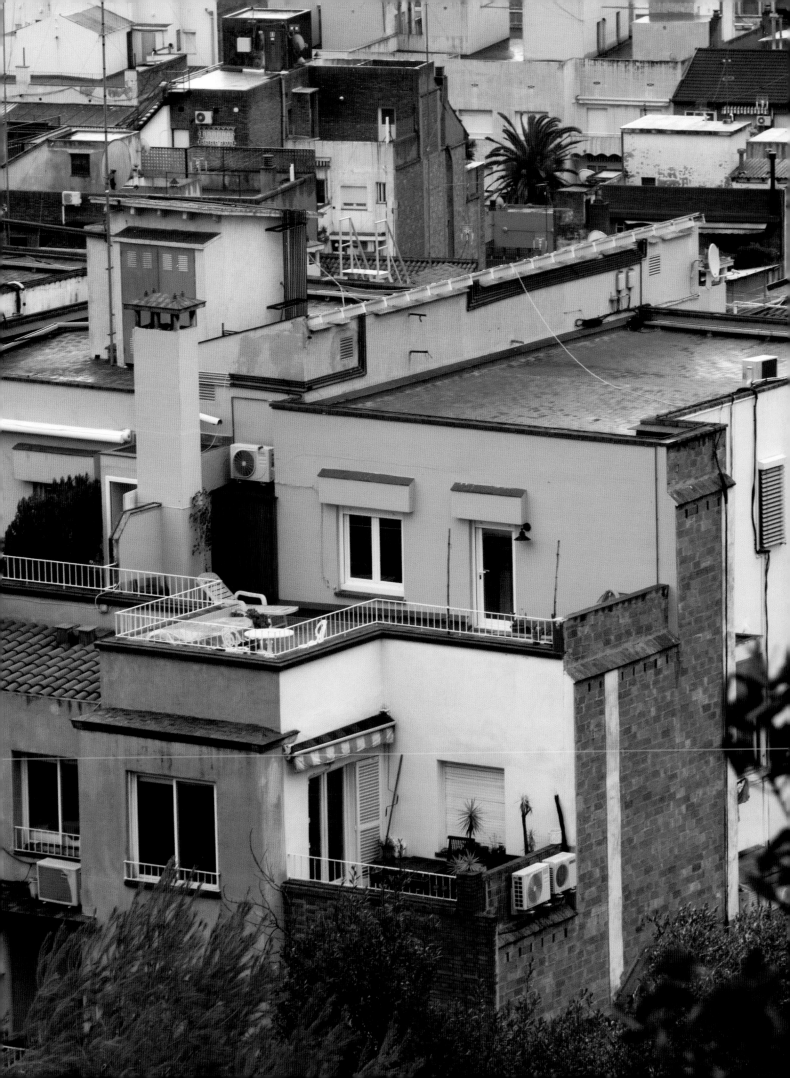

BERLIN

GERMANY

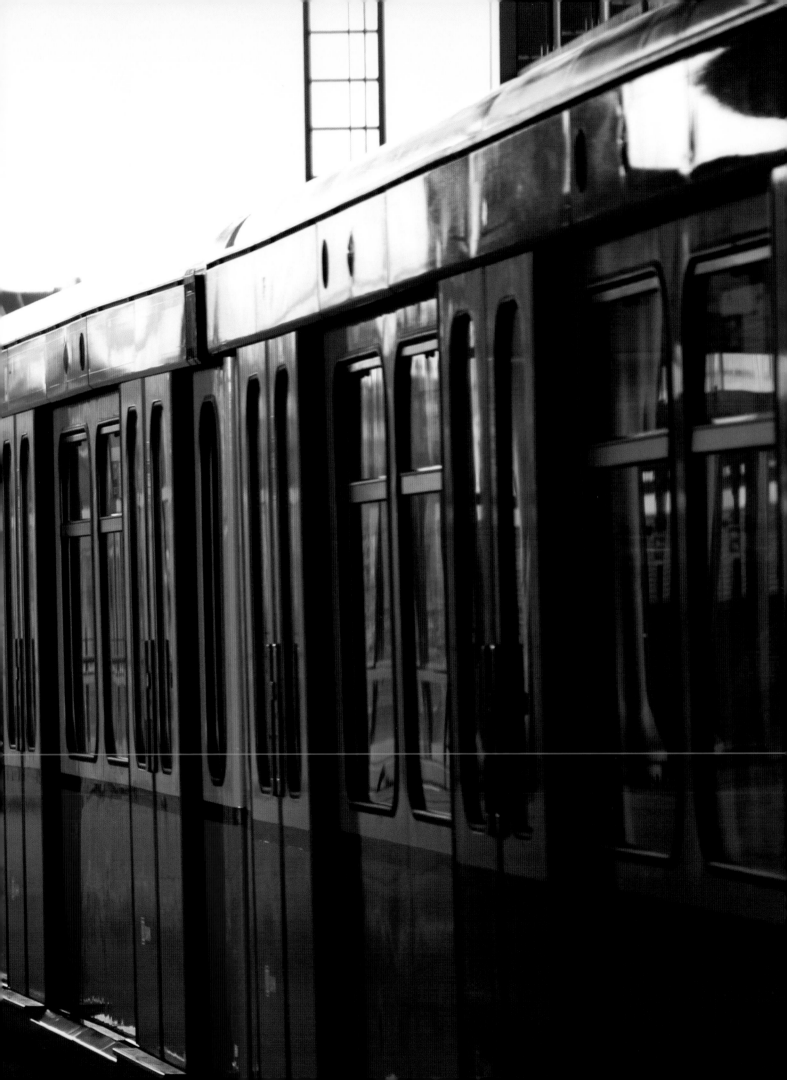

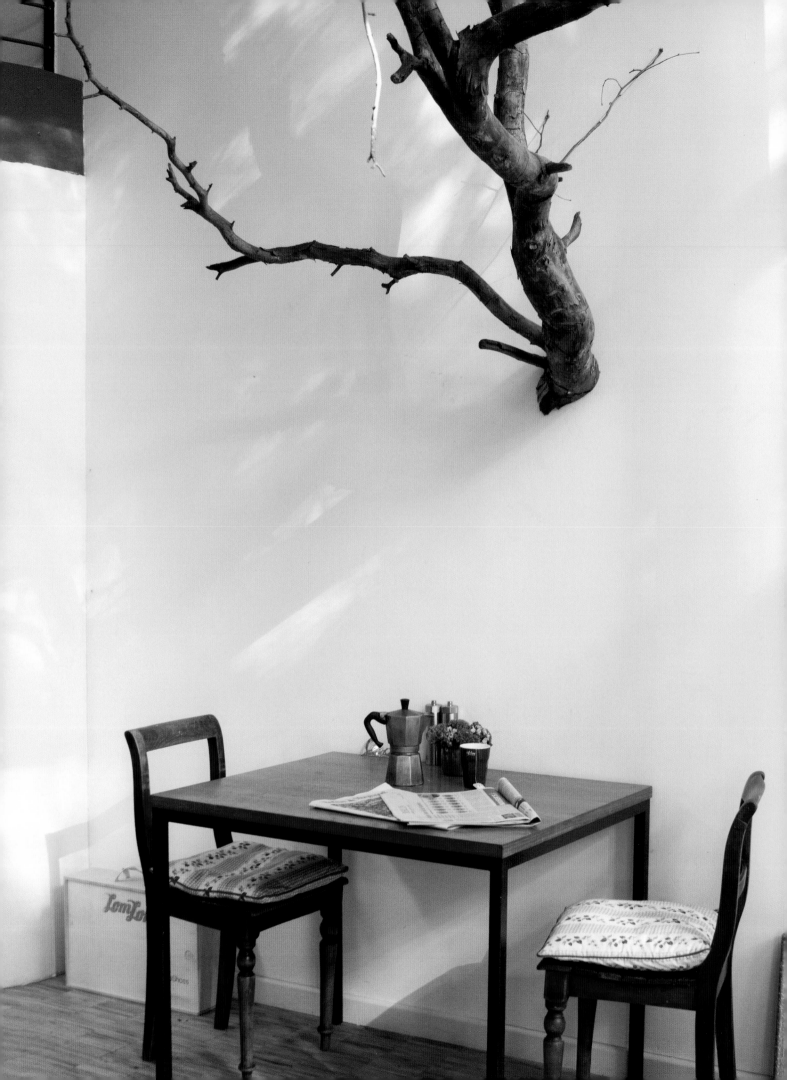

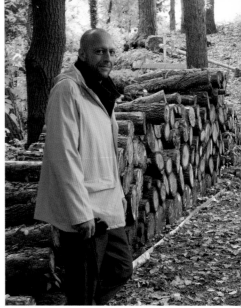

MICHAEL KRAUSS
BRAND CREATOR

Michael Krauss was born in the southern part of Germany. He initially studied graphic design and then studied at one of the most internationally renowned film schools, Film Academy Baden-Württemberg in Ludwigsburg, Germany. He has lived in the United States and also in the mountains of Switzerland. Michael worked for design agencies worldwide before starting his own brand company in Berlin.

He lives in a former school in the northern part of Berlin in a very lush and green section of the city—something you definitely wouldn't expect from the industrial and gray city. The Berlin Wall actually went through his garden. Living in the forest in Berlin has inspired his style of living and his work, as the decor of his home not only feels natural, but is actually authentically organic. He found the large branch mounted to the wall in his living room outside. The large glass windows with a view of the lush forest serve as a kind of wallpaper or texture that becomes a part of the interior of the home.

Michael has created many different products and brands through interesting means. For example, while out sailing he found boat fenders and wondered what other use they could have and created bags out of the fenders. Michael also owns the company Lom Loms, which sells 100% sheep's wool boots with no seams, buckles, buttons, or accessories. His latest company is Spreeliebe Koch & Genussunternehmen Berlin, which

focuses on people's passion for cooking and tasting. The company sells kitchen and food items from Berlin and shares recipes that have been passed down from generation to generation.

Although Michael has lived in other countries around the world, including the U.S. and Switzerland, he is most at home in Berlin and feels that the exciting re-birth the city has undergone is due to the international attention it has gained since the fall of the Berlin Wall in 1989. The fall of the Wall has created a cultural explosion in the city attracting artists and designers from around the world. It is the ideal breeding ground for creativity because of its subculture and inexpensive cost of living compared to other major cities in Europe.

With people from all over the world coming to Berlin to live, the process begins where money arrives and investors see potential in the city. The old desolate lofts that became the artistic face of Berlin are being bought by opportunists and the artists are slowly being pushed out. It can be compared to the similar situation that happens in many cities that start out as 'emerging' and then at some point cross over to mainstream. Still, today, Berlin remains relatively inexpensive and a great place for the artistic community as the re-unified city tries to find a balance between the raw and industrial lifestyle, a modern aesthetic, and newly liberated way of life.

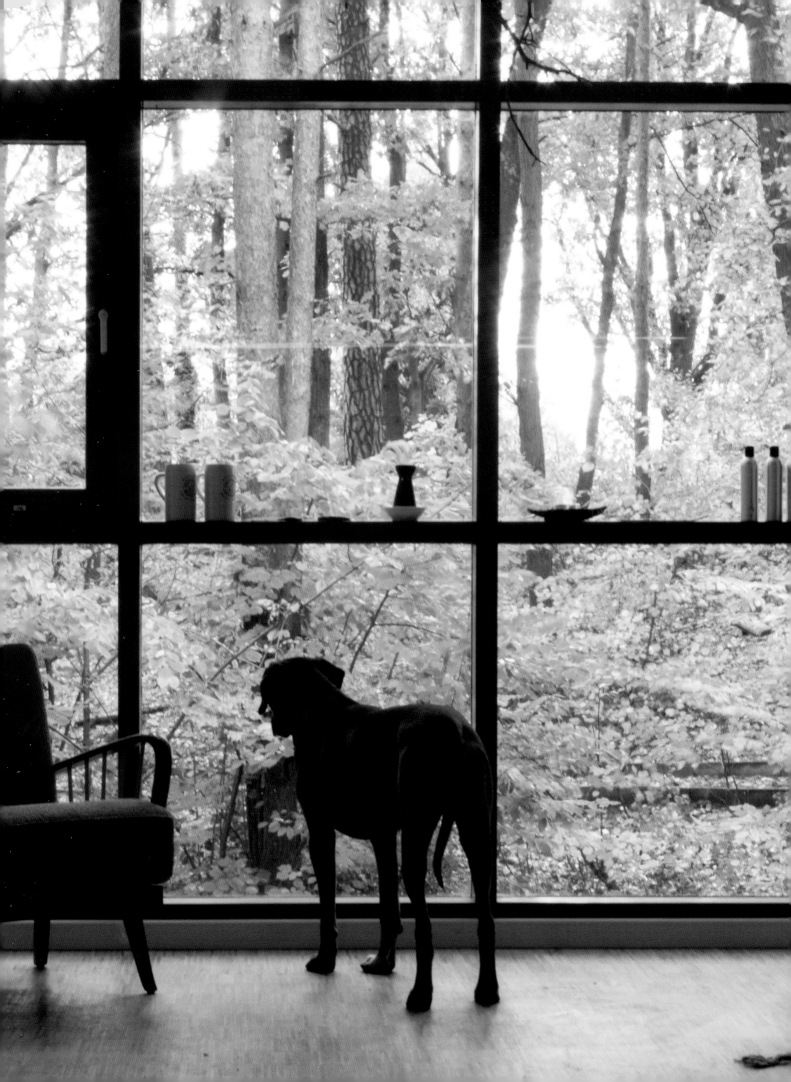

"PEOPLE FROM ALL OVER THE WORLD ARE COMING TO BERLIN; NOT ONLY CREATIVES BUT ALSO A MULTICULTURAL MELTING POT OF MUSICIANS, WRITERS, AND BUSINESS PEOPLE."

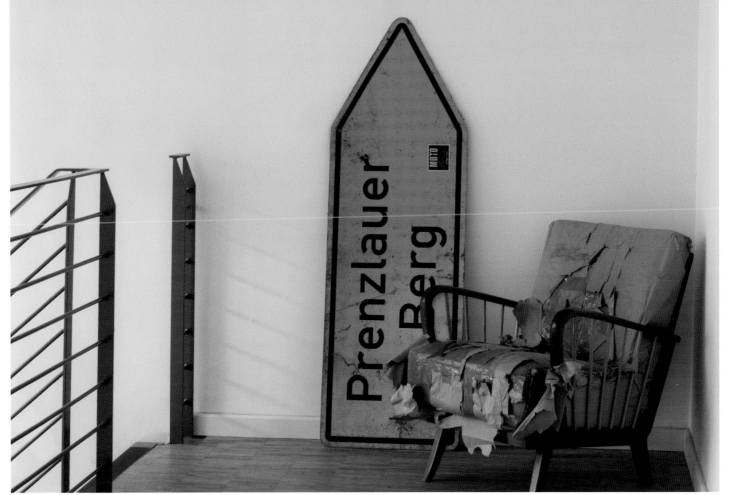

BERLIN IS FAMOUS
FOR ITS ARTIST
SUBCULTURE THAT
INCLUDES SQUATTING
IN ABANDONED
HOMES AND LIVING
IN CONCRETE
BUNKERS.

NOTABLE BERLIN RESIDENTS INCLUDE THE PIONEERING
MASTERS OF MODERN DESIGN, MIES VAN DER ROHE
AND WALTER GROPIUS, WHO WERE FOUNDERS OF THE
BAUHAUS SCHOOL.

THE BERLIN TV TOWER
IS ONE OF THE
TALLEST FREESTANDING
STRUCTURES IN THE
EUROPEAN UNION AND
HAS BECOME A SYMBOL
OF GERMANY.

THE EAST SIDE GALLERY IS
A 1.3 KM LONG SECTION
OF THE BERLIN WALL WITH
105 PAINTINGS FROM
ARTISTS AROUND THE
WORLD, REPRESENTING
INTERNATIONAL FREEDOM
AND HOPE.

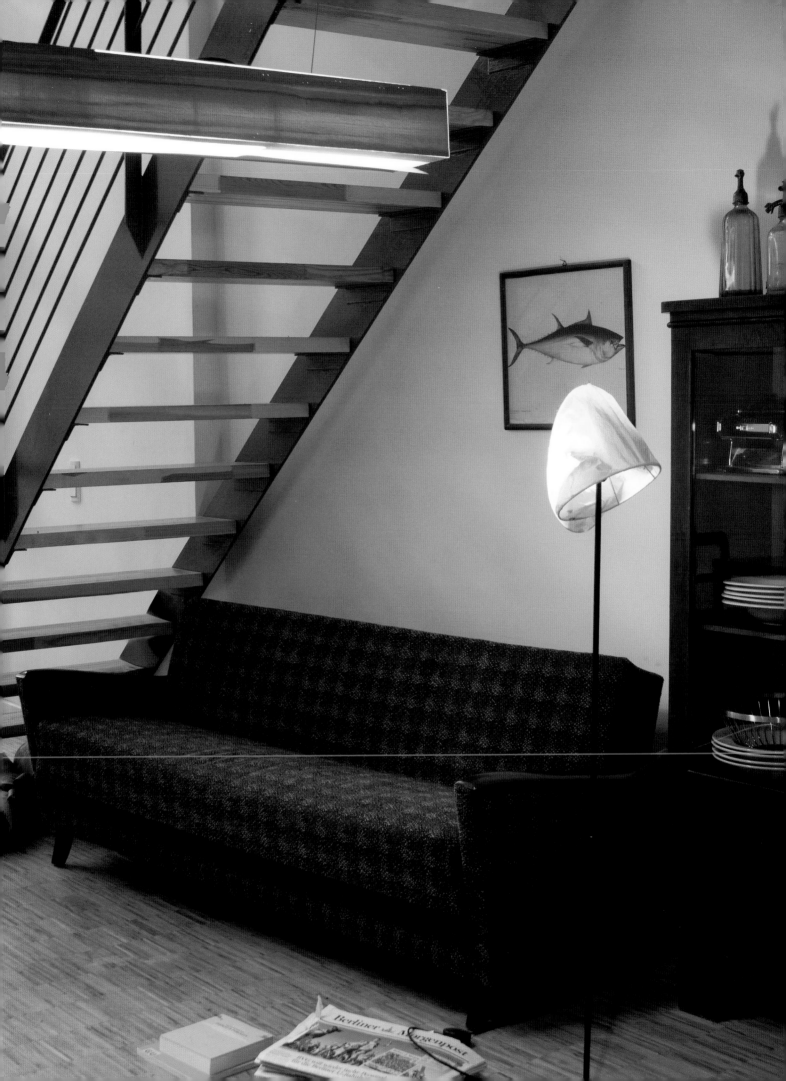

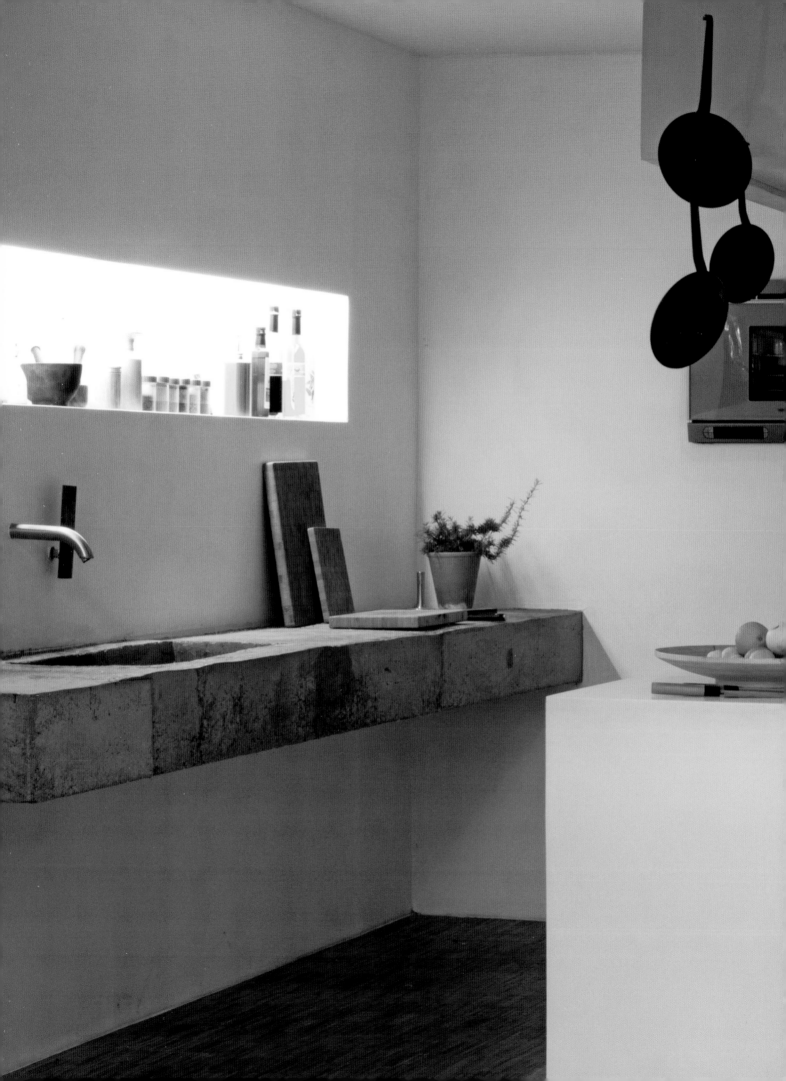

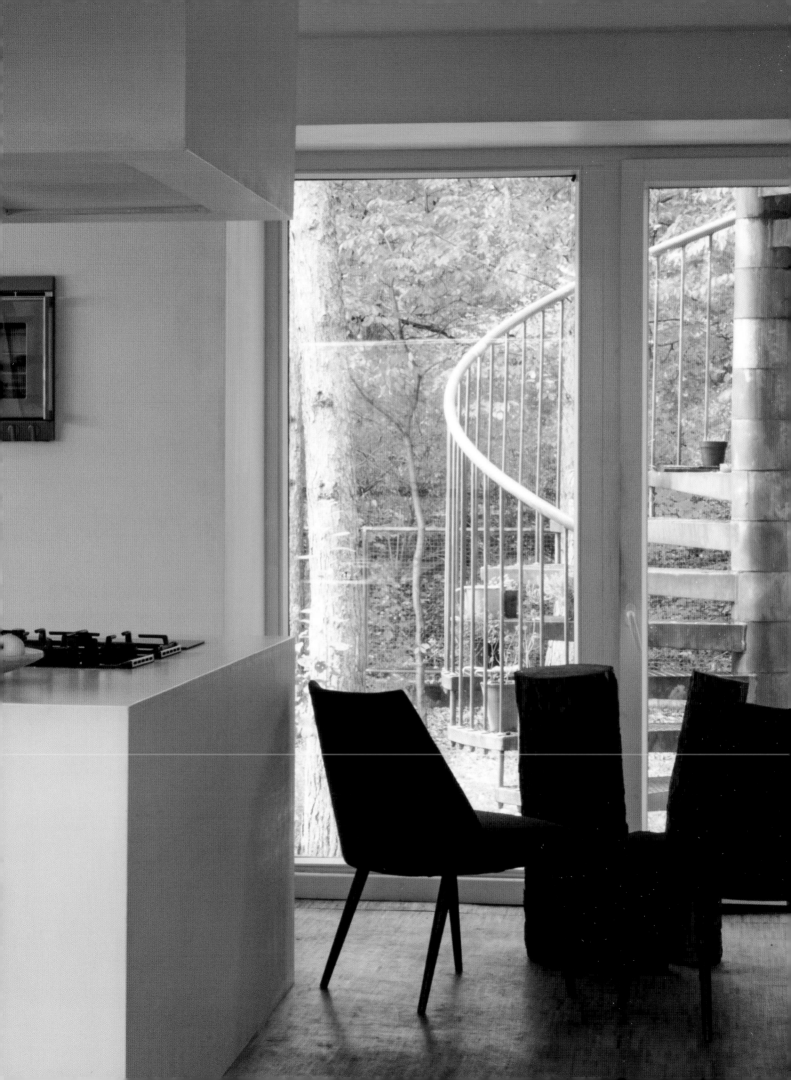

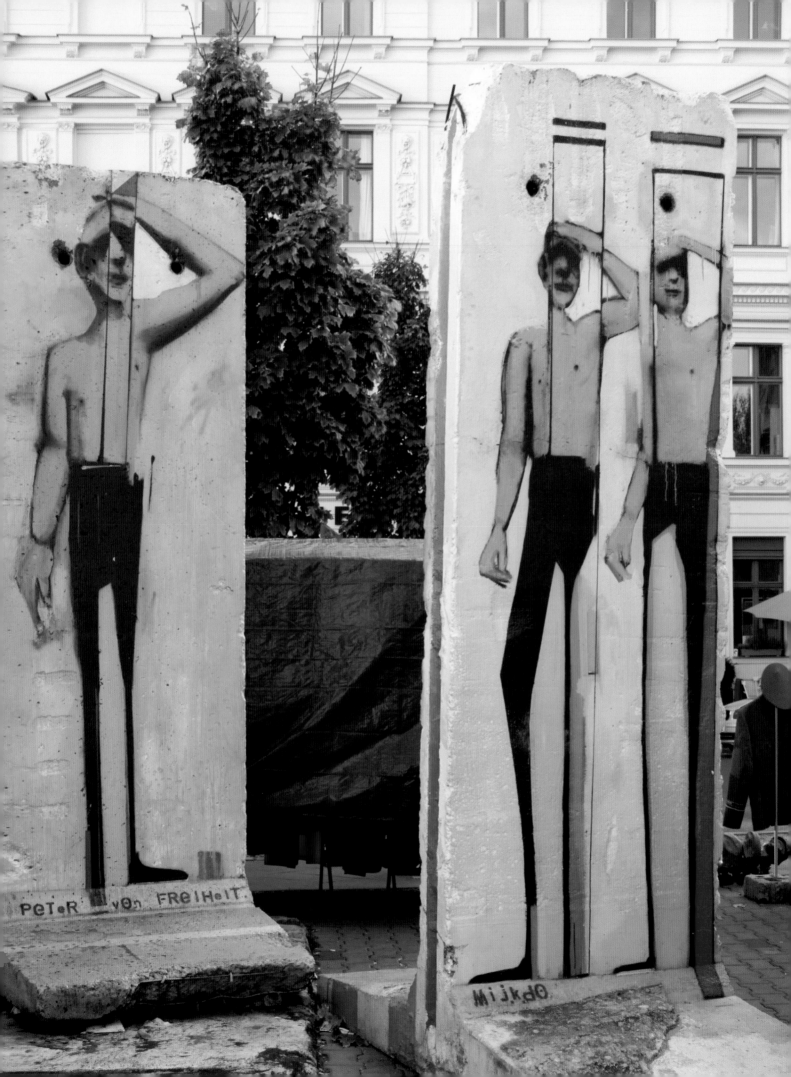

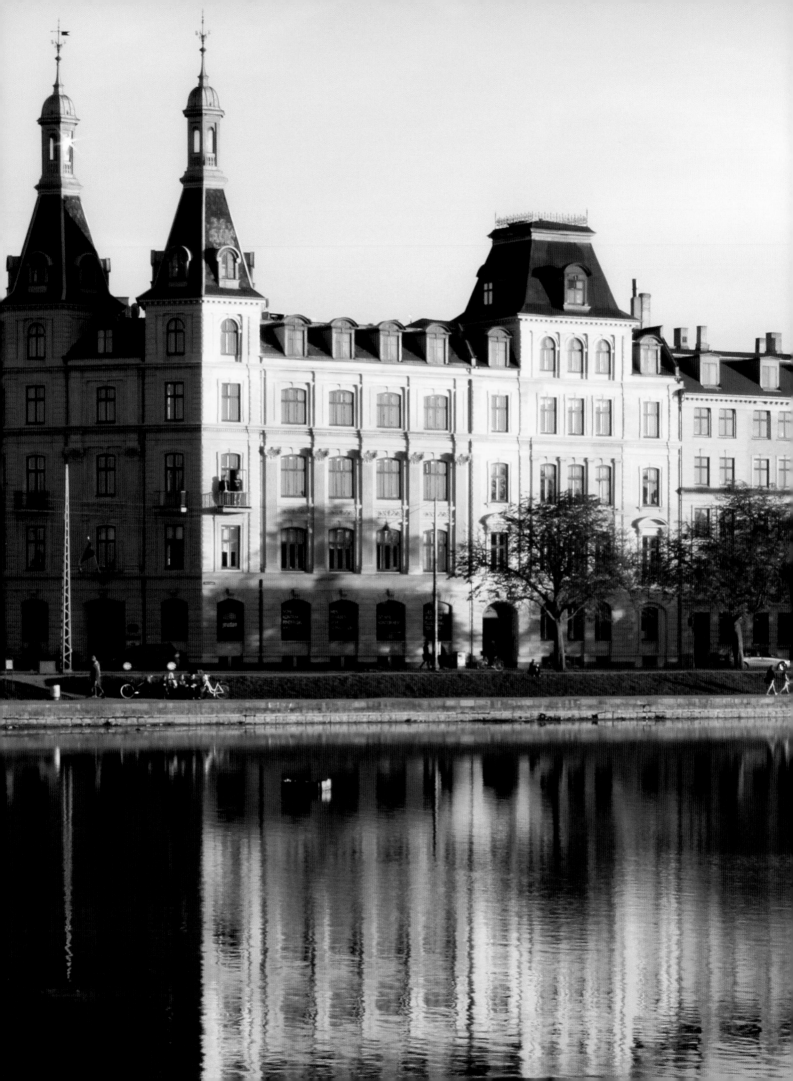

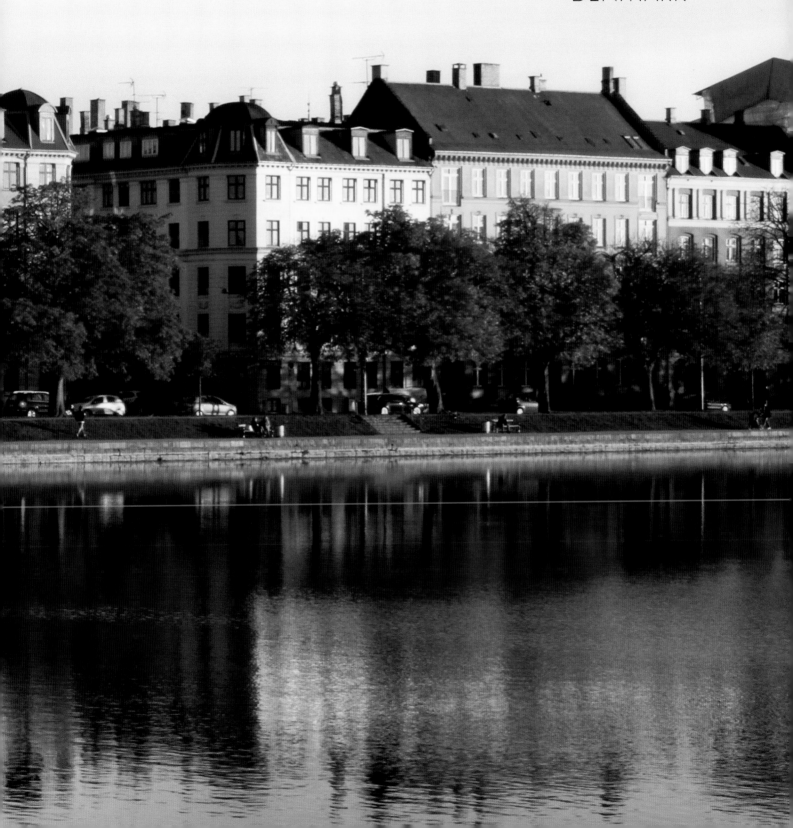

COPENHAGEN

DENMARK

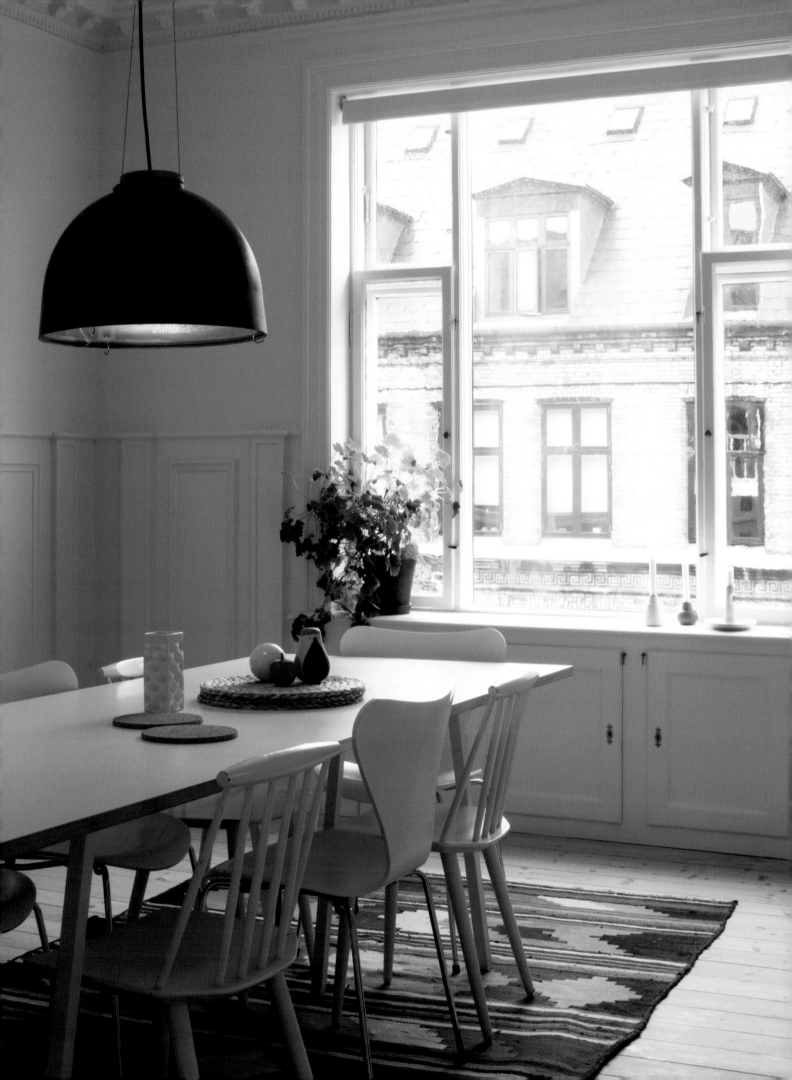

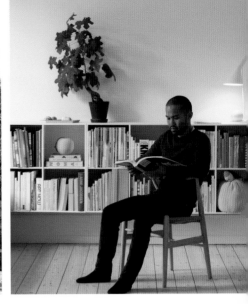

JAN YOSHIYUKI TANAKA
ARCHITECT

Jan was born in Copenhagen to Japanese and Thai parents who encouraged his curiosity for other cultures and living in other parts of the world. He has lived in both the United States and Tokyo for a couple of years each. Being away from Copenhagen made him appreciate all the great aspects of his home city. Jan started an architecture firm with his friends, JAJA Architects, when he returned to live in Copenhagen, and it found great success right from the beginning.

When Jan and his partners at JAJA Architects were students they were shortlisted among 1,176 other proposals for the Stockholm Central Library competition. They received the 4th prize, but it boosted their young egos and was the catalyst to start their architecture firm. This accomplishment will always stand out in their minds. After finishing school they entered many more design competitions with several wins and even more "close ones." Their notable competitions include 3rd prize for their proposal for the Public Library in Daegu Gosan, South Korea, 2nd prize for the National Museum in Oslo, and 1st prize for a green parking house with an active landscape on the roof in Copenhagen. They are currently under construction for 380 housing units in Copenhagen, the transformation of a lighthouse, and a sports hall.

Jan's work takes shape by incorporating inspiration from many different cultures. When he started his studies he was focused on his Japanese roots and was fascinated by the relationship between traditional Japanese architecture and nature. Later on, he was inspired by the pragmatic approach of the Dutch. His partners at JAJA Architects are from Norway and Switzerland, so they offer another perspective for approaching design. Living in Copenhagen— a city whose iconic designers' goal was to create great design for everyone—has really influenced the minimalist approach Jan and his partners take to their projects: seeking to convey architectural ideas with essential means.

Living in Copenhagen provides Jan with a unique experience because it has many of the aspects of a major design city, but it also has a small town feel. He calls Copenhagen an "international town" as it also has some of the world's best restaurants, fantastic architecture, nice bars and cafes, but also is a very green city similar to what you would find in the suburbs. The parks and bicycle paths are some of Jan's favorite elements of the city. It is a very exciting time in Copenhagen right now with many new public spaces opening up, encouraging more and more people to enjoy the city. There is great emphasis on creating a livable city as these public spaces are truly for the public and not just for private interests. With its current progressive architecture scene, welfare state, and numerous large philanthropic foundations that support worthy projects, and numerous talented small and large architecture firms, Copenhagen has created an ideal, yet unique living and work environment for the creative demographic.

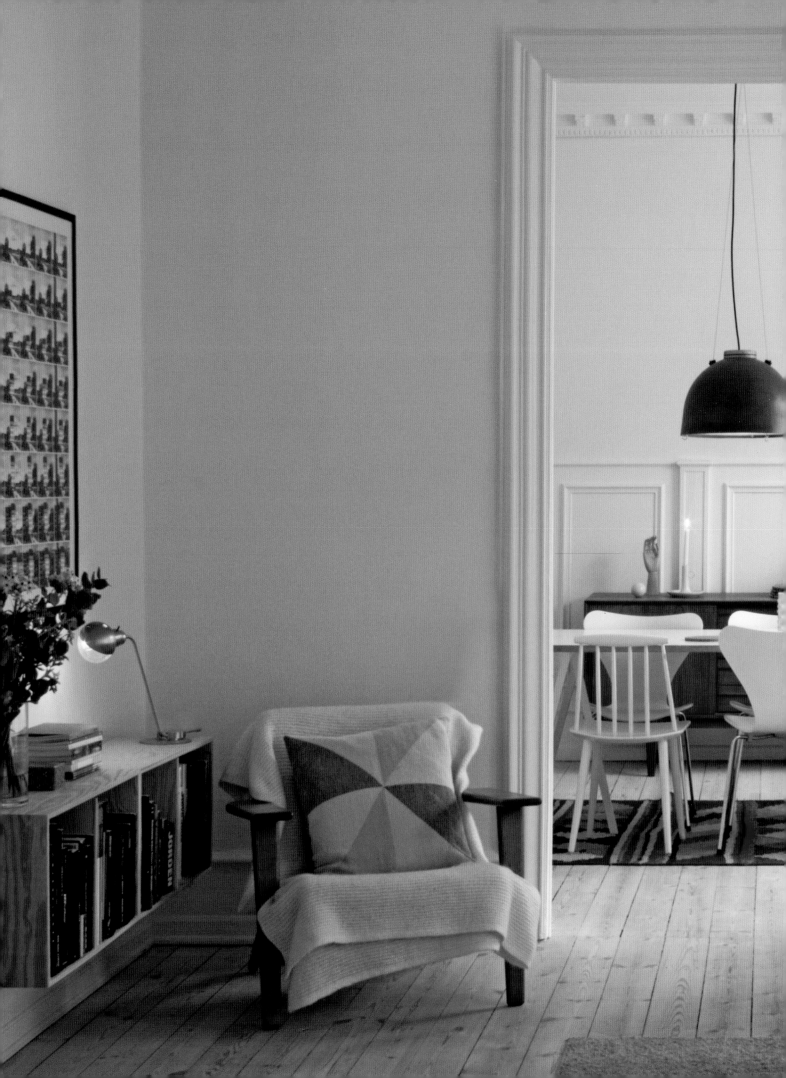

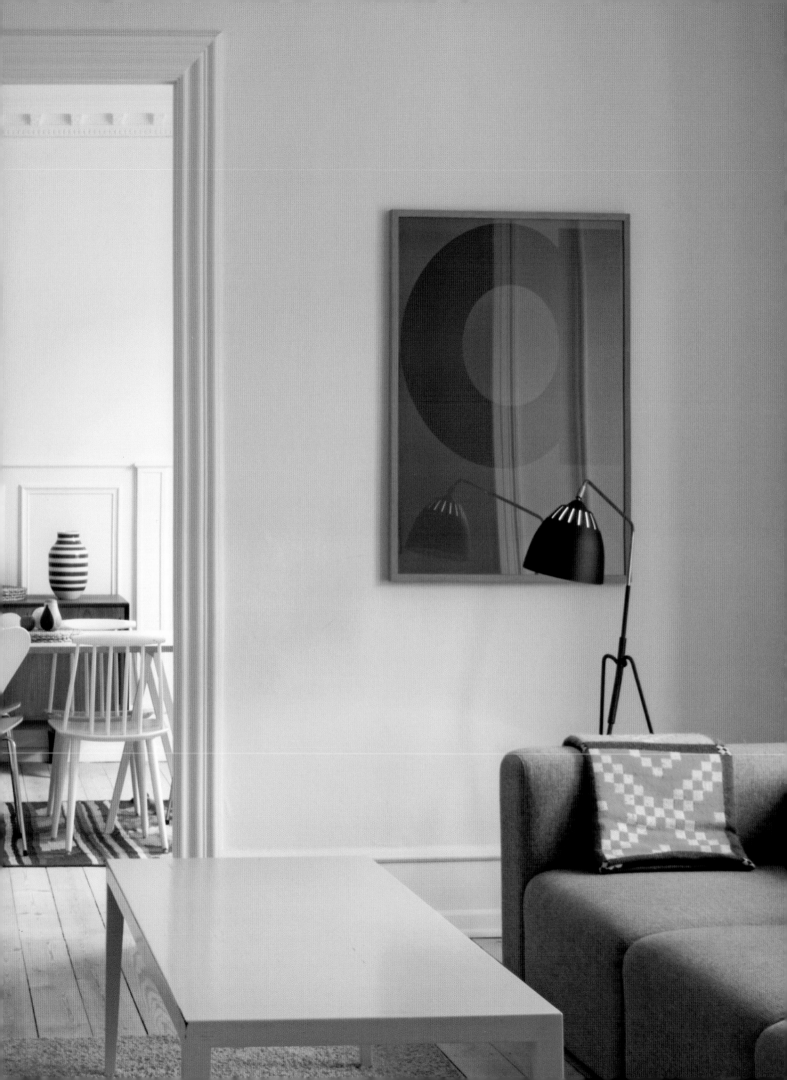

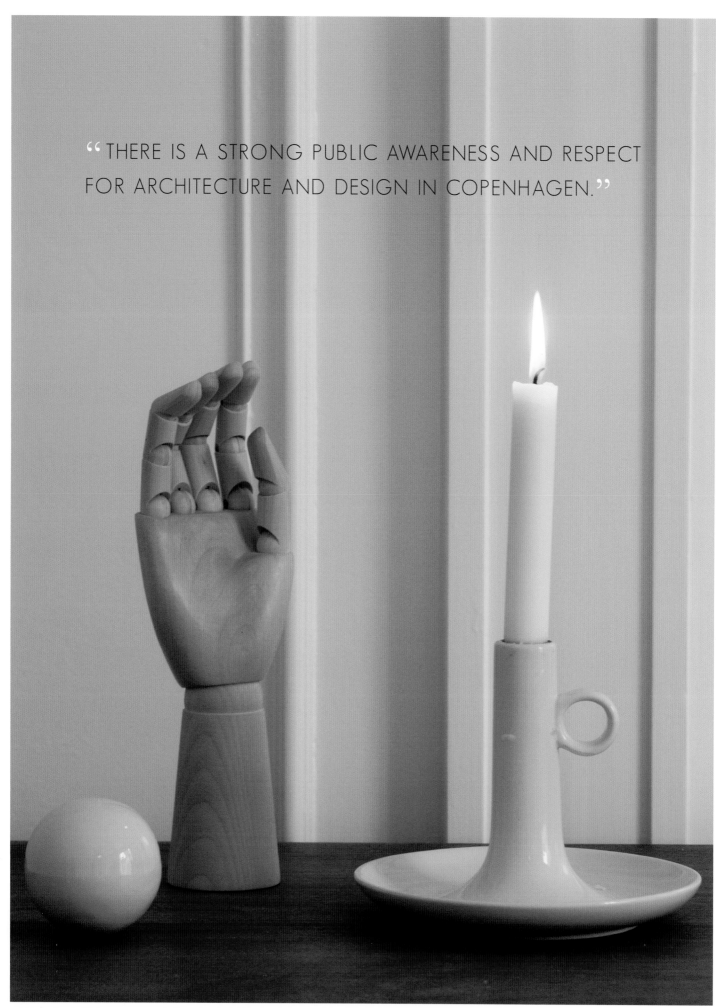

"THERE IS A STRONG PUBLIC AWARENESS AND RESPECT FOR ARCHITECTURE AND DESIGN IN COPENHAGEN."

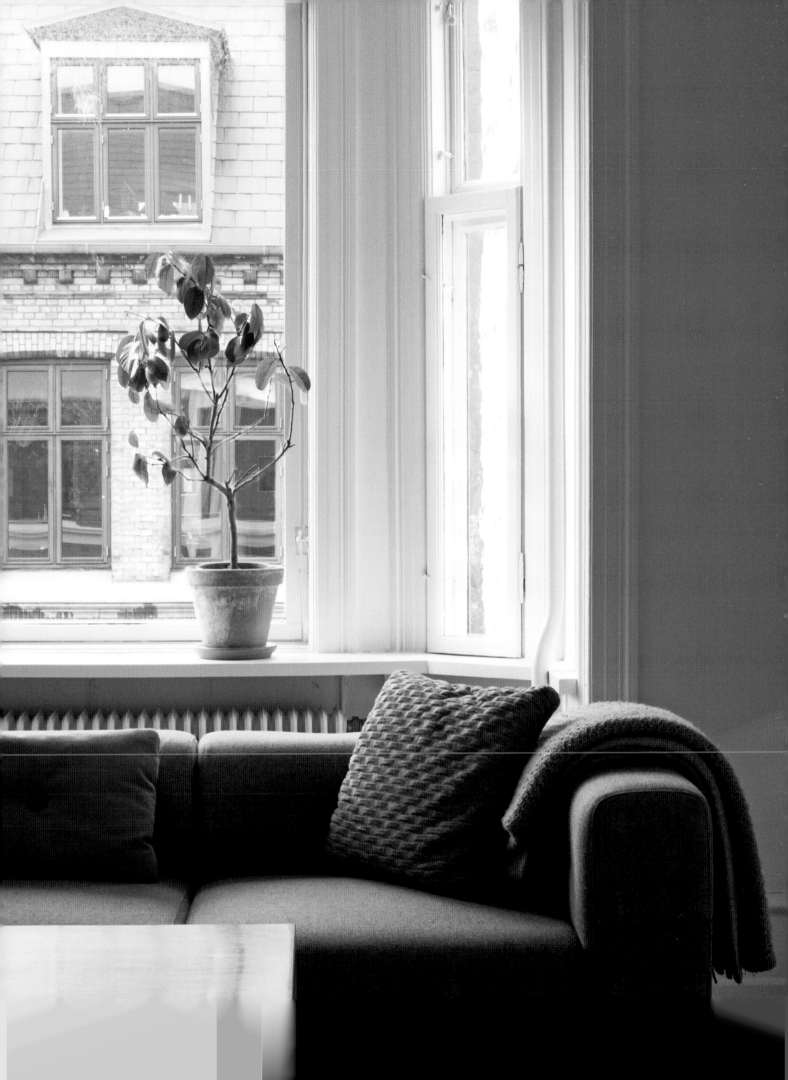

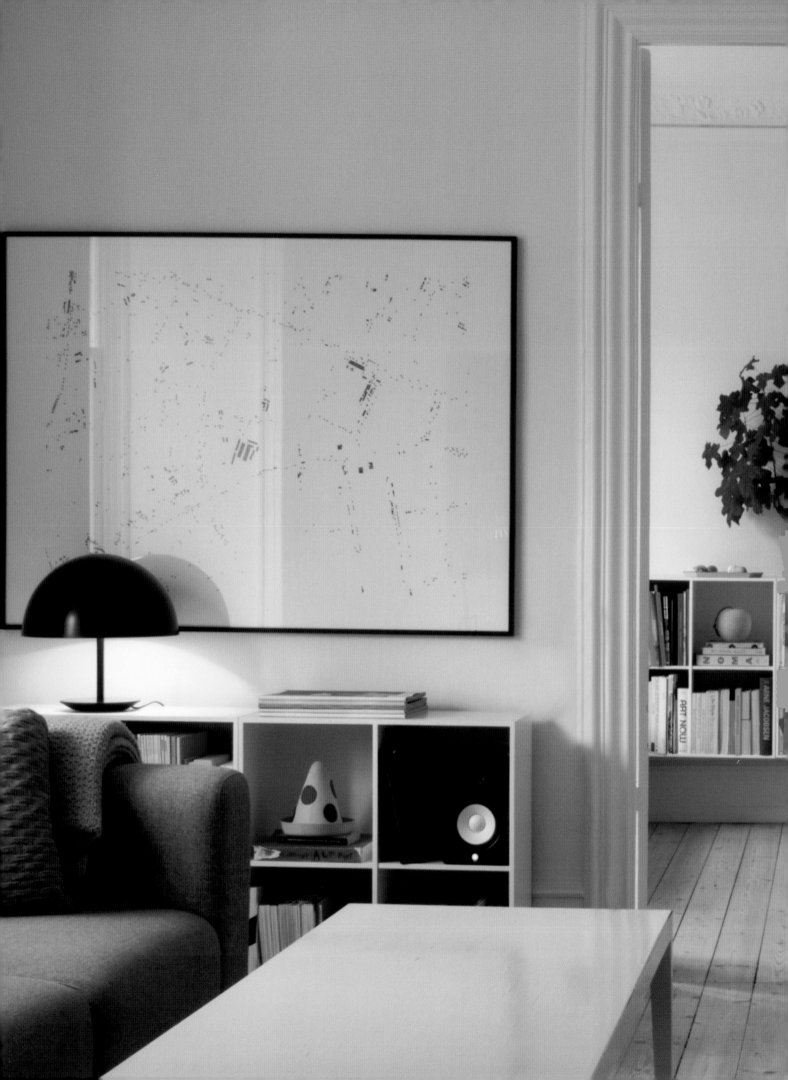

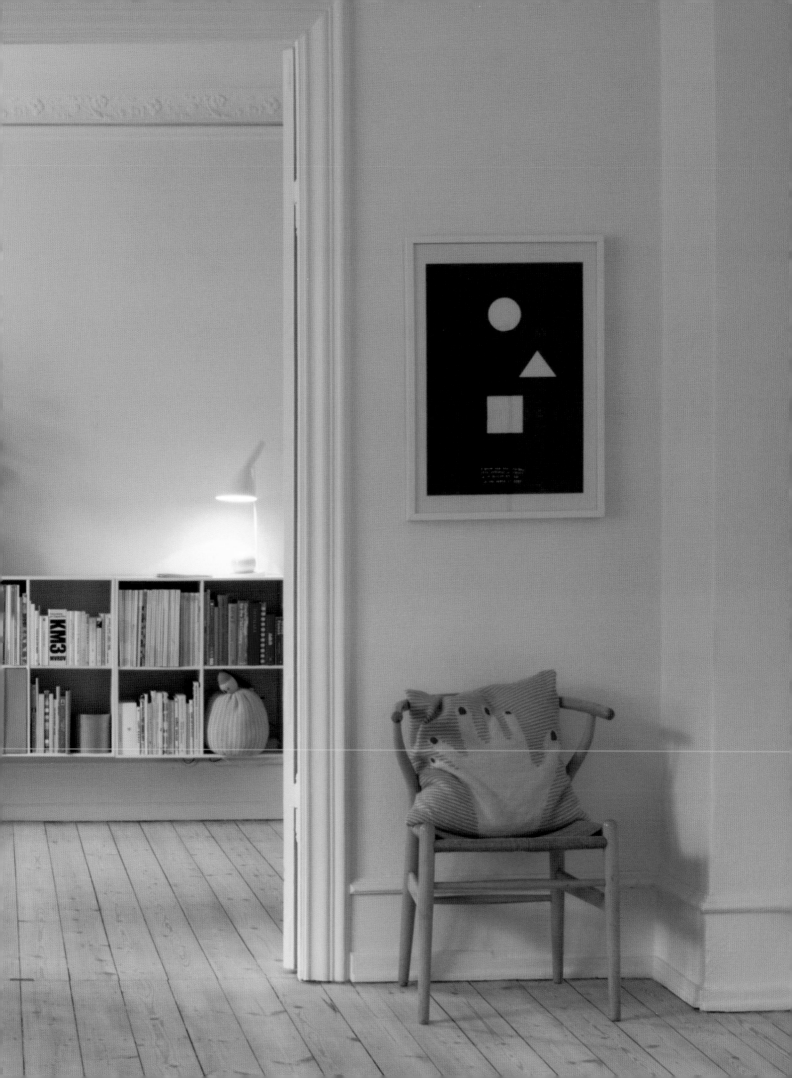

STILL INFLUENTIAL TODAY,
THE DANISH MODERN
AESTHETIC AND STYLE
OF MINIMALIST WOOD
FURNITURE HAS BEEN
EMBRACED WORLDWIDE.

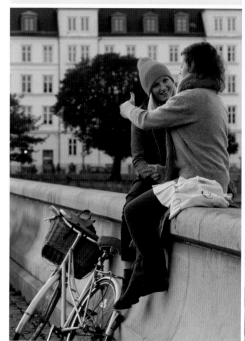

NOTABLE COPENHAGEN RESIDENTS INCLUDE ARCHITECT
AND DESIGNER ARNE JACOBSEN, FURNITURE AND INTERIOR
DESIGNER VERNER PANTON, AND FURNITURE DESIGNERS
BØRGE MOGENSEN AND HANS WEGNER.

KNOWN FOR HIS PH LAMPS,
DANISH ARCHITECT POUL
HENNINGSEN IS SAID TO
BE THE WORLD'S FIRST
LIGHTING ARCHITECT.

COPENHAGEN IS KNOWN
INTERNATIONALLY AS
HAVING ONE OF THE
HIGHEST QUALITIES OF LIFE
BECAUSE OF ITS STABLE
ECONOMY, EDUCATION
SERVICES, PUBLIC
TRANSPORTATION, AND
MANY PARKS.

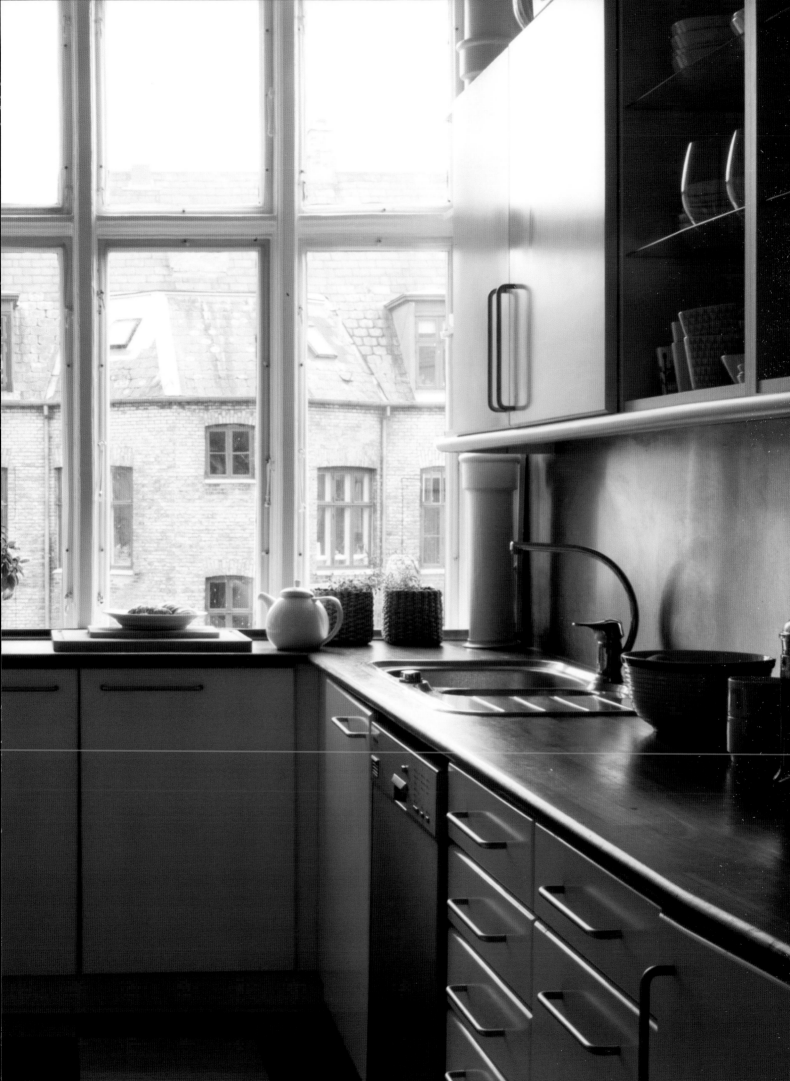

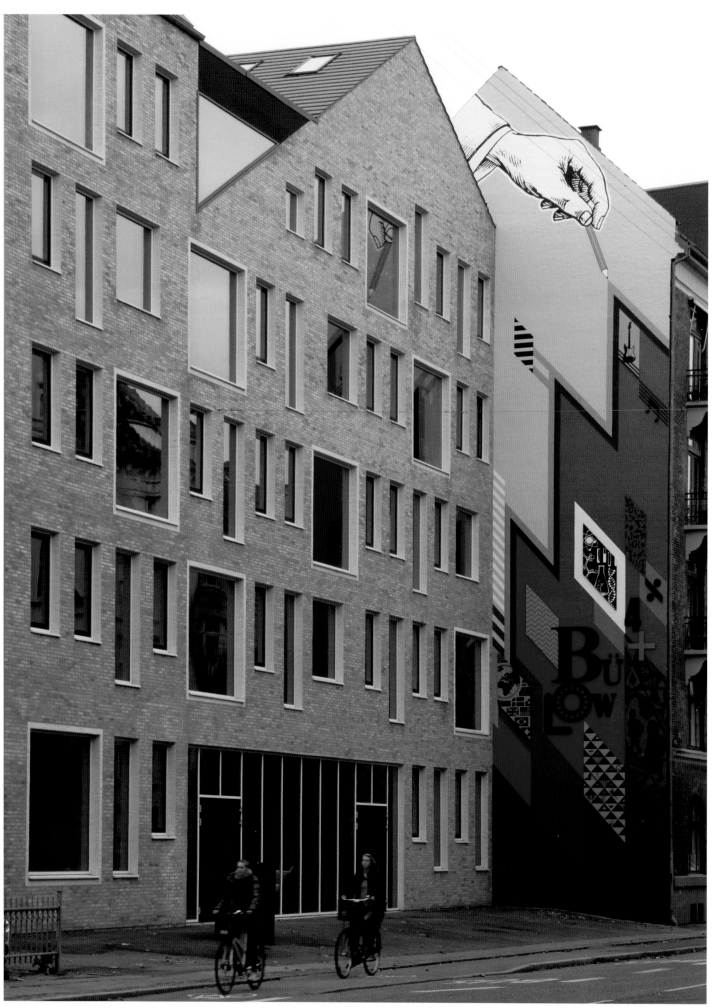

EDINBURGH
SCOTLAND

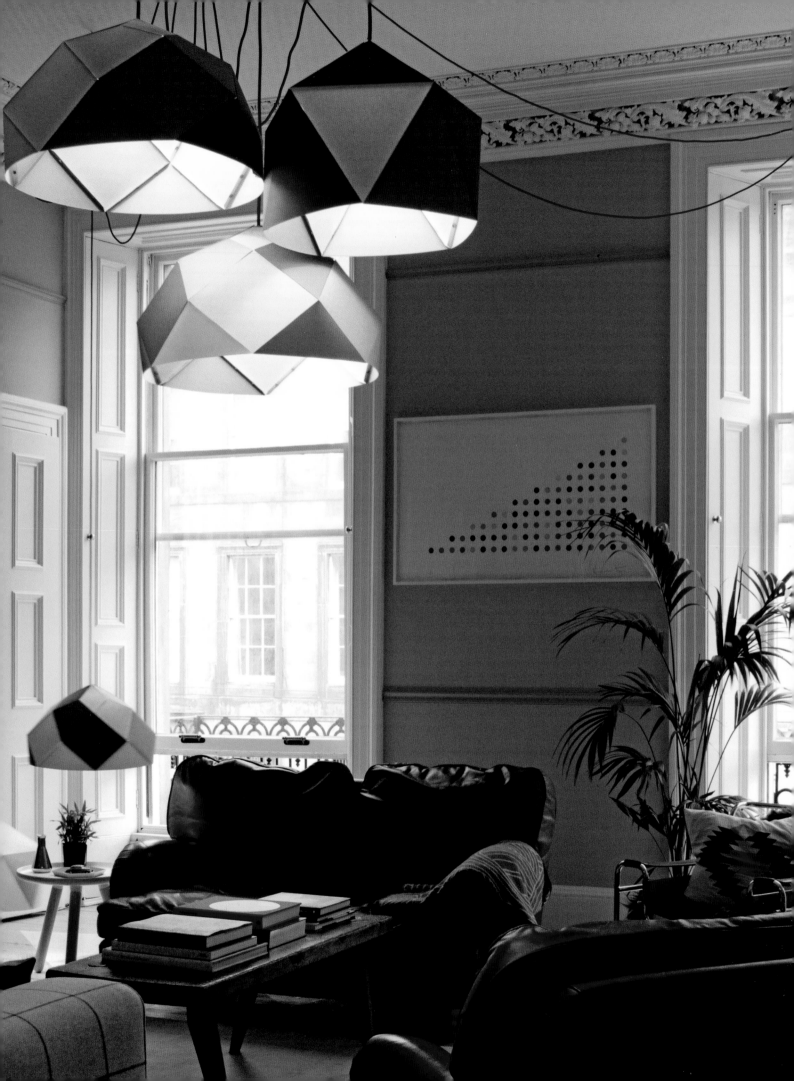

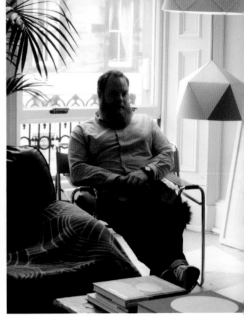

SAM BUCKLEY
INTERIOR BRAND DESIGNER

Sam was born in Muscat, Oman, whose father worked for Shell and whose mother was a landscape designer and artist. Under the age of five, he and his family also lived a year in the Netherlands before they moved to the UK permanently. They lived in a little village in Yorkshire, outside of Leeds, England. Sam attended school at the over 400-year old Queen Elizabeth Grammar School in Wakefield (a district in West Yorkshire).

Growing up in Yorkshire, he was exposed to a number of art spaces that made a strong impression on him from a young age. The Henry Moore Institute was Sam's first experience in an art gallery, but it was not just the sculpture that inspired him, but also its imposing modern design with a black marble façade that stood right next to the city hall in the center of Leeds. In the countryside between Wakefield and Dewsbury, Sam also discovered the Yorkshire Sculpture Park, where he would wander through the endless fields to find large-scale works by James Turrell, Henry Moore, and Sol Lewitt.

In 2000, Sam moved to Edinburgh to study architectural technology and worked as a CAD technician for a number of design firms. He also worked for an architecture office where he designed anti-terrorist public seating outside the Scottish Parliament. When the recession hit, Sam decided to refocus his career on design. He enrolled at Scuola Politecnica Di Design in Milan for a Master's degree in interior design, and while there, he collaborated with the handmade rug company, cc-tapis, and turned a few of his sketches into rugs. Sam has also worked in the field of corporate design and branding working as design strategist as well as designing a number of retail spaces.

He has also been collecting art for the past 10 years, ever since his first fascination with French public space artist Eltono, who really grabbed Sam's attention because he loved the interaction of the art and its immediate environment. He is also a fan of other contemporary English street artists such as Banksy, D*Face, contemporary artist and painter, Antony Micallef, and Dutch artist, Joram Roukes.

Sam has always appreciated Edinburgh for its sense of scale and proportion, but also for Old Town's maze of courtyards and passageways, and the dark stories from its medieval history. Edinburgh's historic cemetery dating back to the 1500s, Greyfriars Kirkyard, is a foreboding place to explore, as it is said to be one of the most haunted cemeteries in the world. Having studied in Italy, Sam really likes the idea of the old architecture of Edinburgh mixing with new, contemporary decor. And for a small city, Edinburgh has a vibrant art scene, but because of its size, one is also only a short drive from the Scottish countryside and other parts of the country's rugged terrain.

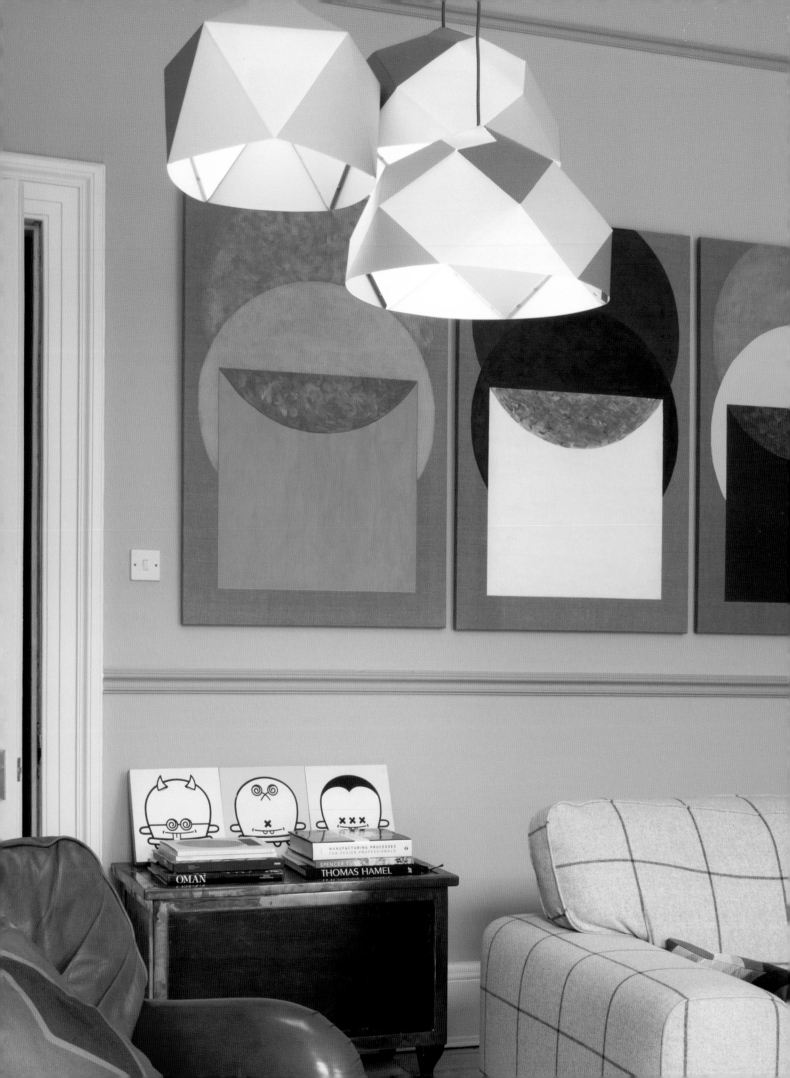

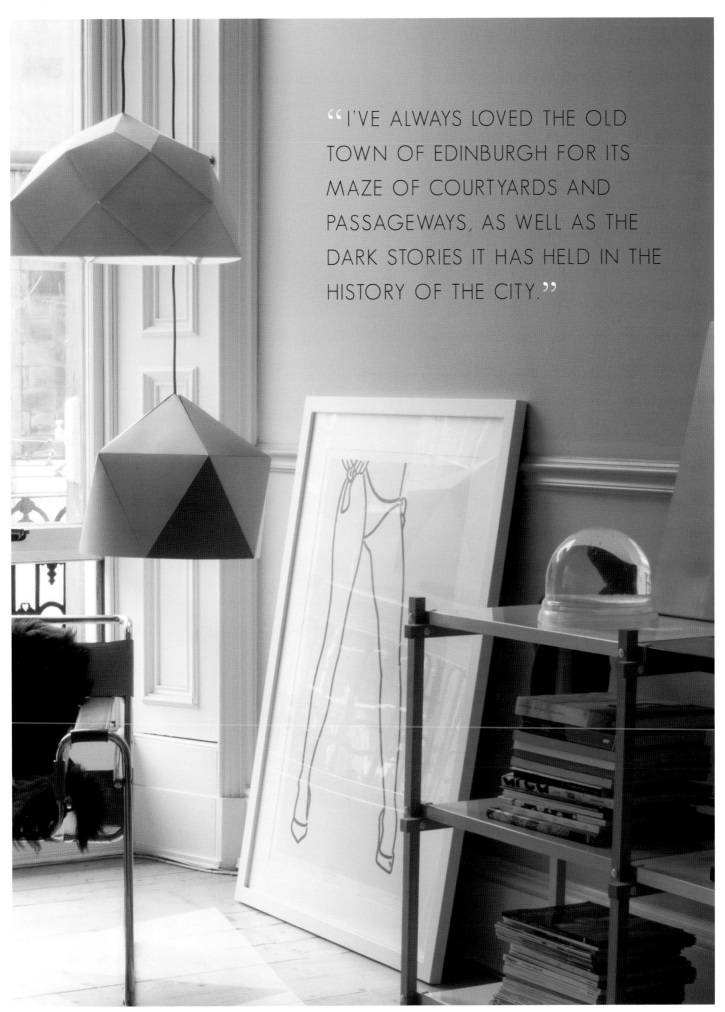

"I'VE ALWAYS LOVED THE OLD TOWN OF EDINBURGH FOR ITS MAZE OF COURTYARDS AND PASSAGEWAYS, AS WELL AS THE DARK STORIES IT HAS HELD IN THE HISTORY OF THE CITY."

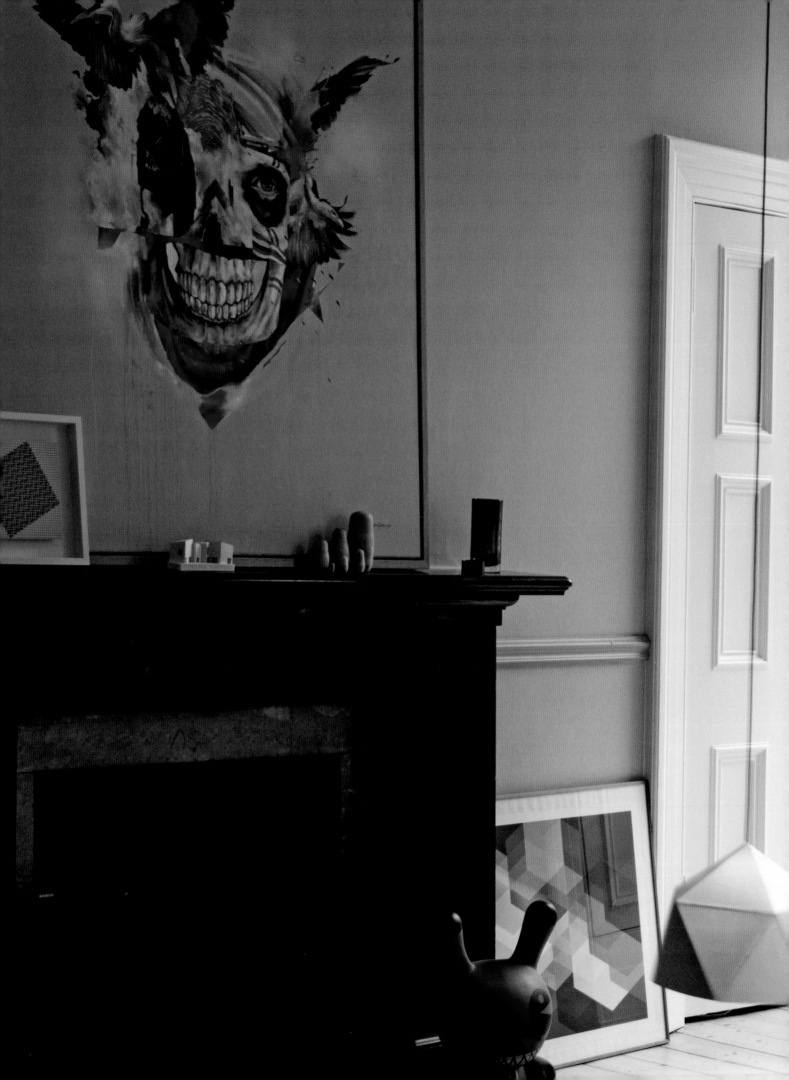

THE OLD TOWN HAS PRESERVED MUCH OF ITS MEDIEVAL STREET PLAN.

EDINBURGH HAS A POPULATION OF UNDER ONE MILLION PEOPLE.

THE HISTORY OF EDINBURGH DATES BACK TO 8500 BC.

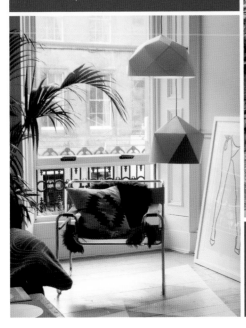

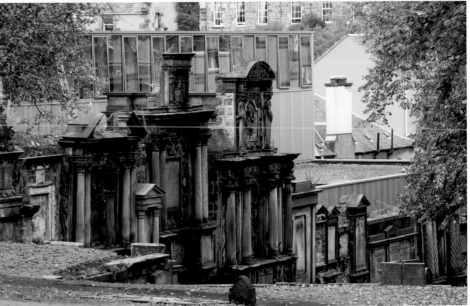

EDINBURGH FESTIVAL FRINGE IS ONE OF THE LARGEST ARTS FESTIVALS IN THE WORLD.

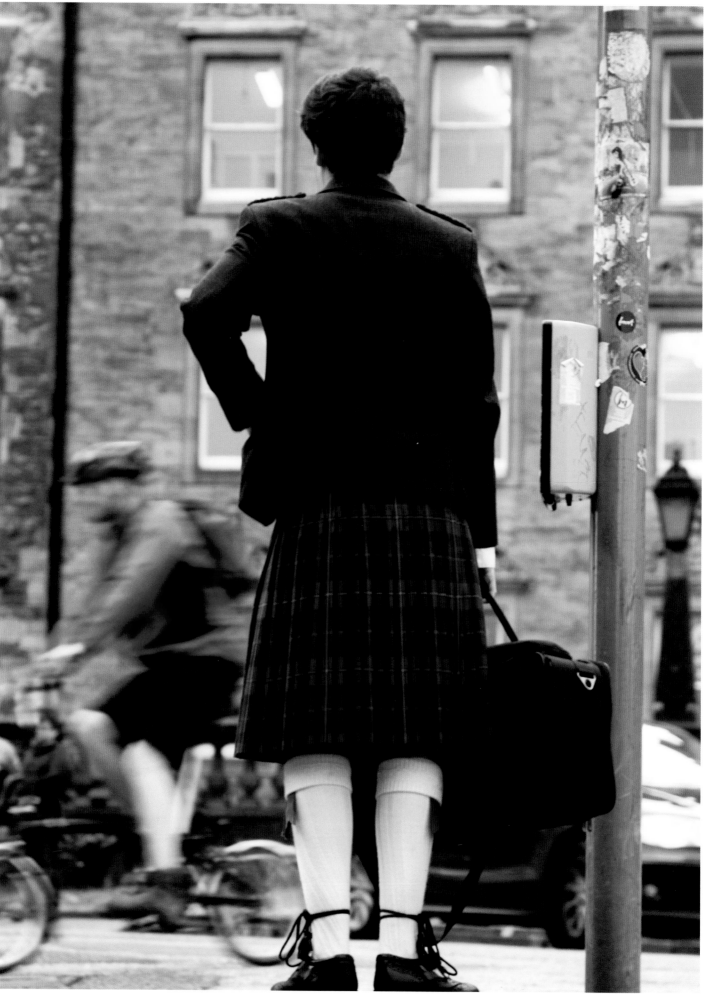

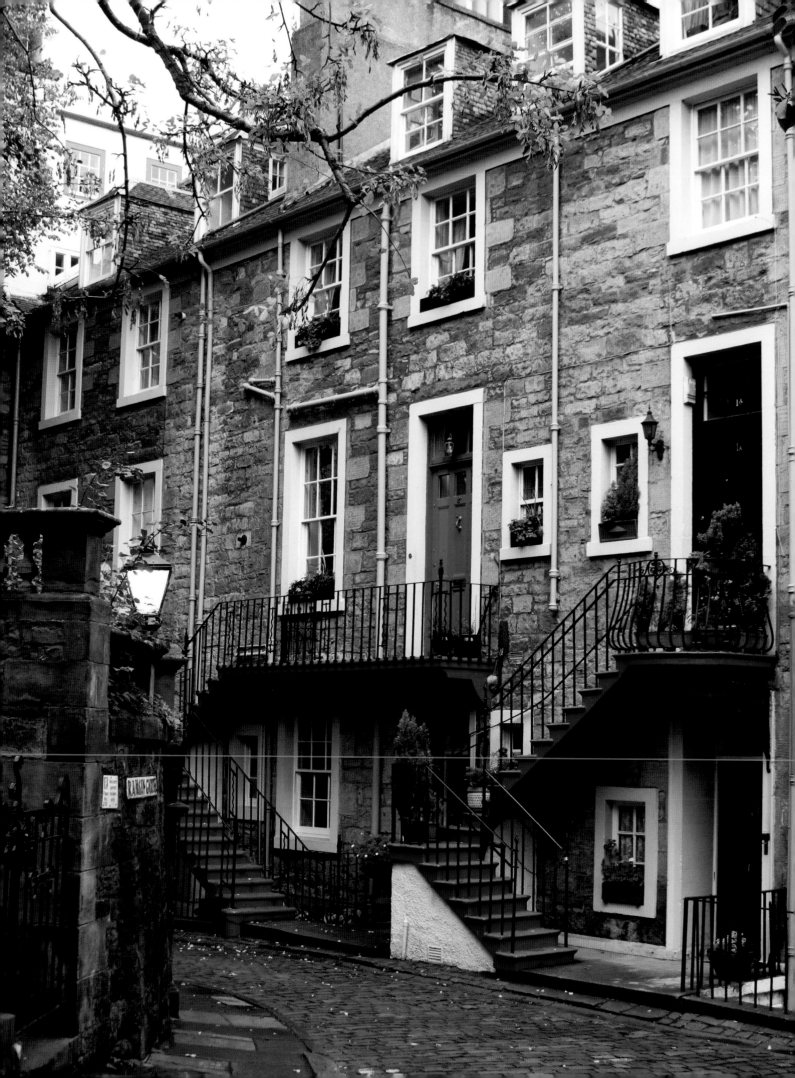

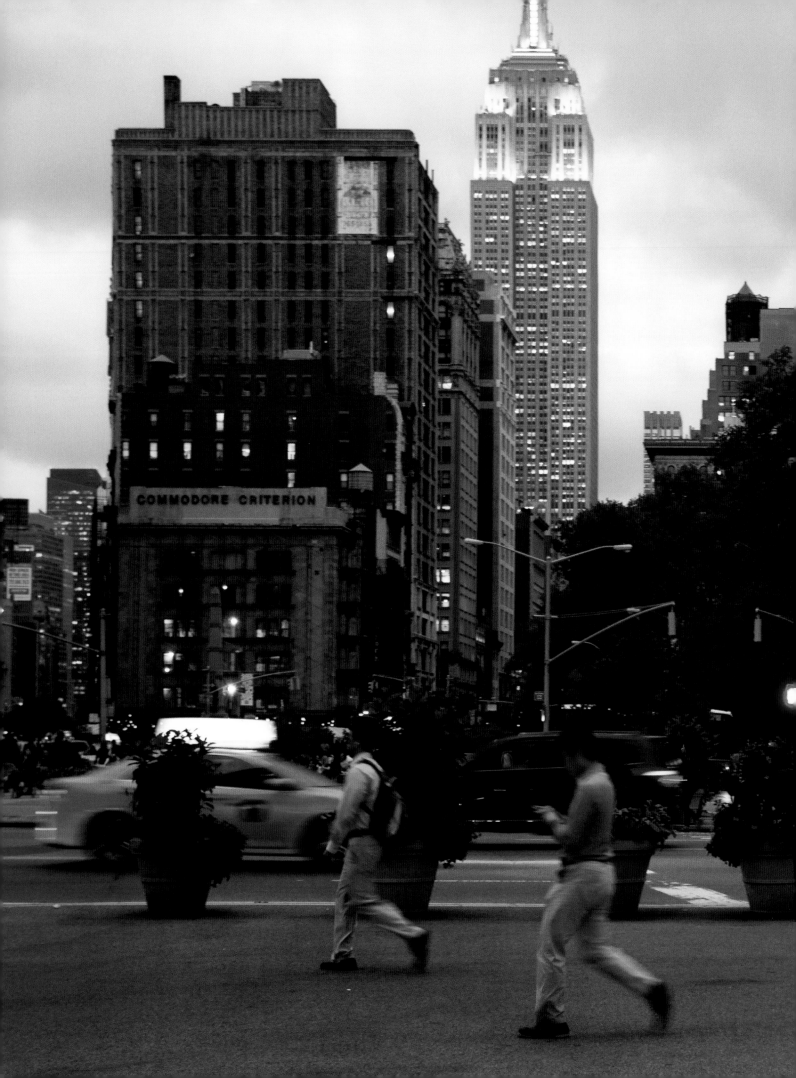

NEW YORK CITY
UNITED STATES

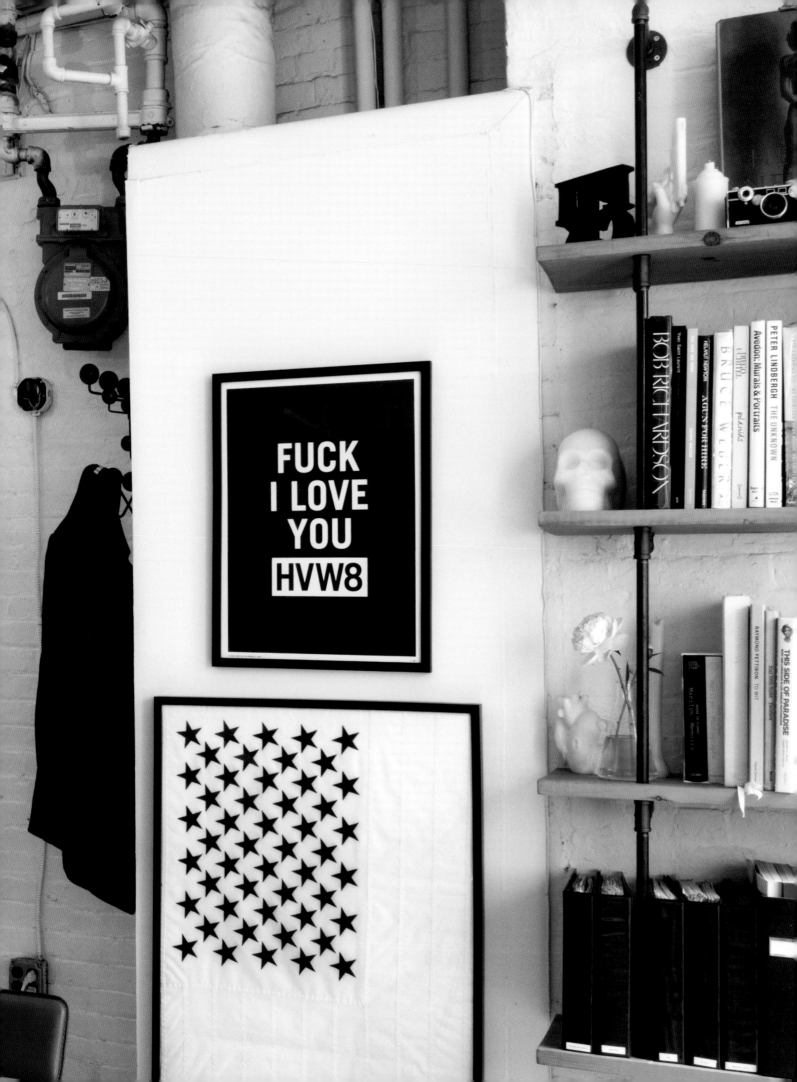

MOSES MORENO
FASHION STYLIST, PHOTOGRAPHER & CREATIVE DIRECTOR

Moses Moreno's story is an example of what is possible in New York City and shows, on a larger scale, the promise of the American Dream. He was born in a suburb of Los Angeles and raised in a single parent household that left him with fractured goals and hopes for the future. At the age of 14, deciding he would be better off alone, he ran away from home, escaping to a life on the street, skateboarding all day and night.

Skateboarding eventually started to lose its appeal and upon the suggestion of an acquaintance, he met with a friend who was the manager at the Miu Miu store on Melrose Avenue in Los Angeles. With no retail experience, Moses was offered a job because he had the right youthful and edgy "look" for the store. He met many stylists while working there, which led to working in the office of Hollywood's top fashion stylist, then shortly thereafter, he began interning on set for the Fashion Director of *W* Magazine. As a youth living on the street, Moses was partaking in an authentic subculture, which unwittingly conceived his form of expression and style. His creativity was naturally borne from his transient lifestyle, at once uninhibited yet constrained by a lack of life options.

Moses' career, natural talent for styling, and raw perspective on fashion grew quite organically with no college education. After gaining some traction with his newfound career in fashion, he decided to move to New York City to get serious about advancing his business to the next level. His determination and hard work opened up doors for him in New York City—an experience that Moses describes as a testament to his realization of the 'American Dream.' Still very young and a new stylist in the fashion industry, he has already obtained an impressive roster of clients from *Rolling Stone* to *W* Magazine.

In order to keep a sense of privacy in a high-profile industry, Moses purposely stays out of the limelight. He prefers for clients to hire him based on his work and what it represents visually in culture versus knowing his age or social status in life. He is rarely photographed and has managed to maintain his allure.

Moses has traveled to many of the large European cities, but he finds most of his inspiration from the everyday life in New York City. He notices the unique aesthetics and energy of ordinary people just walking on the street. He appreciates the mix of cultures from people from around the world all living in the same place, living for a dream, all different, but all somehow the same. It is never easy to work and afford to live in New York City, but, as Moses believes, with tenacity and pushing beyond your own imaginable limits, anything is possible.

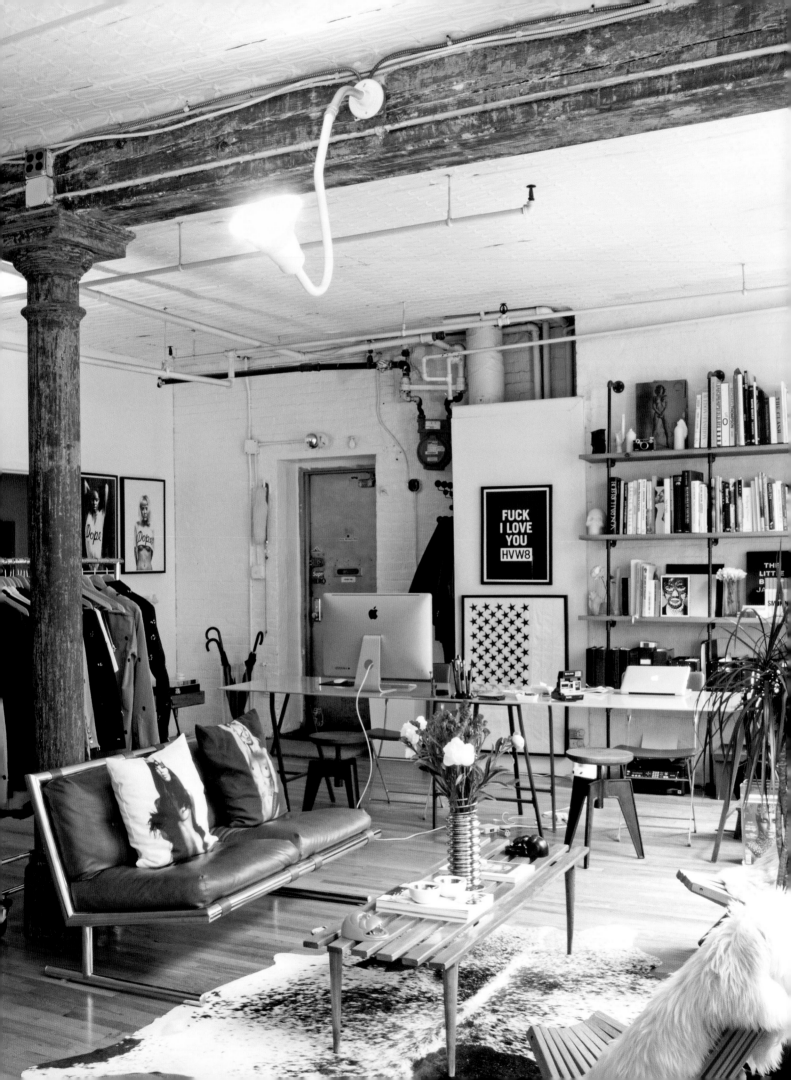

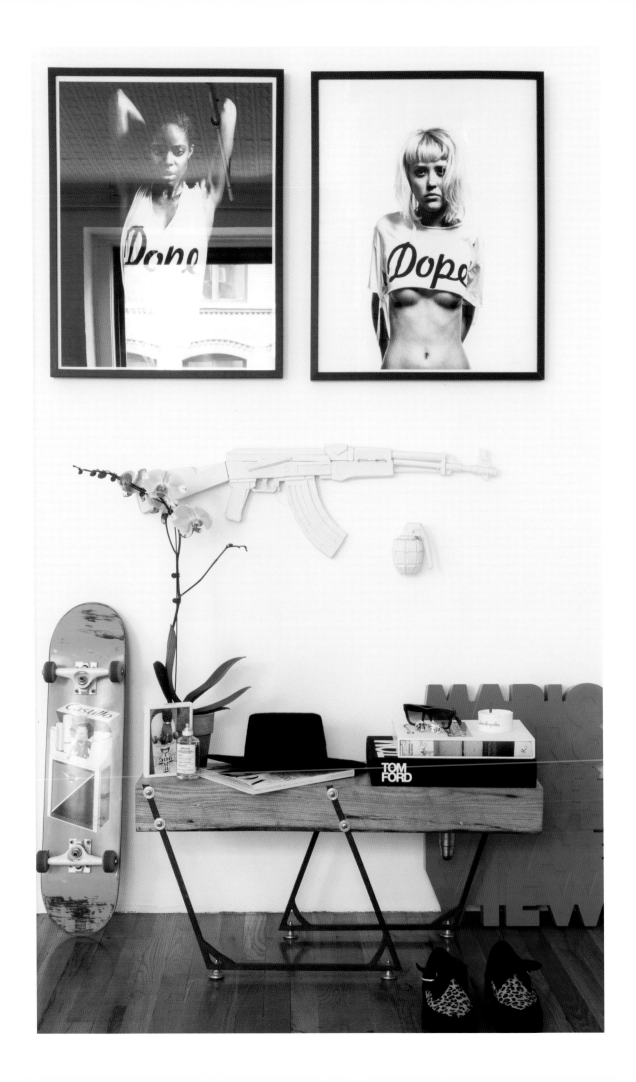

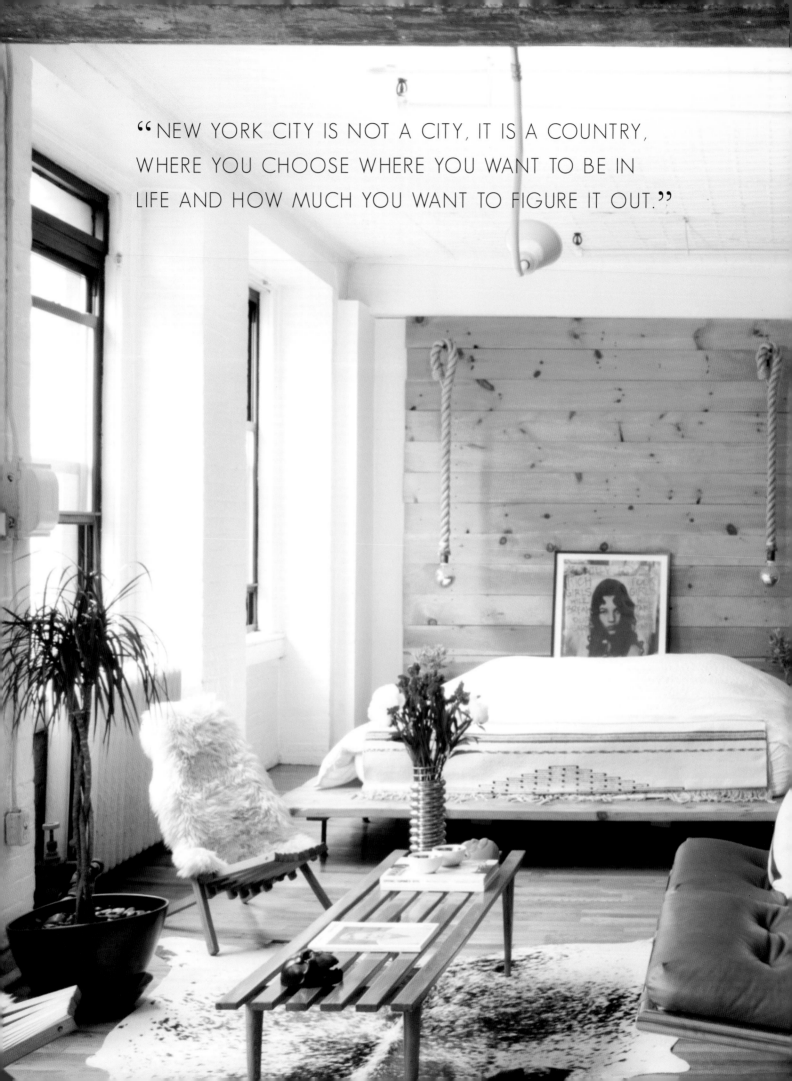

"NEW YORK CITY IS NOT A CITY, IT IS A COUNTRY, WHERE YOU CHOOSE WHERE YOU WANT TO BE IN LIFE AND HOW MUCH YOU WANT TO FIGURE IT OUT."

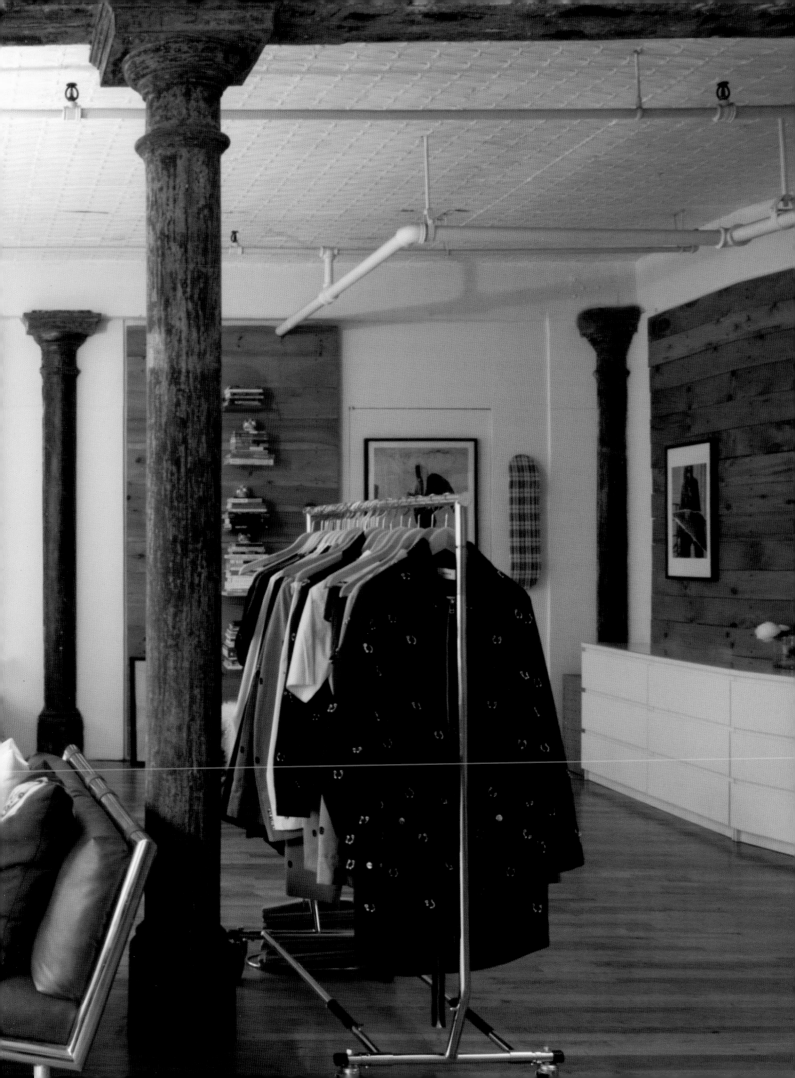

NEW YORK CITY IS KNOWN AS THE GLOBAL CAPITAL FOR CULTURE AND FINANCE.

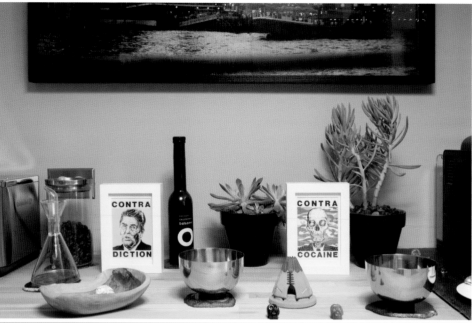

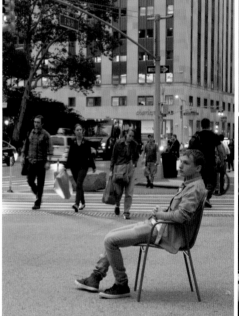

NEW YORK CITY HOSTS A NUMBER OF ART AND DESIGN FAIRS INCLUDING THE RENOWNED INTERNATIONAL CONTEMPORARY FURNITURE FAIR (ICFF).

NEW YORK IS THE FOREMOST CITY IN THE U.S. FOR PUBLISHING ART, DESIGN, AND FASHION MAGAZINES, AND BOOKS ON ART AND ARCHITECTURE.

THE MANHATTAN SKYLINE HAS SOME OF THE WORLD'S HIGHEST SKYSCRAPERS.

NEW YORKER HENRY DREYFUSS WAS A PROMINENT INDUSTRIAL DESIGNER OF THE 1930S AND 1940S WHO CREATED THE ICONIC DESIGNS OF THE WESTERN ELECTRIC 302 TABLETOP TELEPHONE, THE HOOVER MODEL 150 VACUUM CLEANER, AND THE POLAROID SX-70 LAND CAMERA.

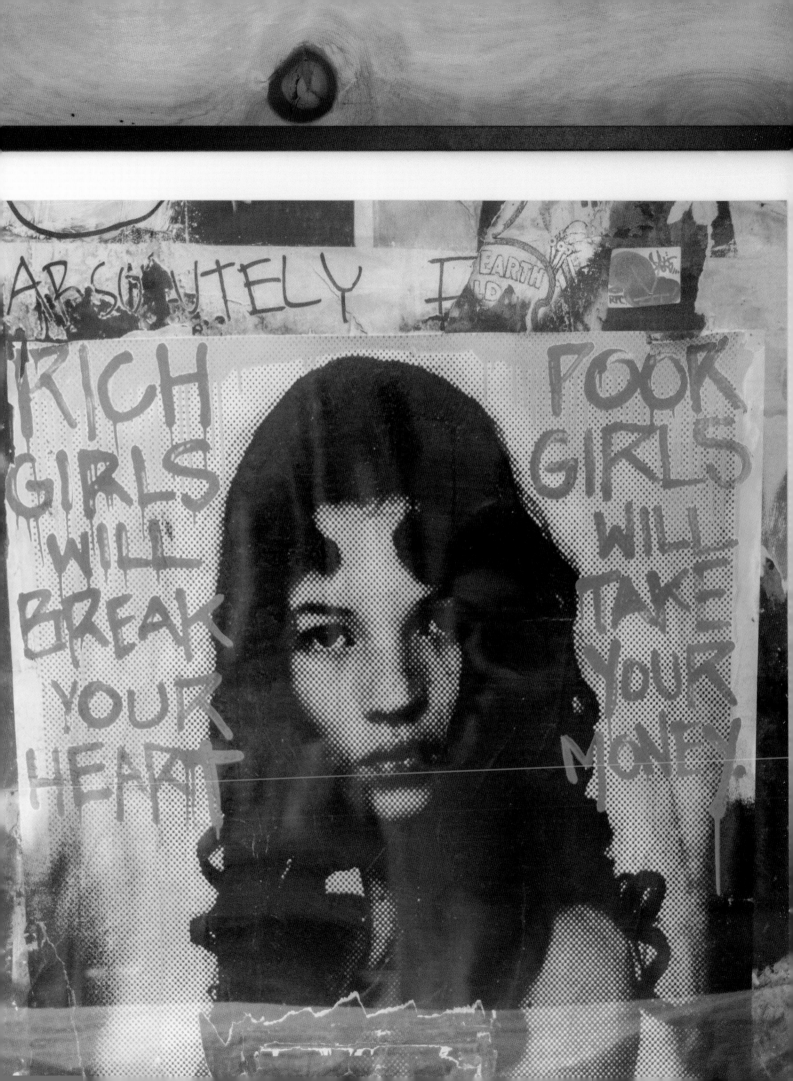

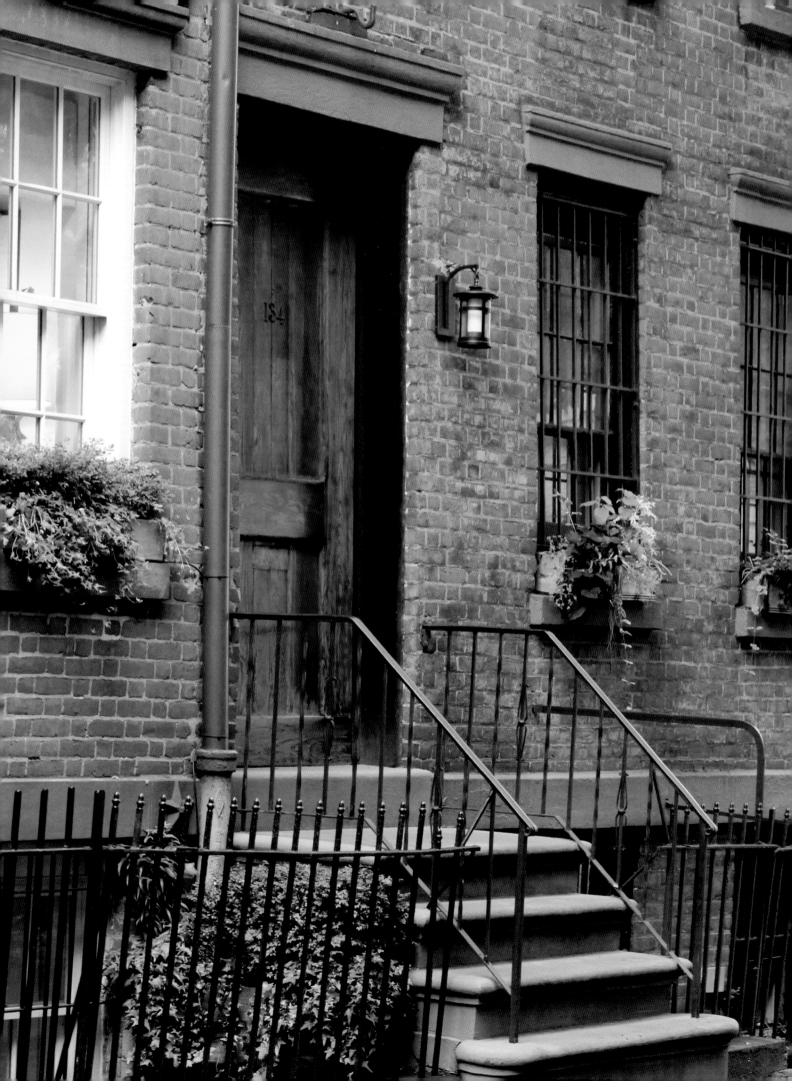

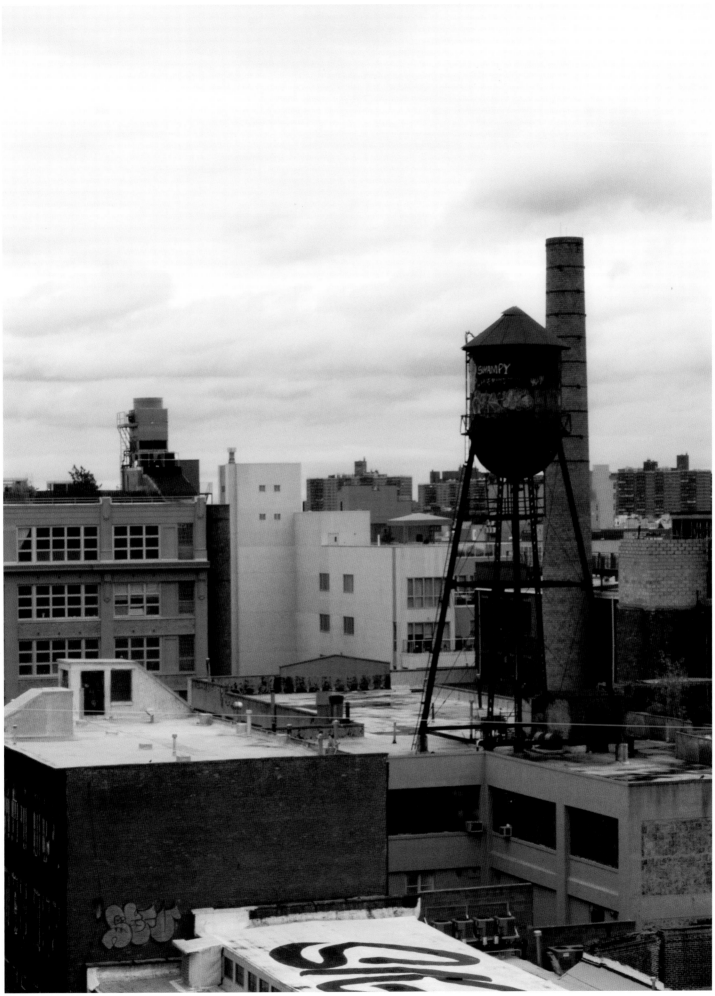

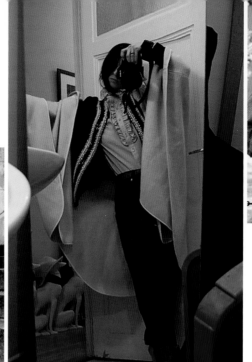

MARCIA PRENTICE

One evening I was sitting in my car having my usual conversation about travel with my Italian friend. I was completely, absolutely consumed with thoughts of more travel, taking Italian classes, staying in touch with new Italian friends from Rome, and making lists of all the cities I wanted to visit in the world and discover its design, art, and people. I wanted to travel, but not just be a tourist or a backpacker. It was very clear that my thoughts of exploring abroad were lasting and that my first Italian holiday had really impacted and stimulated me in a way that I couldn't turn back my mind to a prior way of thinking or living…

I am an American photographer whose style captures the intersection of emotion and design in the home. Starting my career less than five years ago as a self-taught photographer with a background in interior design, I combined both of my sensibilities and built a career as an interior photographer working with designers, home brands, and media. I have established my niche of photographing the homes of creatives with my unique intimate approach, and I have now photographed over 150 homes of designers and artists. My work has been featured in such publications as *Architectural Digest*, *Casa International* (Beijing), *Vanity Fair* (Italia), *Grazia UK*, and the new *Freunde von Freunden* book. I have hosted an interior photography workshop for designers and given a lecture at ESAD Matosinhos College of Art and Design in Porto, Portugal.

ACKNOWLEDGEMENTS

Taking on a project of this magnitude that requires traveling around the world has been a huge personal and professional challenge beyond anything I could ever imagine. From the beginning I had faith that everything would somehow work out and along the way it is the people that surround me that helped me carry through.

First, of course, I would like to thank my family—my mother for always supporting me no matter how outrageous my ideas may seem. I was very fortunate to be raised in a family where I was allowed to be very curious and discover who I am. This is the greatest gift you could have ever given me.

I started this overwhelming project one step at a time moving from country to country and along the way people have nurtured and encouraged me to keep going. Guy and Karen Vidal, thank you for your belief in me and support for many years. I feel very fortunate to have the both of you in my life. Mohamed Keilani, thank you for your immense admiration of my work and your beautiful words that reminded me why I started this project. You were there from the very beginning. Sergio Mignanelli, meeting you made me see who I am, which gave me the confidence to follow my dream. Luca Nichetto, you are a new friend, but a great supporter. A very special thank you to everyone whose homes in which I stayed. I will never forget all the special memories you have given me.

I have endless gratitude for the overwhelming support from every single designer and artist in the book. Without knowing me, you believed in my wild idea and welcomed me into your home and life. I have grown so much as a person and an artist learning from you.

A huge thank you to everyone at teNeues Books—my editor Carla Sakamoto, designer Allison Stern, sales and marketing director Audrey Barr, publicist Jenny Nguyen, and, of course, publisher Hendrik teNeues, and the entire U.S. and German team. Audrey, your level of support from the beginning has been incredible. I will never forget receiving that e-mail asking me to come to the office in New York only hours after you received my book proposal. Carla Sakamoto, I don't know how I got so lucky to have you as my editor. You often seem like a long lost best friend. Just when I think I can't work any harder, you push me further and further all the while we are having so much fun. Allison Stern, having someone translate your work into a book is never easy. This 2-year project has been incredibly emotional, artistic, and so much of myself is in every photo. The way you presented my work so beautifully made me feel like you were right there with me the last two years. Hendrik teNeues, thank you for believing in me and this book! teNeues was my first choice for a publisher for this book, so collaborating together has definitely made my dreams come true. I feel so humbled and honored to be working with such a forward thinking and brilliant publisher.